THE
PHOTOGRAPHY BIBLE

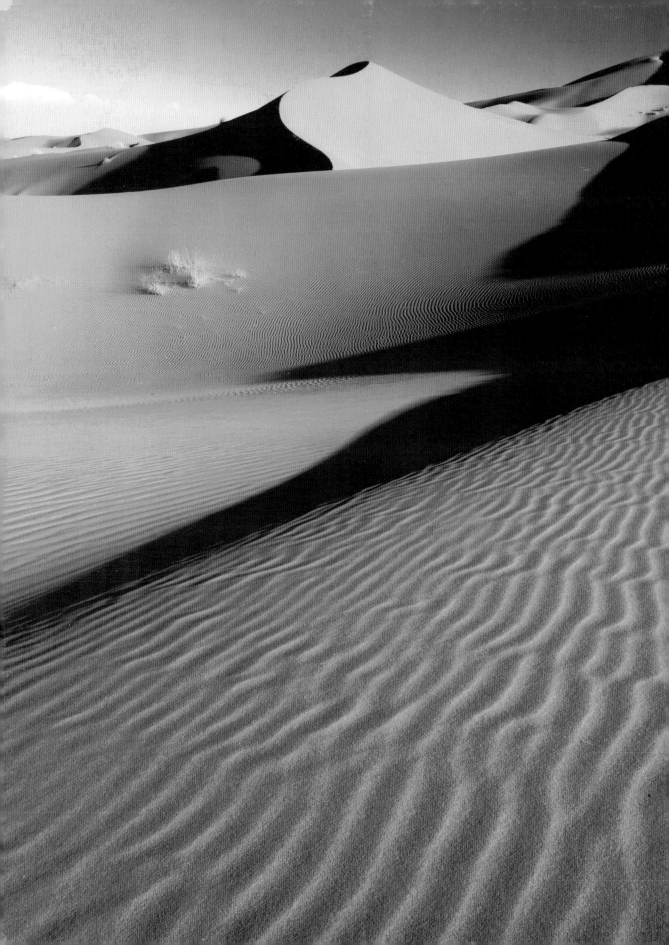

THE PHOTOGRAPHY BIBLE

DANIEL LEZANO

A COMPLETE GUIDE FOR THE 21ST CENTURY PHOTOGRAPHER

D&C
David and Charles

DEDICATION
To family and friends, you are my inspiration.

ACKNOWLEDGMENTS

Thanks you for choosing this book as a companion for your photographic journey. I hope you'll find the advice within helps you to take better pictures and inspires you to improve your photo skills. I'd like to thank the following photographers, who kindly contributed images for use in this latest edition: Lee Frost (www.leefrost.co.uk), Brett Harkness (www.brettharknessphotography.com), Jon Hicks, Ross Hoddinott (www.rosshoddinott.co.uk), Simon Stafford (www.simonstafford.co.uk) and Bjorn Thomassen (www.bjornofinspire.com).

PICTURE CREDITS

© LEE FROST: 2, 7 t, 29 b, 31 r, 62 m, 90, 91 m, 92 t, 93 t, 94, 99 b, 100 all, 103 all, 106 bl, br, 109 t, 113 t, 114, 115 br, 117 t, 119 b, 123, 130, 131 t, 133 b, 134 b, 139 all, 142 r, 143 t, b, 144 all, 145, 148 t, m, 149 t, m, 150 b, 151 all, 154 t, 155 t, 158, 159 all, 160.

© ROSS HODDINOTT: 6 t, 39 m, 40, 55 all, 88 t, 93 b, 96, 97 all, 99 t, 101 all, 102 all, 104 all, 107, 108 all, 115 t, m, 118 all, 119 t, 120 t, 121 b, 122 r, 127, 131 b, 132, 133 t, 134 t, 135 all, 137 all, 138 all, 142 l, 143 m, 150 t, 152, 153 all, 154 b, 155 r, 156, 161 all.

© BRETT HARKNESS: 110 all, 111 b.

© BJORN THOMASSEN: 112, 116 all, 117 b.

© SIMON STAFFORD: 91 t, 140, 141 all.

© JOHN HICKS: 106 t, 157 t.

ABOUT THE AUTHOR

Daniel Lezano is editor of *Digital SLR Photography* magazine (www.digitalslrphoto.com) by Dennis Publishing, one of the UK's fastest-growing photo magazines and available in the UK, USA and many other countries worldwide. He was formerly editor of *Photography Monthly* magazine and technical editor of *Practical Photography*. He's an enthusiast photographer who is passionate about photography and has lectured around the UK and internationally on the benefits of digital SLR photography. He is widely acknowledged as one of the UK's leading photography writers, regularly interviewing the world's best photographers and reviewing the latest equipment.

CONTENTS

INTRODUCTION

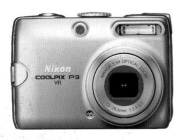

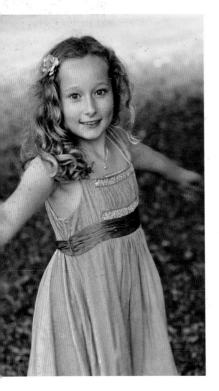

More people than ever before have easy access to great photography, thanks to the digital revolution that reaches into every aspect of our lives. Less than 20 years ago, 'serious' photography was something of a niche, enjoyed in the main by film users. Today, the tools needed to take high-quality images with ease are available to most of us and it is film photography itself that is now a niche, enjoyed by a very small proportion of the population. The pace of this turnaround is something that surprised everyone including myself, with the rapid pace of technological innovation and diversity, as well as the global spread offered by the internet, being at the heart of photography's transformation.

This is the third edition of *The Photography Bible* and has been updated to reflect the dominance of digital and the near extinction of film to the general photographic population. Sure, there remain those who continue to use film – many educational establishments still promote film usage and the traditional darkroom (a policy that has my complete backing – these skills should not be lost) – along with die-hards who prefer the characteristic of film-based images over digital, but for 99.9 per cent of photographers, digital is the chosen medium.

For this reason, this book centres its content on covering digital photography, from technology through to photographic skills and post-processing techniques, and offers very little in the way of reference to film. Those of you old enough to have learned your skills in the film era will most likely understand how difficult, but ultimately justified, this decision was. The fact is the majority of today's photographers honed their skills using digital cameras and are unlikely ever to use film.

That's hardly a surprise when you look at the diversity and quality of digital cameras on offer. While digital SLRs remain the most popular form of interchangeable-lens camera, mirrorless Compact System Cameras have been introduced and gained a strong following in a short space of time. While DSLRs remain the most popular choice, it's not inconceivable for sales of CSCs to match and even overtake those of DSLRs in the future. Digital compacts continue to take serious strides forward in terms of features and performance too, but perhaps the biggest surprise of all is the popularity of Apple's iPhone as a serious picture-taking tool. Boasting a decent-quality lens and several superb photo apps, it has gained a modern 'cult' status and produces images that confound those who believe that mobile phones are incapable of taking high-quality photos.

There is little doubt that photography is going through one of its most exciting and revolutionary stages, not only because of the development of different types of cameras but also for what's possible with your digital image. Once the image file is on the computer, it can be catalogued, edited and transformed in countless ways using software packages like Adobe Photoshop or Apple Aperture. Once edited, superb-quality prints can be made cheaply and quickly at home on inkjet printers, stored online or on back-up discs, sent around the world electronically or exhibited

for a global audience on websites – all from the comfort of your home and within minutes of the image being taken.

Photography has gone through a revolution in recent years and the constant development of technological innovations will ensure that the digital age remains exciting for many years to come. I hope that this book helps you to familiarize yourself with the latest generations of cameras, encouraging you to get the most from all of your available equipment and produce your best-ever pictures. Who knows what the future will bring – with the rate of technological advances, it's quite impossible to imagine what will be available in the next few years.

Daniel Lezano

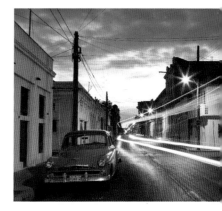

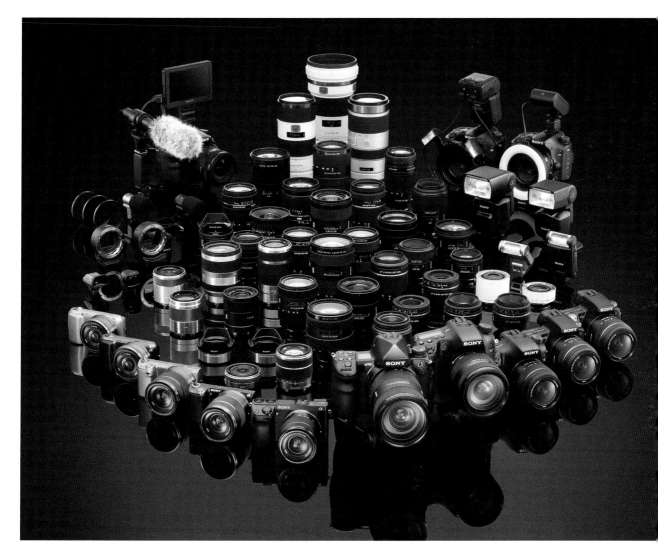

CAMERAS IN THE 21ST CENTURY

DIGITAL SLRS

The digital SLR continues to be the most popular type of interchangeable-lens camera, although the emergence of CSCs (see Compact System Cameras) presents it with its biggest ever challenge. Boasting an excellent range of features, easy operation, unrivalled versatility and superb image quality, it's no surprise that DSLRs continue to be the number one choice with those looking to upgrade from a compact camera.

Digital SLRs look much like their older 35mm film counterparts and in many respects the design has changed very little, but despite its traditional looks, DSLRs incorporate cutting-edge technology. At its heart is the reflex mirror, which provides the viewfinder with an image coming directly from the lens, then flips upwards at the moment of exposure.

ANATOMY OF A DIGITAL SLR

LIVEVIEW

Being able to use the 'LiveView' facility to compose scenes using the monitor rather than the viewfinder is becoming more popular, hence a large button to engage this facility being found on most cameras.

EXPOSURE MODE DIAL

The vast majority of DSLRs have retained the exposure mode dial, as it's so fast and easy to use.

WI-FI

A recent digital innovation is Wi-Fi, a technology that allows the high-speed transfer of images from the camera to the computer without any leads. This has particular applications in the areas of press and sports photography.

CARD SLOT

Most models of digital SLR accept CompactFlash cards, although some accept a choice of two types of card (see Image storage).

INPUT DIAL

Changing variables such as shutter speed and aperture is carried out via the input dial. Most cameras have the input dial located on the top-right corner on the rear of the camera or close to the shutter button. Some high-end models have both.

LCD MONITOR

Most DSLRs offer a 2.7in or 3in monitor, but it's worth checking the resolution – while many have a 460,000-dot screen, some boast a far sharper and brighter display with 900,000 dots or more. Many can be tilted to aid use with shooting at awkward angles.

REVIEW TOOLS

These tools are available to help when reviewing images. The multi-tool allows you to view thumbnails of up to nine images at once on the screen, making it easier to search through multiple images to locate a particular shot. The magnifying tool allows you to zoom into an image to check its sharpness.

VIEWFINDER

Despite the fact it's been around since the middle of the last century, the traditional viewfinder remains the most popular method for framing images.

INTEGRAL FLASH

Virtually all digital SLRs boast a pop-up flash that offers additional light when required. Although not as powerful as external flashguns, they're suitable for shooting nearby subjects and usually offer a decent range of flash features.

TOP TIP

The LCD monitor can be hard to see in bright light, so consider fitting an optional LCD shade to aid viewing.

THE BRIEF LIFE OF THE FOUR-THIRDS DSLR SYSTEM

This digital system, which was developed by Olympus and Kodak, was unique in that it is not based on an existing film system, but has been developed from scratch for digital cameras. The lens mount was developed for various manufacturers to design cameras around it, so that their lenses are cross-compatible. The first camera to use the Four-Thirds System was the Olympus Camedia E-1, a highly specified 5-megapixel camera. Despite several models from Olympus and Panasonic, it failed to make an impression in the DSLR market. However, it formed the basis for the Micro Four-Thirds system of Compact System Cameras, which uses the same sized sensor but, thanks to a smaller lens mount and body, has enjoyed commercial success.

SONY DSLT
Sony's use of a fixed translucent mirror rather than a reflex mirror sets it apart from other digital SLRs.

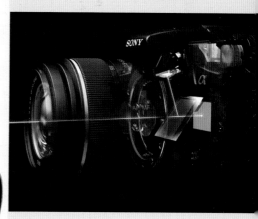

INSIDE A DIGITAL SLR

The digital SLR has more processing power than NASA put into the first mission to land men on the Moon. This high level of computing power is required to control the various functions undertaken by the camera. From the materials used in the body shell to the sophisticated computer circuitry, every part of a modern camera is a marvel of technology, performing complex functions that were impossible to imagine only a few decades ago.

SONY'S DSLTS
Sony's Alpha range is steadily moving away from conventional DSLRs to what it describes as DSLTs. These models have replaced the reflex mirror with a fixed translucent mirror, which allows the majority of light through to the sensor while reflecting a small but sufficient amount to the finder. This has meant the traditional viewfinder has been replaced with an electronic finder, which divides opinion. While earlier finders were good but not as clear or bright as traditional finders, the latest versions (on the A65 and A77) offer a performance comparable with a traditional finder. The key advantages of the translucent mirror are that because it never moves, the continuous frame rate can be higher and the viewfinder never blacks out.

BODY FRAME
Magnesium alloy is a popular choice for the chassis or frame due to its combination of strength and its light weight. Polycarbonate, a very strong and robust plastic, is used for most outer housings.

MIRROR
The semi-silvered mirror reflects light passing through the lens up to the pentaprism and into the viewfinder.

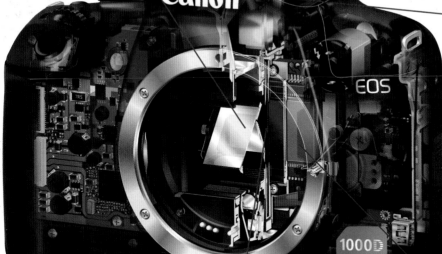

PENTAPRISM
Light travelling through the lens is viewed in the viewfinder via a mirror in the camera body and a prism, housed in the pentaprism.

SHUTTER BLIND
This light-tight blind prevents light from reaching the sensor until an exposure is taken. Shutter speeds can vary from hours up to extremely fast speeds: a top shutter speed of $\frac{1}{8000}$ sec is commonplace today.

IMAGE SENSOR
Digital SLRs use CCD or CMOS image sensors to capture images; these sensors come in a variety of sizes and resolutions depending on the camera.

LCD MONITOR

The rear screen is the information centre of the camera. It displays exposure settings, an on-screen menu system and allows you to review images.

VIEWFINDER

When you look through the camera's viewfinder, you will see the autofocus (AF) points and often a metering area in the screen. With many systems, the AF points light up in red when they are activated. A comprehensive readout is often located beside or below the viewfinder screen.

POWER SOURCE

Lithium batteries are normally the main source of power, offering longer life and faster flash recycling times than the more traditional alkaline cells.

FOUR-WAY CONTROLLER

Many cameras use a four-way control set-up to help the user change functions more quickly and easily. Every button has its own function, but they also serve a secondary purpose in allowing users to scroll through menu systems displayed on the LCD monitor.

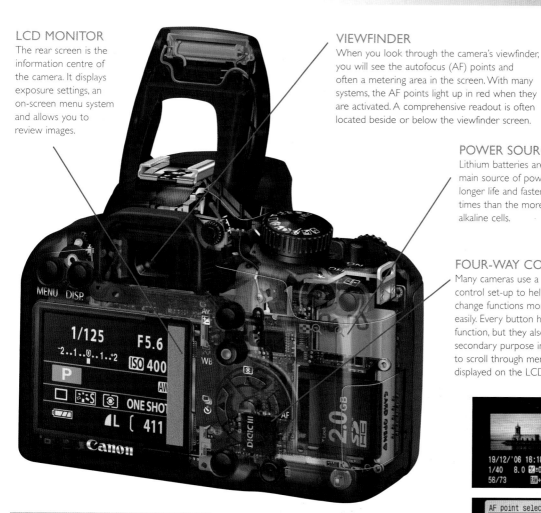

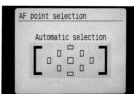

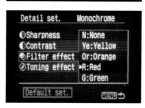

COMMON FEATURES

Metering sensors

In digital SLRs, most sensors are found beneath the semi-silvered mirror, in the pentaprism, or positioned so that they measure the light reflecting off a pattern on the shutter blind.

Focusing screens

Top-end SLR models allow the user to change focusing screens to suit a particular type of photography or an individual preference.

White balance

Digital sensors can be set to work under different forms of light source by adjusting the white balance. In the auto setting, the camera automatically calculates the appropriate white balance setting.

CAMERA INNOVATIONS

Digital filters

Many SLRs feature a set of digital filters that allow the camera to capture images in black and white. When shooting in black and white, digital colour filters (red, yellow, etc.) can be used to vary the contrast of the images, as well as shooting with digital tones, such as sepia.

Picture styles

Using the on-screen menu, you can select picture styles, which refer to the way in which colour images are captured. For instance, you can set the camera to record vivid or neutral colours, or bias its colour reproduction for shooting landscapes or portraits.

LCD ON-SCREEN OPTIONS
The LCD monitor on the rear of the camera is one of the main reasons behind the success of digital SLRs. As well as displaying the images stored on the memory card, they allow for an unparalleled amount of information and options to be listed, and they are very easy to navigate and use.

COMPACT SYSTEM CAMERAS

Digital SLRs remain the most popular type of interchangeable-lens camera, but they face an increasingly strong challenge from Compact System Cameras (CSCs), which are also commonly termed hybrids or mirrorless cameras. Offering the versatility of interchangeable lenses but with the advantage of being smaller and lighter, CSCs are gaining popularity as an alternative to DSLRs. They offer a very similar range of features to DSLRs, in fact they have more similarities than differences, which has made it easy for users of film or digital SLRs to migrate to using CSCs. Understanding the characteristics of CSCs and how they differ to DSLRs is important, as both camera types have their own advantages and disadvantages.

WHAT IS A COMPACT SYSTEM CAMERA?

This term refers to cameras with interchangeable lenses that lack the reflex mirror found inside digital SLRs. By doing away with the mirror, manufacturers have been able to design cameras that are smaller, slimmer and lighter than DSLRs and also cost less to manufacture. The loss of the mirror means that there is no conventional viewfinder – instead the camera boasts an electronic finder, which displays an image being sent direct from the sensor, or no integral finder at all. The lack of an optical viewfinder is one of the major reasons why many photographers still prefer using digital SLRs. Another key reason is because the majority of CSCs use smaller sensors than those found in DSLRs, resulting in image quality being close to but not quite as high as from DSLRs. Finally, as it's a relatively new type of camera system, the number of lenses and accessories is less than that available for DSLRs, although it is growing all the time.

ANATOMY OF A COMPACT SYSTEM CAMERA

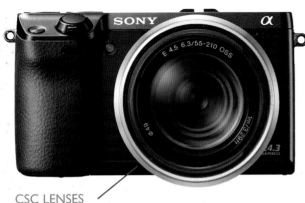 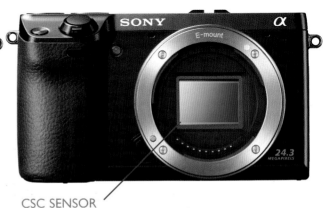

CSC LENSES
As with DSLRs, every brand has its own lens range. However, it's worth noting that Olympus and Panasonic share compatibility as both use the Micro Four-Thirds system. Also, adapters are available that allow lenses from the DSLR range to be used with CSCs.

CSC SENSOR
The lack of a mirror means the sensor is exposed when the lens is removed. This increases the risk of dust settling on the sensor when swapping lenses.

LCD MOUNT

Several cameras boast LCD monitors housed on a tilt and swivel mount, allowing for LiveView and movie shooting at awkward angles such as low-level shooting or for holding the camera overhead.

INTEGRAL FLASH

Not all models boast a built-in flash. Those that lack a flash offer a hotshoe to allow optional units to be fitted.

SLIM ACCESSORY SHOE

As well as flashguns, accessory shoes also allow microphones and optional electronic finders to be attached.

VIEWFINDER

Some models boast an electronic finder for image framing, although many have no integral finder at all, with the LiveView facility of the LCD being used to compose images or video.

LCD MONITOR

The LCD monitor plays an essential role, allowing access to the main functions via the on-screen menu, LiveView for taking pictures or video, as well as image/video review. A touchscreen facility is found on some models.

DIGITAL COMPACTS

Digital compacts are the number one choice for those looking for point-and-shoot simplicity but there are also advanced models that offer a superb specification and image quality that rivals those of consumer-level DSLRs and CSCs. The variety of models is amazing with compacts to suit every budget and type of photographer.

MAIN TYPES OF DIGITAL COMPACT

ZOOM COMPACT

This is by far the most popular type of digital compact with every brand offering a choice of models. Most offer a decent zoom range of 4x or better from wide-angle to telephoto. Despite using small sensors, image resolution of 10 megapixels or more is common and with excellent lens optics, models deliver very high-quality results. The majority are pocket-sized and offer a range of features and innovation, including HD video. Many models now boast semi-auto and manual modes as well as the wide choice of scene program modes. One facility that's missing on most is an optical viewfinder, as the LCD monitor is used to compose images.

WATERPROOF COMPACT

One of the fastest-growing sectors in the compact market is the all-weather camera designed to be tough enough to withstand use underwater, which makes them particularly appealing for those who predominantly use cameras on holiday. Almost all use the porro-lens design, which uses an internal zoom facility to retain the camera's shape and waterproofing. The latest generation has seen a major jump in quality and performance, with many boasting a tough 'shell' able to withstand the camera being dropped or knocked. The resolution of these models are usually around 10 megapixels but the zoom range is restricted by the camera design and the enhanced build quality makes them more expensive than similarly featured standard zoom compacts.

'BRIDGE' CAMERA

Also often referred to as a 'prosumer' camera, these models boast powerful zoom ranges that make them a great choice for those who want a range of focal lengths without the need to change lenses. Image quality is high despite the zoom range, although sharpness does drop as you reach the tele-end of the zoom. The features range from the standard set of compact modes at the budget end to more expensive models sporting features you'd normally only expect to find on DSLRs or CSCs. In general, prosumer models offer a 12-megapixel or more resolution and zoom ranges of 10x (28–280mm) or better. Some models, like the Canon PowerShot SX40 HS and Nikon Coolpix P500 boast image-stabilized superzooms. Both have a 12.1-megapixel resolution, with the Canon offering a 35x zoom (24–480mm) while the Nikon has a 36x zoom (22.5–810mm) range.

PREMIUM COMPACT

Many photographers seek cameras with the ultimate combination of portability but with minimal compromise in image quality. Step forward the premium compact. These models are designed to be the perfect companion for the serious photographer for when they don't want to carry around a DSLR or CSC. Built to be robust and tough, they're larger than the standard zoom compact but deliver image quality that proves a match for many CSCs and gets very close to the quality of DSLRs. Many use a sensor that's larger than the type used on standard compacts and boasts very high-quality optics. As you'd expect, there is no shortage of features or modes and with most, an optical viewfinder as well as swivel-mounted LCD monitor is present. The Canon PowerShot G1 X is regarded as one of the very best, boasting a 14.2-megapixel CMOS sensor that shoots Full HD, a 4x image-stabilized zoom and an extensive range of features and exposure modes.

DIGITAL COMPACT ACCESSORIES There are many useful add-ons available for digital compacts.

Lens attachments Some models allow attachments to be fitted to the lens. A wide-angle converter increases the angle of view, while a teleconverter increases the telephoto range.

Underwater housing Fancy trying your camera beneath the waves? You'll find that most manufacturers make dedicated underwater housings.

Filters Many models feature a thread for screwing filters in front of the lens element.

Flashgun A number of the prosumer and premium compacts sport a hotshoe for fitting an external flashgun.

Remote control Infrared remote controls are fairly commonplace on digital compacts as an option to the self-timer.

OTHER TYPES OF DIGITAL CAMERAS

MEDIUM-FORMAT DSLRS

The benefits of the larger frame size of medium-format film cameras has been transferred into the digital age by the development of digital backs to replace those that once held 120/220 roll film. This has allowed photographers to benefit from larger-than-full-frame sensors that offer incredibly high resolution and exceptional image quality. Mamiya, Phase One and Hasselblad/Imacon are the major players in the digital medium-format arena, producing cameras and backs with resolutions as high as 80 megapixels.

Most sensors measure around 54x40mm, considerably larger than a standard full-frame (36x24mm) sensor. As you'd expect, the cameras, backs and lenses are expensive compared to other systems but for professionals requiring the very best quality, the price is worth paying.

DIGITAL CAMCORDERS

Digital camcorders can shoot still images of acceptable quality (usually around 2 megapixels), although the ability to shoot HD video on most other forms of digital camera, as well as mobile phones, means that their future is threatened.

MOBILE PHONES

The mobile 'imaging' phone captures more digital images than any other type of camera. Many might be mere snapshots but improved lens optics and higher-resolution sensors have made mobiles, in particular Apple's iPhone, a serious proposition. The potential of the Apple iPhone as a picture-taking tool is explored in more detail later (see iPhoneography).

LYTRO: THE NEXT GENERATION...

Currently at early stages in its development is the Lytro 'light-field' camera. It uses a sensor that captures light in a radical new way that allows you to focus an image post-capture. In effect, you shoot an image and focus where you want afterwards.. The original prototype has an 8x zoom and fixed f/2 aperture and captures images at 1.1 megapixels. It's an interesting and unconventional concept that could develop into a radical new form of camera.

LEICA S-SYSTEM

Leica has developed the S2, a camera that looks like an oversized DSLR and sporting a 37.5-megapixel sensor measuring 30x45mm, which is 60 per cent larger than a full-frame sensor.
It's expensive but is enjoying success thanks to its unique handling and superb quality.

FILM CAMERAS

The 21st century is the dawn of the digital age and has seen an incredulous decline in the number of photographers using film, which is now a niche medium. Most are no longer in production. The following film cameras are still available, but are now used by a relatively small number of people.

35MM AF SLRS

The versatility of 35mm autofocus SLRs makes them the most popular choice of film camera, particularly with students in further education. The compatibility of lenses and accessories has also helped retain popularity in this type of camera.

35MM FILM COMPACTS

Compact film cameras were for a long time a favourite with amateur photographers, but with the exception of budget and child-friendly cameras, these have been replaced by digital compacts.

DIRECT-VISION

The Leica range of M-series 35mm rangefinders continues to have a small but loyal following, with many enthusiasts and professionals still enjoying the unique merits of this prestigious and traditional range of cameras.

LARGE FORMAT

As the name suggests, these cameras are big, with the most popular type uses 5x4in sheet film. The quality is amazing but they are cumbersome, slow to use, and the running cost per image is high.

iPHONEOGRAPHY

No area of photography has seen as much growth as the increase in popularity of the Apple iPhone. This can be put down to two main factors: a major upgrade in hardware and the wealth of excellent photo apps available for use with the iPhone.

While the iPhone 3G and 3GS had a strong following, it was the arrival of the iPhone 4 and its 5-megapixel camera that saw Apple's imaging phone receive widespread confirmation as a true photographic tool for consumer and professional use. The Apple iPhone 4s, with its 8-megapixel camera takes image quality further. However, while the iPhone 4/4s boasts a capable camera, its status as a versatile picture-taking device is due mainly to the abundance and quality of its apps, of which the most important are covered here. While there are other brands of imaging phone using the Android system, none have yet come close to matching the popularity of Apple's iPhone and its compatible range of apps.

HIPSTAMATIC

Hipstamatic is the app that converted many to using the iPhone for creative photography and continues to be adored by millions of users around the world. There are a number of factors behind its success and its continued growth in popularity. Firstly it is cheap, which is always a draw, but once you have it, you discover it is very easy to use to take great pictures. And it's the quality of the images it produces – and the variations of effects that are possible – that are its biggest selling points. Hipstamatic produces square, rather than rectangular images, which make them instantly recognizable. It also offers a selection of Hipstapaks that consist of a choice of lenses, films, flashguns and 'housings'. Changing the combination of films and lenses allows you to vary results, while there is a choice of flash effects when shooting in low light. As you'll discover, your iPhone takes on the appearance of a classic camera, which can be varied by the housing you select. As well as the supplied Hipstapaks, you can also buy further 'paks' through the app, giving you even more creative options.

All this allows you to capture brilliant images and have fun while you're doing it, but the app then allows you to share your images too while still in the app. You can upload them to Facebook, Twitter, Tumblr or Flikr, your own album in 'Hipstaland', or enter them into one of Hipstamatic's regular competitions.

HIPSTAMATIC CONTROLS
The icons along the bottom allow you to change the film, flash or lens, or access the online store to buy more 'paks' or order prints. The rear has the viewfinder at the centre, with the yellow shutter button to its right. Directly below it is the flash-on lever while at bottom left is a marker informing you how many images are currently being processed, as well as a gallery icon to access pictures you've taken. Above these is a 'film window' so you can see what film is loaded.

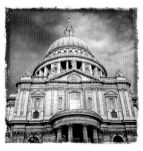

HIPSTAMATIC SHOTS
Hipstamatic proves to be one of the most versatile and enjoyable photo apps for the iPhone and is capable of producing stunning results, which can be printed at 30x30cm (12x12in) or larger. Try it – you won't be disappointed!

OTHER POPULAR APPS

The following are all excellent iPhone apps that are also worth considering.

Camera (default app)

This is the camera app supplied as standard on the iPhone and while basic, it's easy to use and a good introduction to the iPhone's camera. Recent updates have added a digital zoom facility, HDR mode and grid screen, to go with the flash functions. Use this app to shoot stills or video, both of which are selected via a slider in the silver bar next to the shutter release button.

Photoshop Express

Adobe Photoshop is synonymous with photo editing on computers, so it's no surprise to discover a version for the iPhone too. Express offers an excellent if somewhat limited range of editing tools and effects to suit the less advanced user. It's very easy to use with icons along the top that when pressed, offer drop-down menus with a choice of options. These vary from cropping or straightening images to applying exposure or colour changes, through to adding a range of effects or borders. It's a simple, intuitive app that is most suitable for novices to post-processing.

Incredibooth

This app takes the passport photo booth concept and transforms it into a fun app that kids in particular will love. You can choose from a number of different booths each giving different effects then, as you would in a real booth, pose for four separate images to be taken. Wait a few seconds and a strip of images appear, which you can then share on Facebook, Twitter or email.

Camera+

This uses a similar layout to the default camera app but offers several extra features. As well as the flash mode and zoom facility, you can also engage a digital stabilizer to help minimize shake when shooting in low light, a five-second self-timer and a burst mode that fires a fast sequence of images at low-resolution. It also offers a Lightbox facility for reviewing images, which can be edited to crop, improve clarity, apply effects or add borders. Its range of features means it takes a little getting used to but it's worth it, as it offers a good variety of options.

SwankoLab

Feel like trying your hand at a spot of digital darkroom processing? Then give SwankoLab a try. It allows you to choose any image from your library and mix a number of chemicals together to produce fun results. There is a range of chemicals to choose from, with the option to buy more should you wish. Once you've filled the tray with your mix of chemistry, you can process your image and save or share your results. You can also save the formula of your favourite mix of chemistry to apply to images in the future.

SWANKOLAB
These images show how running an ordinary snap through Swankolab can deliver a far more creative and artistic result.

straight shot

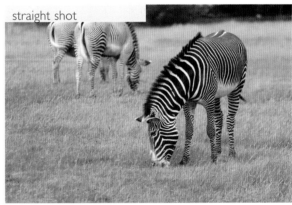

processed in Swankolab

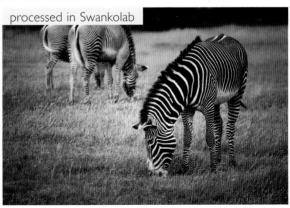

LATEST INNOVATIONS

Digital SLRs and Compact System Cameras are without doubt the most versatile tool available for taking great pictures. The latest generation of models are packed with features that improve picture quality through better image processing and overcoming problems such as camera shake and dirty sensors. Some of the major innovations are covered here.

IMAGE PROCESSORS

The image processor is the engine at the heart of a digital camera and has a number of functions. It is very important for determining image quality, as the processor contains the algorithms that are used to process the signals from the sensor that eventually become the final image. This includes colour reproduction, noise reduction and dynamic range. The power of the processor also determines the speed at which it can handle images and in turn the rate at which a sequence of images can be shot. Another benefit of a powerful processor is a reduction in the start-up time – that is, the delay between switching on the camera and it being ready to take pictures.

IMAGE STABILIZATION

Canon pioneered image stabilization by introducing lenses for its 35mm EF lens range with built-in gyroscopes that detected and compensated for camera movement, thereby reducing the risk of images being ruined by camera shake. Since then, a number of other manufacturers have developed their own lens-integral systems, including Nikon with VR (Vibration Reduction), Tamron with VC (Vibration Compensation) and Sigma with OS (Optical Stabilization). However, some other manufacturers have taken camera-shake reduction even further by developing anti-shake systems that are built into the camera rather than the lens. Although this adds to the cost of producing the camera body, it has the major advantage of offering a reduction in camera shake for every lens that is used with the camera. This feature now appears on a number of brands, including Sony (SteadyShot Inside) and Pentax (Shake Reduction).

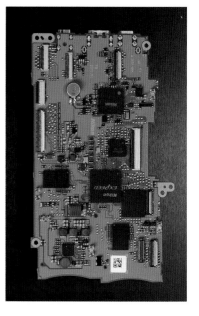

PROCESSOR
The image processor is the engine of a digital camera. It handles most of the processes used in capturing a digital image.

SHAKE AND SHARP
Image stabilizers allow for handheld shooting in low-light situations.

SENSOR CLEANING SYSTEMS

One of the major problems that occurs with digital SLRs and Compact System Cameras is dust settling on the image sensor. This usually occurs when swapping lenses, which allows dust to enter the camera body. During an exposure dust is attracted to the sensor's surface by the static charge. The result is that images suffer from unsharp black spots, which are most evident on even tones such as an expanse of blue sky. Digital SLRs have the advantage of a mirror chamber and shutter curtain in front of the sensor, but with CSCs, the sensor is exposed as soon as the lens is removed.

All DSLR and CSC manufacturers have addressed this problem by introducing a sensor cleaning system that vibrates the sensor at extremely high speeds, resulting in the dust being shaken off the sensor. Most vibrate the sensor when you switch the camera on and off and in general are highly effective at removing all but the most stubborn dust particles.

A number of sensor cleaning products such as compressed air sprays and sensor brushes have been released that can be used when internal cleaning systems haven't worked. Although these are quite effective, there is always a risk of the user accidentally damaging the sensor during the cleaning. Arguably the best cleaning accessory is the Visible Brush system, which uses a vibrating brush to clean off specks.

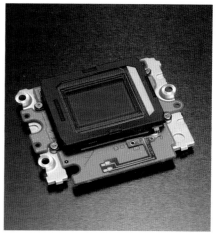

SELF-CLEANING
The problem of sensor dust has resulted in many cameras placing the sensor within a housing that vibrates to shake off any particles.

DUST
Dust particles appear as unsharp dark blobs and are most evident on light, even tones. This image has three dust particles present on the left of the frame.

MULTI-ANGLE LCD MONITOR

An increasing number of cameras now sport an LCD monitor housed on a hinged platform, which can be swivelled and tilted to allow the screen to be viewed from a multitude of angles. As well as proving useful when shooting images from low or high viewpoints, it is also a handy facility when shooting video too.

ART FILTERS

Being able to add art effects to images has become increasingly popular, with most new consumer-level DSLRs and CSCs including a decent selection of art filters for you to try out. Many effects touch on the good old days of film, such as grainy black and white, Lomo-type effects and pinhole. Others offer such weird and wonderful effects as Miniaturization, which makes subjects appear like small scale models and fish-eye, which adds a strong distortion effect (see In-camera special effects). Most of the art filters offer the chance to have a bit of fun, but some of the effects can be used to produce interesting creative results. While you normally select the art filter before taking the shot, many cameras allow you to choose an image on your card and apply the effect, which is saved in addition to the original file.

LIVEVIEW

A viewfinder is the conventional method for framing the subject, but using the LiveView facility on the camera's rear LCD monitor is becoming more common, especially as many CSCs lack a viewfinder. When shooting in LiveView, the monitor provides a live feed from the sensor, allowing you to compose images accurately. One major problem with the LiveView system on DSLRs was the speed and accuracy of the autofocus in LiveView mode, which was poor. Most current DSLRs have a good, if not perfect LiveView AF system, with the exception of Sony's Alpha range, which provides a superb LiveView focusing system. The LiveView AF of Compact System Cameras is excellent too, with Panasonic and Sony being particularly responsive.

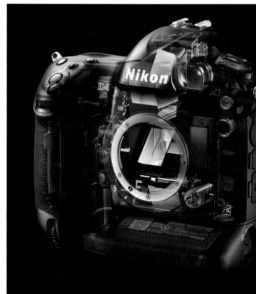

ENHANCED AF/METERING

Digital SLRs have boasted sophisticated autofocus and exposure systems for a number of years, but their accuracy has been further improved in some cameras by combining the data from each system. Canon's iFCL (Focus Colour Luminance) metering system and Nikon's Scene Recognition System use information ranging from skin tones, subject movement and brightness to ensure the image is correctly focused and exposed. Although primarily found in professional and enthusiast-level cameras, it is now finding its way into DSLRs at all price levels.

HD VIDEO

One of the most important innovations in recent years is the addition of a High Definition (HD) Video function to all types of digital camera, from imaging phones to digital compacts, through to DSLR and CSCs. This has allowed photographers of all levels to shoot high-quality movies without the need for a camcorder. While this is a real bonus for amateur photographers, it is of major importance to professional filmmakers, who are rapidly adopting digital SLRs to shoot commercial TV and movie footage. The large size of a full-frame sensor compared to traditional movie sensors offers the advantage of a much shallower depth of field, which has proven highly desirable with film studios.

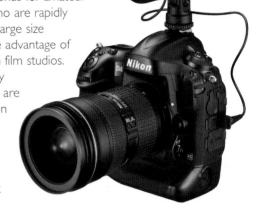

The terminology behind HD Video can be confusing but is relatively straightforward. When talking about HD video, the two main formats are 720P and 1080P, which relates to the resolution. 720P has a resolution of 1280x720 pixels, while 1080P has a superior resolution of 1920x1080 pixels. The other important figure is the frame rate – the higher the frame rate the smoother the video. Some cameras offer a choice of frame rates, with slower speeds giving slightly less smooth video but taking up less memory. You should look to shoot at at least 24 or 25 frames per second (fps) although 30fps or faster (ideally 50 or 60fps) will yield far better results.

INNOVATIONS BY MANUFACTURERS

With so many cameras offering an extensive range of features and high image quality, every manufacturer is striving to offer their own unique innovations. The following is a small selection of unusual features.

Samsung i_Function

This innovative feature, unique to a range of Samsung's NX-series lenses, helps speed up camera operation through the use of a button and dial on the lens. Rather than go through the camera menu to change settings, you can press the i_Function button on the lens to access key functions and change everything from shutter speeds to apertures, or apply exposure compensation by turning a ring on the lens. It's fast, easy to use and very intuitive.

Direct ethernet/Wi-Fi transmission

With news and sports agencies demanding images within minutes of them being taken, the latest professional cameras, including Canon's EOS-1D X and Nikon's D4, now have ethernet ports allowing direct transfer of images. Optional Wi-Fi transmitters that connect to a camera's dedicated socket also allow for fast trasmission of images. Nikon's WT-5A, when attached to the D4, offers additional features too, including allowing you to control the camera using the web browser on your iPhone and/or iPad to operate camera controls including LiveView and HD Video.

Smart Photo Selector

Fed up of trying to capture a split-second event but failing to time the moment correctly? Then the Smart Photo Selector function on Nikon's 1 System cameras could be just what you need. Set to this mode, the camera fires a rapid sequence of 20 high-resolution images, then automatically analyses them and selects the best five for you to choose from later.

Motion Snapshot

Another innovative facility unique to Nikon's 1 series cameras, Motion Snapshot mode combines a still image with slow-motion movement and audio to emphasize a certain moment in time. It's a function that is unlikely to be used regularly, but provides an unusual and original attempt at adding an extra dimension to still photography.

CHOOSING THE RIGHT CAMERA

Deciding which camera is best for your needs isn't straightforward, simply because there are so many good options, each offering their own benefits. However, by considering the following factors and using them to shortlist the most appropriate models, you can ensure you make the best choice.

DECIDE ON A BUDGET

The first decision you need to make is how much you want to spend on your camera outfit. You need to bear in mind that as well as the camera and the kit zoom, you may also want to include another lens – such as a telezoom – in the outfit, so you need to budget for this. By determining how much you want to spend, you can quickly exclude models outside of your budget and concentrate more on those you can afford.

While it's generally true that the more you pay, the better the camera, it's worth noting that cameras in different price bands may share the same sensor. So rather than see a major gain in image quality, your extra cash buys you superior build quality and handling, as well as additional features.

Be sure to keep an eye out for offers, such as sales or 'cashback' deals, which allow you to reclaim part of the cost direct from the manufacturer.

DECIDE WHICH FEATURES ARE MOST IMPORTANT

While most cameras share common features, some offer innovative or unique options that may make them more attractive to you, so be sure to read up on every camera in your shortlist to see if any offer a facility that you'd really benefit from.

The image resolution is often the biggest selling point of a camera and it's hard to argue against going for an 18-megapixel camera that costs the same as a 12-megapixel model. But bear in mind that the number of pixels isn't the only deciding factor on image quality – the lens optics as well as the image processor both heavily influence image quality too. Arguably more important than resolution is sensor size: the rule that the larger the sensor the better the quality is generally true, so a 12-megapixel full-frame sensor will usually deliver better results than images from a 16-megapixel APS-C or Four-Thirds sensor.

CHECK OUT THE SYSTEM BACK-UP

The beauty of interchangeable-lens cameras is that they form the heart of a system, so be sure to look at the lenses, flashguns and accessories of each camera system in your shortlist to ensure it offers what you need now, or may need in the future.

DSLR OR CSC?

Both camera types deliver great quality results so choosing between the two is difficult. However, as a guideline, if size and weight of the outfit is a primary issue for you, then a CSC is a better option. Where DSLRs have the edge is in image quality and in ease of use, although the differences with both these factors is small.

CHECK OUT REVIEWS

You'll find expert tests and reviews of every camera online and in specialist magazines, so be sure to read them before deciding which to buy. As well as highlighting what's good about the cameras, these tests will indicate any potential shortcomings a camera may have.

TRY BEFORE YOU BUY

Once you've shortlisted some cameras, the best thing you can do is visit your local camera store and handle them. What you'll most likely discover is that you like the general handling and control set-up of some models more than others. As many cameras offer such a similar specification, determining which you feel will be more enjoyable to use could well be the deciding factor.

SUMMARY

- For snapshots and general picture-taking, a mid-range digital compact is the most cost-effective option.
- A Compact System Camera (CSC) is ideal for those looking for a portable option with the versatility of interchangeable lenses.
- For the ultimate quality in a pocketable camera, check out a premium compact.
- For the ultimate in flexibility and image quality, go for a digital SLR.
- Smartphones like the iPhone are the perfect 'take-everywhere' option and benefit from an incredible choice of apps.

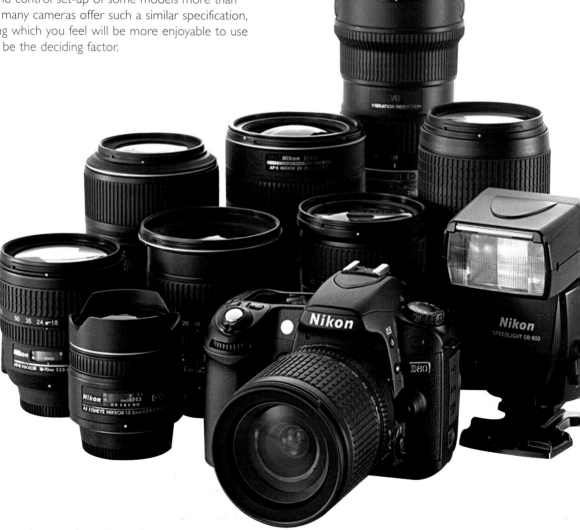

HOW CAMERAS WORK

AUTOFOCUS

With the exception of a handful of models, all modern cameras offer an autofocus (AF) system that works quickly and quietly to focus the lens automatically on the subject. Every generation has seen progressively more sophisticated systems being developed and there are now two very distinct and reliable AF systems being used in cameras, commonly known as phase detection AF and contrast AF.

MAIN TYPES OF AUTOFOCUS SYSTEM

Phase detection AF

This is the most common type of AF system and is used in digital SLRs as the primary form of autofocus. It's been around since AF appeared on 35mm SLRs and has been developed and improved for decades to provide a very fast and accurate form of autofocus. The system works by directing light travelling through the lens into a beam splitter that sends it to a sensor that measures what's called the 'phase difference' to calculate the required focusing distance. It's a system that works extremely well but has its problems in low light or where the subject lacks contrast. However, it remains the most popular AF system even though the latest contrast AF systems rival it for speed.

TOP TIP

AF sensors require light to work correctly. A good way of noting the sensitivity of an AF sensor is to find out the smallest aperture it can work with to provide effective AF. Most sensors require a lens with a maximum aperture of at least f/5.6, while some very sensitive systems can work well at f/8 (see Aperture).

AF ASSIST LAMP

In low light, when phase detection systems struggle to focus, the AF assist lamp, located on the front of the camera or built into the integral flash, can be used to aid AF. It works by firing out a burst of flash or a beam of patterned light that helps the camera focus on the subject. It's a useful system but its range is limited to a few metres.

Contrast AF

This AF system uses contrast to determine focus and is used by the majority of Compact System Cameras, as well as the LiveView systems used on digital SLRs. In the past it was an inaccurate and slow system but in recent generations of camera has developed to offer fast and responsive AF. With CSCs, the performance from contrast AF systems have matched and in some cases surpassed the AF speed of a DSLR's phase detection system. The LiveView systems of DSLRs lag behind the contrast AF of CSCs with the exception of the Sony Alpha range, which has far more responsive LiveView than other DSLRs that is on a par with the performance of CSCs.

ACTIVE FOCUSING SYSTEMS

This system is outdated in comparison to the main two AF systems. Found most commonly in compact cameras, it works by emitting an infrared beam, which bounces back from the subject and is detected by a sensor on the front of the camera. This determines the camera-to-subject distance by measuring the angle or strength of the beam or the time difference between it being emitted and it being received. This system is fast but its range is limited to a few metres.

MOVING SUBJECTS
Professional SLRs can track a moving subject even if it is travelling at high speed.

FOCUS AND METERING

Many of the more advanced cameras have systems that link the autofocus system with the White Balance and metering systems to give better exposures. Nikon's SRS (Scene Recognition System) was the first to use this highly accurate combination and was followed by Canon's iFCL (Focus, Colour and Luminance) system.

MULTI-POINT AND SINGLE-POINT AF

The autofocus point is the area of the frame where the autofocus sensor is located. In the past, autofocus cameras used a single AF point at the centre of the frame but today multi-point AF systems boasting a number of autofocus sensors arranged in a pattern in the central area of the frame is the standard set-up. The benefit of this system is that the increased area of coverage makes it easier for the AF system to lock on the subject, in particular if it is off-centre or moving across the frame. Multi-point AF allows for a far easier and faster system, as all the sensors can be left active, with the AF point(s) over the subject closest to the camera being activated. Most multi-point systems allow the photographer to choose between leaving all the AF sensors active or selecting individual points for when single-point AF is preferable. For general use, multi-point AF represents the most convenient option but when you're trying to focus on a very specific point in the frame, selecting single-point AF is better.

AF SENSORS

There are two main types of AF sensor: cross and line. Cross sensors are the most sensitive, as they have vertical and horizontal sensors, which allow for faster and more accurate AF. Line sensors measure in one plane only, and, although suitable for most situations, do not match the accuracy of a cross sensor in low light or with moving subjects.

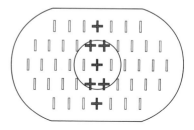

Black:	Vertical line sensors operational with f/5.6 or faster lens
Blue:	Cross-type sensors operational with f/2.8 or faster lens Vertical line sensors operational with f/5.6 or faster lens
Red:	Cross-type sensor operational with f/4 or faster lens Vertical line sensor operational with f/8 or faster lens

OTHER FOCUSING MODE OPTIONS

Touchscreen focusing

A growing number of cameras boast a touchscreen LCD monitor that allows you to select functions by pressing the screen with your finger. This proves very useful for focusing, as you're able to touch the screen on the subject you wish to focus on and the camera immediately adjusts AF to lock onto it. This system can also be used to track moving subjects too.

Face-priority AF

As its name implies, selecting this mode locks focus on a subject's face. While this might sound like a gimmick, it's an ingenious system that is ideally suited for beginners, especially when subjects are off-centre.

Smile-detection AF

This system takes face-priority a stage further by having the camera trigger the shutter release once a smile is detected. It is ideal when shooting a group of people – ask them to smile and the camera detects the moment and takes the picture.

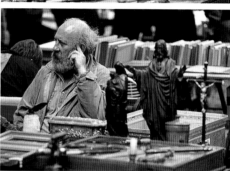

CHANGING FOCUS
The emphasis of the image is completely changed, depending on where you focus the lens.

AUTOFOCUS MODES

Most cameras offer a choice of autofocus modes, which are optimized for particular shooting situations.

Single-shot AF

Single-shot AF (also termed one-shot AF or AF-S) is the standard autofocus mode. This system locks onto the subject when you half-depress the shutter button and remains locked at this focusing distance until you take the picture or release the shutter button. If the subject moves, the autofocus will not compensate for the change in distance, which is where the Servo AF mode comes into play.

With the camera set to multi-point AF, this system automatically locks focus on the nearest subject. However, if you prefer to focus on another subject, switch to single-point AF, place the central AF sensor over the subject and half-press the shutter release button. This activates the AF system to 'lock' on the subject – as long as you keep the shutter button partly depressed you retain 'focus lock', allowing you to recompose the image and fully depress the shutter release to take the picture. It's an ideal technique to use when multi-point AF keeps focusing on the wrong subject.

Servo AF

Also known as Continuous AF, this is the standard mode for photographing action, with the camera adjusting the focusing distance to account for movement. On compacts, DSLRs and CSCs, you can engage Servo AF by selecting the sports or action mode, while all DSLRs and CSCs offer the option of a dedicated Servo AF mode. The Servo mode does more than just track the focus movement and set the focus distance accordingly, it also uses a system known as predictive focus where the camera uses the ever-changing information to predict where the subject will be at the time of exposure. It's a system that works well when subjects are moving at a constant speed or acceleration, but is less accurate if the subject is moving erratically. In these situations, using the Focus Assist facility if available will improve the rate of success.

Automatic AF

Also known as AI focus, this is a popular choice with beginners. It provides a combination of the two modes, with the AF starting off in single-shot mode, then automatically switching to Servo AF when the camera detects that the subject has started to move.

MANUAL FOCUS

There is little doubt that using autofocus makes complete sense for the vast majority of general picture-taking situations. However, there are times when using manual focus makes sense. When shooting landscapes, advanced photographers prefer to focus manually on the hyperfocal distance to maximize depth of field. Macro photographers also often use manual focus as AF struggles at such close distances and also due to the minimal depth of field on offer, focusing manually is the only way to ensure the correct point of focus is achieved. Manual focus also makes sense where AF struggles, such as in very low light or when shooting through glass.

Deliberate defocus

As odd as it sounds, it is sometimes worth producing a deliberately out-of-focus picture to create an artistic result. This technique can be used to create moody black-and-white abstracts or powerful colour compositions. The key is to use subjects in the frame that have very distinctive shapes, so that you can recognize them even though they are out of focus.

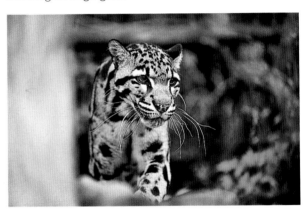

BIG CAT
When photographing caged animals, a wide aperture ensures the barrier doesn't appear in the frame.

CREATIVE TECHNIQUE: DIFFERENTIAL FOCUS

This technique mixes precise focus with a very shallow depth of field to create an imaginative result. Differential focus is particularly favoured by portrait photographers, but can be used to enhance any subject. For portraiture, using a wide aperture throws the background out of focus to really emphasize the main subject. You can also use differential focus to produce a tight crop of a face and put only one feature, say an eye or a nose, in focus, to give a distinctive and unusual portrait.

Because differential focus works by keeping only a narrow band of the image in focus, it isn't suited to two-dimensional objects. However, three-dimensional still life subjects like flowers work particularly well. By shooting at an angle and focusing at the centre of the flower, you can record the petals in the foreground and background as a blur.

FOCUS ON MOVING SUBJECTS

Even with the Servo AF mode engaged, keeping fast moving subjects in focus is tricky, and making sure the subject records sharp is even more difficult. The following modes and techniques will increase your chances of capturing sharp action pictures.

Focus Assist

Many cameras with multi-point AF allow you to select a small group of AF points to track moving subjects. Known as 'focus assist', this improves response, because the camera uses the central AF sensor as the primary focus point and the selected points around it as secondary AF points that also track the subject.

Trap focus

This feature is useful if you regularly photograph moving subjects. With this mode, you set the camera to focus at a specific distance and when the subject reaches it, the shutter fires automatically.

Follow focus and prefocus

Finally, there are two useful techniques for increasing the hit-rate for sharp pictures of moving subjects: follow-focus and prefocus.

Follow-focus involves the photographer making continual adjustments to the focus to keep up with the action. It demands much practice, but for erratic movement, such as in sports like boxing, soccer or rugby, it is a useful technique to learn.

Prefocus is a very good technique to use when you know the subject will pass particular points. The technique is simple: watch the path your subject takes, and focus on a point you know they will cross. Then, just before they reach the point, depress the shutter and fire a sequence of pictures. This technique is used in fast, repetitive sports like athletics and motorsports.

AUTOFOCUS PROBLEMS

There are times when even the most sophisticated autofocus systems fail to cope with a scene. The following are the most common problems and solutions.

Low-contrast scenes

Autofocus systems work by detecting contrast on the subject. So when photographing plain objects, such as a white wall, the AF system cannot detect the subject distance.

Zoo animals

When trying to focus on an animal at a zoo, the autofocus locks onto the fence or cage.

In these two situations, the easiest solution is to focus manually, or, if this isn't possible, focus lock on a subject a similar distance away, then recompose the frame.

Low-light photography

Autofocus systems work within a particular illumination range, so once light levels fall below a particular threshold, they have problems.

Engage the AF assist beam if it has one, or use one of the options above.

Shooting through glass

Because AF systems generally try to focus on the closest subject, taking pictures through glass presents the problem that the lens focuses on the glass, rather than the subject behind it.

There are various options, the first being to focus manually. If this isn't possible, see if the camera has an infinity focus mode that sets the lens to focus at infinity. If not, get as close to the glass as possible and shoot through it at an angle.

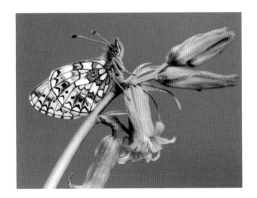

INSECT
Macro photography requires very accurate focusing and while AF systems are generally reliable, it's best to focus manually.

EXPOSURE

Exposure can be defined as the duration and amount of light needed to create an image. Getting the correct exposure requires calculating how much light reaches the image sensor to an incredible accuracy. Too little exposure and the image is dark; too much and it is too light. The exposure is controlled by a combination of three factors: the lens aperture, the shutter speed and the ISO rating.

THE FUNDAMENTALS OF EXPOSURE

The three main factors in determining the exposure are the aperture, the shutter speed and the ISO rating. It is worth mentioning an important point before explaining what these terms mean and how they affect the exposure. The basic unit of exposure is usually referred to as a stop. One stop is equivalent to a doubling or halving of an exposure. So the difference between an exposure of 1sec and 2sec is one stop; 1sec to 4sec is two stops, and so on. This will become clearer when shutter speeds and apertures are explored in greater detail later on.

SHUTTER SPEEDS

Understanding how shutter speeds work is easier for most people than apertures. Most exposures require shutter speeds that only last a fraction of a second, although some long exposures can take seconds, minutes, or even hours!

Shutter speeds are generally quoted in stops. Below is a list of shutter speeds from ½ sec to ¼₀₀₀ sec in half-stop increments. On most cameras the shutter speeds are displayed on the LCD monitor and the viewfinder display without the ¹⁄, so ¹⁄₆₀ will be shown as 60, ¹⁄₁₂₅ as 125, and so on. Full seconds are usually shown with a ", for instance two seconds will be shown as 2".

There is no hard-and-fast rule that determines what shutter speed is applicable to particular subjects. See Which shutter speed when? for some recommended settings.

> ½ sec ⅓ sec ¼ sec ⅙ sec ⅛ sec ¹⁄₁₀ sec ¹⁄₁₅ sec ¹⁄₂₀ sec ¹⁄₃₀ sec ¹⁄₄₅ sec ¹⁄₆₀ sec ¹⁄₉₀ sec ¹⁄₁₂₅ sec ¹⁄₁₈₀ sec ¹⁄₂₅₀ sec ¹⁄₃₅₀ sec ¹⁄₅₀₀ sec ¹⁄₇₅₀ sec ¹⁄₁₀₀₀ sec ¹⁄₁₅₀₀ sec ¹⁄₂₀₀₀ sec ¹⁄₃₀₀₀ sec ¹⁄₄₀₀₀ sec

Handholding

There is a general rule to remember about shutter speeds when you are taking handheld pictures that helps you avoid camera shake: always keep the shutter speed to above whatever the reciprocal of the lens's focal length is. For example, when you are shooting with a 300mm lens, make sure that the shutter speed is always above ¹⁄₃₀₀ sec. When using image stabilization, you can normally use a shutter speed two to three stops slower than this and still capture sharp images.

ISO RATINGS

All exposure systems use the ISO (International Standards Organization) rating as the basis for their calculations. The ISO rating is used on all digital cameras, even though it was originally developed to be a universal guide for film speeds. In simplistic terms, the ISO rating provides an indication of the sensor's sensitivity to light. The higher the ISO rating, the more sensitive it is to light. Changes in ISO ratings are measured in stops in the same way as apertures and shutter speeds, which simplifies exposure calculations. For example, changing the ISO rating from ISO 100 to ISO 200 is an increase of one stop. As you increase the ISO rating, you boost the signal strength through the sensor, which leads to an increase in digital noise. Therefore, for optimum quality, it's best to use lower ISO ratings. Use higher ISO ratings when you need to allow faster shutter speeds to avoid camera shake.

USE YOUR HISTOGRAM

The quickest way to check the exposure of your image is to look at it on the LCD monitor. However, while this is convenient it's not an accurate measure of the brightness of the image. A far better method is to check the histogram, which is a graph that provides a visual representation of the spread of tones in the image from shadows on the left to highlights on the right. The higher the peaks, the more tones in this area. With general scenes, you want a histogram where the graph has slopes that gradually rise to a peak towards the centre of the graph. If the graph peaks to the left, it indicates underexposure or an overly dark scene, while bright or overexposed scenes have a peak to the right side of the graph.

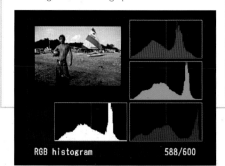

RGB histogram 588/600

EXPOSURE VALUES

A correct exposure can be achieved by a variety of combinations of aperture and shutter speed. For instance, if 1/60 sec at f/4 gives the correct exposure, it is possible to use 1/125 at f/2.8 or 1/30 sec at f/5.6 and have the same amount of light reaching the sensor or film. All combinations of aperture and shutter speed have what is known as an Exposure Value, or EV.

WHICH SHUTTER SPEED WHEN?

So when should you use a slow, medium or fast shutter speed? The choice really depends on factors such as the light level, but the following gives a rough guide.

Slow shutter speed: slower than 1/30 sec

Use this at night when a long exposure is required to record the scene. Use it during the day with a small aperture to blur moving subjects.

Medium shutter speed: 1/60–1/200 sec

This is ideal for general photography. Use when handholding the camera with a standard lens to avoid camera shake. This choice is suitable for slow-moving subjects, such as a jogger.

Fast shutter speed: 1/250 sec and faster

This is the best choice for freezing the motion of fast-moving subjects such as galloping horses or speeding cars. Also use faster speeds when using a telezoom.

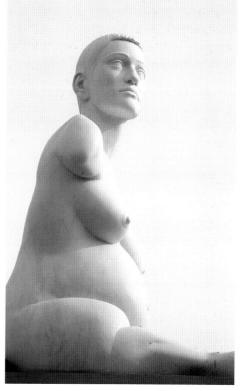

WHITE STATUE
You need to take great care when photographing unusually light (or dark) subjects to ensure that your image isn't incorrectly exposed.

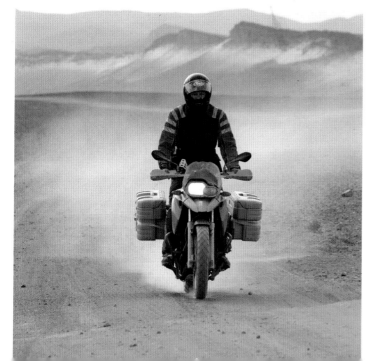

MOTORBIKE
A fast shutter speed freezes the action of fast-moving subjects.

IS THERE SUCH A THING AS A CORRECT EXPOSURE?

This is not as odd a question as it might seem. There is an argument to say that there is no such thing as a correct exposure, let alone a perfect one. Some people prefer more detail in the highlights, while others prefer more emphasis on the shadows and therefore expose an image in line with their personal tastes. In this way, the same scene may be recorded at slightly different exposures, with some people preferring the lighter image and others the darker one.

APERTURE

The lens aperture controls the amount of light reaching the image sensor or film during a given exposure. The aperture is the common term relating to the iris in the lens. Like the pupil of an eye, controlling the size of the lens iris determines the amount of light entering the lens. A wide-open aperture allows more light through than an aperture that is closed down.

The lens aperture can be closed down in regular intervals. Although the majority of cameras allow adjustments only in half-stops, some of the more sophisticated systems allow the aperture to be changed in third-stop increments.

The maximum aperture relates to the widest setting of the lens iris, while closing it down to its smallest setting (in other words, allowing the least amount of light through) is referred to as the minimum aperture.

On every lens there is an f/number, which is how aperture values are stated. This figure indicates how the aperture value relates to the lens focal length – see Which aperture when? for details. Aperture values can seem confusing at first, but once you start to use them, they become much easier to understand. A wide aperture has a low figure, for instance f/2, while a small aperture, in other words one that is closed down, has a higher figure, such as f/16.

f/2.8

f/11

f/5.6

f/16

f/8

f/22

TOP TIP
Most SLRs offer a depth-of-field preview facility that allows you to set an aperture and then use the preview to gauge how much depth of field it creates.

HOW IS AN F/NUMBER MEASURED?
This information isn't vital to taking a picture, but it is worth understanding, if only to impress fellow photographers with your knowledge of photography. The f/number corresponds to a fraction of the focal length. So f/2 means that the diameter of the aperture is half the focal length; f/4 is a quarter; f/8 is an eighth and so on. With a 50mm lens, the diameter at f/2 is 25mm; at f/4 it is 12.5mm, and so on.

The problem of diffraction
When it comes to depth of field, the general rule is that the smaller the aperture, the more depth of field in the image and the more of the scene that appears in sharp focus. So in theory, setting the smallest aperture should give you the sharpest results. However, at very small apertures an optical problem called diffraction occurs, which reduces the sharpness of an image. Therefore, rather than setting the minimum aperture, select an aperture two stops wider and while you'll record less depth of field, the image should prove sharper as it suffers less from diffraction.

APERTURES

Apertures are normally quoted in half or full stops. On the scale here, running from left to right, each full stop results in half the exposure, and vice versa.

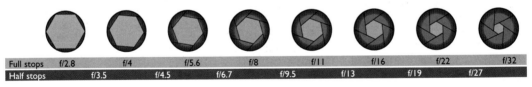

Full stops	f/2.8	f/4	f/5.6	f/8	f/11	f/16	f/22	f/32
Half stops		f/3.5	f/4.5	f/6.7	f/9.5	f/13	f/19	f/27

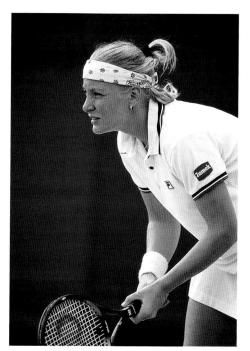

TENNIS
Use a wide aperture to throw the background out
of focus and concentrate emphasis on the subject.

WHICH APERTURE WHEN?

There is no set rule for when you should use
a particular aperture, but as a general guideline,
follow these suggestions.

Wide aperture

Use when shooting in low light and handholding
the camera, as it reduces the risk of camera
shake by increasing the shutter speed.

Use when you want a shallow depth of field –
in other words, an out-of-focus background.

Mid-aperture

Use when you want the best resolution from the
lens – the sharpest is at f/8–11.

Small aperture

When working in extremely bright conditions,
you may need to set a small aperture to give a
usable shutter speed.

When you require the background to appear
sharp, try setting a small aperture in order to
increase depth of field.

Use a small aperture when shooting macro
or close-up photography to give as much depth
of field as possible.

What is a fast lens?

Some lenses are referred to as being
'fast'. This means that their maximum
aperture is wider than the norm, giving
a correspondingly faster shutter speed.
For instance, a 70–200mm f/2.8 lens
is deemed a fast lens, as a standard
70–200mm is more likely to have a
maximum aperture of around f/4.

Apertures and depth of field

By varying the aperture, it is possible to affect the depth of field. The general
rule is that depth of field increases as you stop down the lens. In other words,
the widest aperture gives the minimum depth of field, while the minimum
aperture gives the most depth of field. For a far more comprehensive
explanation of depth of field, see Depth of field.

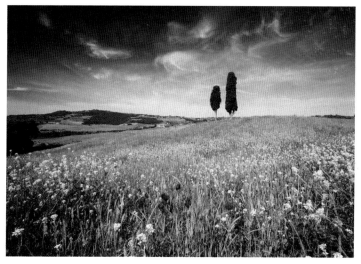

LANDSCAPE
Use a small aperture like f/16 (ideally with a wide-
angle lens) to capture stunning scenics that are
sharp from the foreground to the background.

Why do some lenses have two
maximum aperture values?

Most zoom lenses have two maximum apertures listed, for instance 80–200mm
f/4.5–5.6. This means that the maximum aperture of the zoom changes as you
change its focal length. Taking the example given, the maximum aperture at
80mm is f/4.5, while at 200mm it is f/5.6. If you have the zoom on a camera
set to its widest focal length and maximum aperture, slowly zoom the lens:
you can see on the LCD when the aperture changes from f/4.5 to f/5.6.

EXPOSURE SYSTEMS

Light is at the very heart of photography, and likewise, the exposure system is at the heart of a camera. Although you can find some models that lack any form of metering system, all must have control of the exposure of an image to produce a photograph successfully.

EXPOSURE MODES

An exposure is made up of two key elements: the amount of light passing through a lens (determined by the aperture), and the duration of light allowed to reach the film or image sensor (determined by the shutter speed). Most cameras offer a multitude of modes that all aim to give the same result – a perfect exposure – but each has its own bias towards particular creative goals, such as providing the fastest shutter speed or combining the flash with ambient light. You'll find the letters AE after most of the modes – this stands for Auto Exposure and signifies that the camera automatically tries to set the correct exposure for you. An explanation of the most popular modes follows.

THE CORE FOUR

Most DSLRs and CSCs sport what is termed the core four exposure modes: program, aperture priority, shutter priority and manual. These are often described as creative modes, as they offer the user varying levels of control over the exposure.

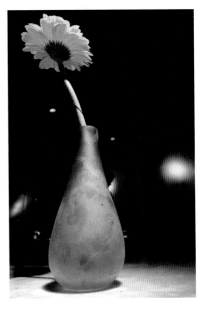

VASE
Selecting the correct exposure mode is vital to give the effect you want. A slow shutter speed in shutter priority AE was used here to allow the ambient light to create the pleasing lighting effect. If set to Full Auto, the camera would have automatically fired the flash, due to the low light conditions, ruining the mood of the scene.

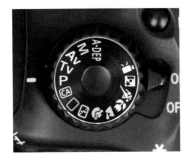

Program AE

Shown as P, program AE is a point-and-shoot mode where the camera sets the aperture and shutter speed for you. However, with most camera models you are offered a degree of creative control over the exposure in the form of program shift. This allows you to vary the combination of aperture and shutter speed without affecting the overall exposure. For example, if the camera sets $\frac{1}{125}$ sec at f/8, but you want a faster shutter speed, you can shift the combination along – in this case, to $\frac{1}{250}$ sec at f/5.6, or $\frac{1}{500}$ sec at f/4. The overall exposure remains unchanged, but you have biased the camera to your preference. Most cameras also allow you to affect the exposure in P mode by selecting the flash or setting exposure compensation.

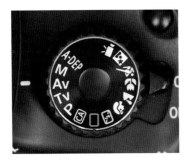

Aperture priority AE

Arguably the favourite mode among enthusiast photographers, this mode gives you control over the aperture, with the camera selecting the appropriate shutter speed. As well as being an ideal exposure mode for general photography, aperture priority AE is particularly favoured by landscape photographers, as it allows them full control of depth of field. Most cameras signify aperture priority AE as A or Av.

Shutter priority AE

Shutter priority AE (S or Tv on most cameras) offers the opposite control from aperture priority AE; in other words, you select the shutter speed, and the camera sets the corresponding aperture. This mode is most often used by people who want to set a shutter speed at the extremes of the shutter speed range – for instance, action and sports photographers who want a fast shutter speed to freeze action, or creative photographers who purposely want to choose a slow shutter speed to blur moving subjects.

Manual

Manual, or M, is the favourite choice of exposure mode among professionals, who value their understanding of the scene over what the camera thinks. This mode allows full control of the exposure, so the user sets both the aperture and the shutter speed. With many cameras, a scale in the viewfinder indicates any deviance between what the camera believes is the correct exposure and what the photographer has set. Manual is the mode to use if you are taking an exposure reading with a handheld meter and need to set this on the camera, or if you are using the camera with studio flash.

LONG EXPOSURES WITH BULB

The Bulb (B) is used when very long exposures (from minutes to hours) are required. With Bulb, the shutter remains open as long as you keep the shutter button (or remote release) depressed.

On many cameras, battery power is consumed during the exposure, so be careful how long you use the camera in this mode.

NO MORE APERTURE RINGS

In the past, lenses featured an aperture ring for varying the size of the iris on the lens barrel. However, electronics now means that this feature is more or less defunct on a modern SLR. Instead, the aperture is selected and the camera closes the lens iris to the appropriate setting electronically.

X-factor

The X mode, also known as X-sync, was once a common feature on cameras but is now found almost exclusively on medium-format cameras and one or two DSLRs. Set the camera to X and it automatically switches to the camera's flash synchronization speed. This is selected when using the camera with an external flash source such as studio flash.

Flashing numbers

In some instances, particularly in very bright or very dark conditions, you may notice that the reading for the aperture or shutter speed flashes. This indicates that the current combination of aperture and shutter speed is not possible in that situation. For example, if you are using shutter priority and have selected a very fast shutter speed, the aperture value may blink, indicating that the camera cannot set the aperture required to give a correct exposure because it is wider than the lens's maximum aperture. When this happens, you should change your setting until the blinking stops. In this instance, you would need to lower the shutter speed until the lens is able to set an appropriate aperture.

SUBJECT-BIASED PROGRAMS

The core four exposure modes described up to now have long been the most frequently used modes. However, the development of modern electronics brought with it the opportunity to develop programs tailored to specific types of photography.

Often termed Scene modes, subject-biased programs bias the camera's exposure, focusing and frame transport facilities for specific subjects. These modes are often a good choice for beginners who are unsure about how best to use their camera in specific shooting situations. Subject-biased programs are found on the majority of SLRs and compact cameras, and the pictures that follow show the symbols that are used for these programs on nearly all cameras.

Full auto AE

This is similar to the standard program AE mode, but doesn't allow you any control over the exposure. Often termed the 'idiot mode', this is the one to use if you lack even a basic grasp of photographic knowledge, with the camera making all the necessary exposure calculations and even popping up the flash if required.

Portrait AE

As the name suggests, this is the perfect choice for taking pictures of people. The camera will select a wide aperture in order to throw the background out of focus, sets the autofocus to one-shot mode, and uses a burst of fill-in flash as well.

Landscape AE

In this instance, the camera tries to select an aperture that gives good depth of field while at the same time not dropping the shutter speed so low as to cause camera shake. The flash is disabled, as the subject is presumed to be too far away for it to be any use, and the autofocus is set to one-shot, as the subject is static.

Close-up AE

In this mode, depending on the camera you use, the system selects either multipoint AF or the central AF point only. The integral flash will be set to Auto and the camera will set an aperture with a mid-range combination of shutter speed and aperture.

Action AE

With this mode, the subject is presumed to be moving, so the autofocus is set to continuous AF. The camera also sets its transport system to continuous shooting mode to record an action sequence. The bias is towards a fast shutter speed and wide aperture.

Depth AE

This mode is exclusive to the Canon EOS range of cameras. It allows you to specify the amount of depth of field in a scene by highlighting the nearest and furthest points in the scene that you want in focus, with the camera then determining the appropriate aperture and shutter speed settings. Some models feature the A-Depth AE mode, which is a simplified form of the Depth AE mode.

CAMERA SETTINGS FOR SUBJECT-BIASED PROGRAMS

The following table gives an at-a-glance view of how a typical camera automatically adjusts its main systems to compensate for different shooting situations. Please note that some cameras will deviate from the settings shown – check your camera's instruction manual for details.

Mode	Autofocus	Exposure	Flash
Full auto	Set to AI Focus	Mid-range combination of aperture and shutter speed	Fires if required
Portrait	Set to one-shot AF	Wide aperture for minimal depth of field	Fill-in flash
Landscape	Set to one-shot AF	Mid-range combination of aperture and shutter speed	Disabled
Close-up	Set to continuous AF	Mid-range combination of aperture and shutter speed	Fires if required
Action	Set to continuous AF	Fast shutter speed Continuous frame advance	Disabled
Night portrait	Set to one-shot AF	Very slow shutter speed	Always fires

Night portrait AE

With this mode, the camera tries to create the right balance of flash and ambient light. It assumes the camera is mounted on a tripod (or set on a steady surface), and sets a long exposure time to record detail in the background. It also fires the flash with enough power to expose the subject in the foreground correctly.

Alternative scene modes

Many digital cameras offer a very extensive list of scene modes that cover very specific shooting situations. These include a sunset mode, sand-and-ski, underwater or party modes. With each of these, the camera automatically sets its exposure and focusing systems to what it thinks best suits these scenes. If you're a novice they're worth using but with experience you should be able to know how to handle these situations yourself.

LAS VEGAS
General scenes such as this dusk image pose no problems for the standard AE program mode.

METERING SYSTEMS

Most camera meters assume that an average of all the tones in a scene equates to 18 per cent grey, although some digital cameras work to a slightly lighter 12 per cent grey. For most scenes, this proves to be highly accurate. However, although many shooting situations fit nicely into this assumption, there are times when this is not the case. Where the meter system falters is if the scene is overly white, such as a snowy winter landscape, or blacker than usual, say a close-up of a crow's head. In these situations, the meter will underexpose and overexpose respectively. The metering patterns of today's cameras aim to keep exposure error to a minimum, and although they succeed to a large degree, the only true way to eliminate inaccurate exposures is to understand how a camera meters, and to know when to take things into your own hands.

METERING PATTERNS

How a camera determines the exposure for a scene is determined by how it measures the light reaching the metering sensor. The term 'metering pattern' refers to how a camera's exposure system measures not only the amount of light in the scene, but how the light varies within the scene. Most cameras offer a choice of metering patterns, each of which measures the light in different ways.

Multizone metering

This is the most common type of metering pattern, and provides the highest ratio of success. It works by dividing the scene into a number of zones, with an individual reading taken from each. Some zones are given a higher priority than others, and the camera's microprocessor examines the various readings to determine the final exposure. Often the camera has its own library of thousands of scenes, and compares data from these to help assess what it believes is the correct exposure – all in the blink of an eye!

The number of metering zones varies from camera to camera, with around 16 being common but some models using over 1000 zones or pixels.

Selective (partial) metering

As the name suggests, this type of pattern takes a reading from a selective part of the frame, usually the central 7–9 per cent of the frame. It is used in tricky lighting situations where the photographer believes the multizone meter may be ineffective, such as strong backlighting. By taking a selective reading from a midtone, achieving the correct exposure is far more likely.

Spot metering

A spot meter is essentially a far more refined version of a selective meter, allowing a reading to be taken from a very small part of the frame – usually between 1 and 3 per cent. This is extremely accurate when used correctly. Some cameras offer a multispot facility, which allows you to take several spot readings and use the average one.

Centre-weighted average metering

The oldest of all the metering patterns, this system takes an average reading of the scene, with emphasis given to the central 70 per cent of the frame. It is relatively basic, giving underexposure in scenes with plenty of sky in the frame or in backlit conditions. However, it is consistent, and photographers who know how it works are reluctant to move to newer, more sophisticated patterns. It's also the preferable metering pattern to use when using the autoexposure lock (AE-L) facility.

Reflected and incident light readings

A camera's integral meter takes what is known as reflected readings. In other words, it takes a reading of the light being reflected from the subject. As reliable as these systems usually are, they can be prone to inaccuracy when the subject in the scene is very dark or very light: dark subjects are overexposed, while light subjects are underexposed.

Incident light readings do not suffer from this problem, as they measure the light falling on the subject, rather than reflecting off it. The tonal characteristics of the subject do not influence the meter reading. This is why handheld meters, which take incident light readings, are used by experienced photographers.

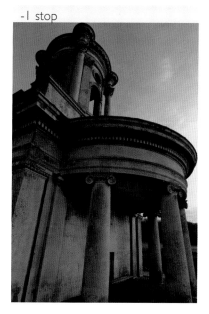

-1 stop

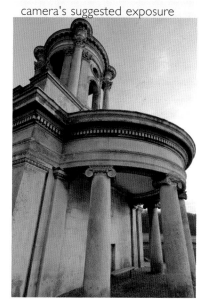

camera's suggested exposure

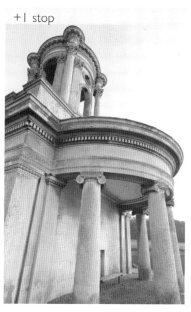

+1 stop

EXPOSURE BRACKET
Shooting a bracketed sequence increases the odds of getting the correct exposure.

EXPOSURE OVERRIDES

As reliable as a camera's autoexposure system is, there are times when a photographer requires some control over the final exposure. Almost all cameras offer this option in one form or another. The three most common types of control are described here.

Exposure compensation

By using this facility, you will be able to give a little more or a little less than the indicated exposure. If you set a '+' value, you will add some exposure; if you set a '–' value you will then reduce the exposure. Most cameras will allow you to set half-stop increments; some models offer third-stop increments, and still others allow you to select either increment. Depending on what mode you select, the camera will make this exposure compensation by altering the aperture or the shutter speed. Shooting a series of images at slightly different exposures in this way is known as bracketing your exposure.

Autoexposure bracketing

This function allows you to shoot a bracketed series of exposures. Set autoexposure bracketing (AEB) to half a stop and the camera shoots at the normal exposure, then half a stop under and half a stop over (although not necessarily in that order).

Autoexposure lock

More commonly referred to as AE-L, this facility allows you to lock an exposure value independently of the focus. This feature is particularly useful if you are shooting in tricky lighting conditions, or when the scene is markedly bright or dark.

What is a midtone?

If you imagine a scale from pure white to pure black, a midtone is an area in between that represents a midtone of grey. In the real world, finding this colour is unlikely, unless you are in the middle of a concrete jungle. However, if you are looking to take a spot or selective reading off a midtone, suitable subjects include the skin tones of a Caucasian person, grass, blue sky or brickwork.

BEACH PORTRAIT
Strong sidelighting and an off-centre subject can cause metering problems. Here, AE-L from the face ensured a perfect exposure.

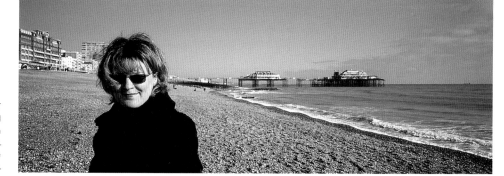

TAKING CONTROL OF EXPOSURE

A camera's metering system may get it right most of the time, but you need to know when it is likely to go wrong and act accordingly. If you understand that a camera's metering system assumes the average tone of a scene is 18 per cent grey, then it becomes far easier to grasp when the exposure system can have problems.

WALL AND FLOWERS
The white wall fools the camera into underexposing the main subject. Ensure that you add exposure compensation of at least one stop in similar situations.

BRIGHTER-THAN-AVERAGE SCENES

Imagine a winter wonderland where everything is covered with a thick layer of glistening white snow. You know the snow is white but the camera averages the scene as grey and underexposes the image.

What to do:
1. Use the exposure compensation facility to shoot at +1 and +2 stops over the camera's indicated reading.
2. Place a grey card in the scene and take a meter reading from it.

DARKER-THAN-AVERAGE SCENES

You are photographing a slate quarry on a dark, overcast morning. The whole scene is oppressive and dark grey. Leave the camera to its own means, and it will ruin the mood by overexposing the scene by 1 to 2 stops.

What to do:
1. Use the exposure compensation facility to shoot at -1, -1½ and -2 stops under the camera's indicated reading.
2. Place a grey card in the scene and take a meter reading from it.

PERSON IN FRONT OF A WHITE BACKGROUND

You are taking a portrait against a white-washed wall, such as you would find in the Mediterranean. Unfortunately, all the light reflecting from it fools the camera into underexposing the scene and almost turning your subject into a silhouette.

What to do:
1. Use the exposure compensation facility to shoot at +1 and +1½ stops over the camera's indicated reading.
2. Have the subject hold a grey card and take a reading from it.
3. If the person is Caucasian, take a spot/partial reading from their face.

HAND
This close-up of a black statue would result in overexposure without the necessary precautions.

PERSON IN FRONT OF A BLACK BACKGROUND

Imagine that the subject of your portrait is now positioned against a clean, black door, which dominates the scene that you are photographing. The camera, assuming that the door is grey, gives too much exposure, completely bleaching out the detail.

What to do:
1. Use the exposure compensation facility to shoot at -1, -1½ and -2 stops under the camera's indicated reading.
2. Have the subject hold a grey card and take a reading from it.
3. If the person is Caucasian, take a spot/partial reading from their face.

BACKLIT SUBJECTS

A subject set against a bright backdrop, such as a sunset, is underexposed.

What to do:
1. Use the exposure compensation facility to shoot at +1 stop over the indicated reading.
2. Get the subject to hold a grey card, and take a reading from it.
3. If the person is Caucasian, take a spot/partial reading from their face.

HIGH-CONTRAST SCENE

You are in the grounds of an abbey with streams of light breaking through the trees. The scene is made up of bright highlights and dense shadows. How the camera exposes the scene is a complete guess.

What to do:
1. Take a spot or AE-L reading off a midtone (stonework is fine) and take a bracketing sequence in full stops from +2 to -2 stops.

SUNNY LANDSCAPE

It is a beautiful summer's day and you discover a glorious scene. You follow all the rules for landscape photography but the result is far too dark. This has occurred because the sky has influenced the meter into underexposing.

What to do:
1. Tilt the camera down and use the AE-L facility to lock the exposure reading.
2. Fit a neutral density (ND) graduate filter to balance the sky and the foreground.
3. Use the exposure compensation facility to shoot at +1 stop over the camera's indicated reading.

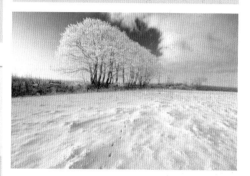

SOLUTIONS FOR EXPOSURE ERROR

The following are the most common methods used to ensure a correct exposure. Regardless of the camera you use, some or all of these options are available to you.

CAMERA FEATURES

Autoexposure lock (AE-L)
This facility allows you to take a meter reading independently of the autofocus system. This is useful when you want to get close to a particular part of the scene, lock the reading and then use this exposure to capture the final photograph.

Partial/spot metering
Many cameras have a facility that allows an exposure reading to be taken from a selective part of the scene. Spot and partial meters are the most common types and give accurate results as long as they are used to take a reading from a midtone.

Exposure compensation
With practice, you will learn how many stops to add or subtract from a scene to give the correct exposure. An exposure compensation facility is one of the most useful features a camera can possess.

TECHNIQUES

Exclude the sky
With landscapes, an easy method to prevent the sky from affecting the meter reading is to point the camera towards the ground and use this exposure reading. Be sure that the area you point the camera at is in the same lighting conditions as the rest of the landscape.

Grey card
The humble grey card is an often overlooked accessory. It costs relatively little, but using it in a scene can guarantee you get the correct results if you take a meter reading from it, as it is 18 per cent grey in colour.

Bracketing
This is the term that is used to describe the process of taking a series of exposures at regular steps, usually set using the exposure compensation facility.

WINTER LANDSCAPE
This snowy landscape will fool metering systems into underexposing, so add exposure compensation for a better result.

BLUE BUILDING
Subjects directly lit by sunlight can result in underexposure. Use AE-L from the grey pavement to avoid the problem.

IMAGE CAPTURE

RESOLUTION AND IMAGE SIZE

The image resolution of a digital camera refers to how many pixels make up the image. It is normally referred to in megapixels; 1 megapixel = 1 million pixels. As digital cameras have advanced, it is the pixel count of the image sensor that has taken the headlines. The more pixels that make up an image, the bigger the file size, which allows the image to be printed at larger sizes or for more severe crops to be made with minimal loss in quality. The illustration below provides a visual guide as to the size at which images of different resolutions can be printed at 300dpi (dots per inch), which is the standard printing resolution.

THE MEGAPIXEL MYTH

There is a very common misconception that you can determine the quality of a camera simply by judging it on the number of megapixels it has. Although a higher resolution is a contributing factor in providing better-quality images, there are several other areas that determine the final image quality, including the lens optics, image processor and sensor quality. It is worth bearing this in mind when choosing a camera: the megapixel count is important, but you should also consider how good other areas of the camera will be.

Number of megapixels	Image resolution (pixels)	Print size at 300dpi
6	3008x2000	10x6.7in
8	3456x2304	11.5x7.7in
10	3648x2736	12x9in
12.2	4288x2848	14.3x9.5in
16.2	4912x3264	16.3x10.9in
18	5184x3456	17.3x11.5in
21.1	5616x3744	18.7x12.5in
24.3	6000x4000	20x13.3in

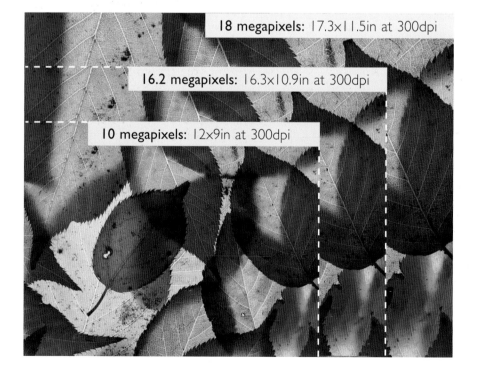

18 megapixels: 17.3x11.5in at 300dpi

16.2 megapixels: 16.3x10.9in at 300dpi

10 megapixels: 12x9in at 300dpi

TOP TIP

Adobe Photoshop's 'Save for Web' option allows you to optimize your images for web use.

PRINT AND SCREEN RESOLUTION

You can change the resolution of your image to suit its use for different applications. A resolution of 72dpi is sufficient for web and screen use, while 300dpi is recommended for producing prints. If you plan to make prints of a particular image and also want to view it on screen, it is recommended that you make an individual file for each use. This is easily done in most applications; in Photoshop simply select *Image > Image Size* to bring up the window. Then it is a case of setting the width, height and resolution to what you require for each use.

TOP TIP

Although it is recommended that you produce prints at 300dpi, you can print at lower resolutions and produce images that look as good. Many people find that you can set the printer at resolutions between 150 and 250dpi and still produce satisfactory results. This is worth trying out if you want to make prints at a certain size. Factors that determine how good the final print is include the quality and sharpness of the original image and the quality of your printer and paper.

72dpi

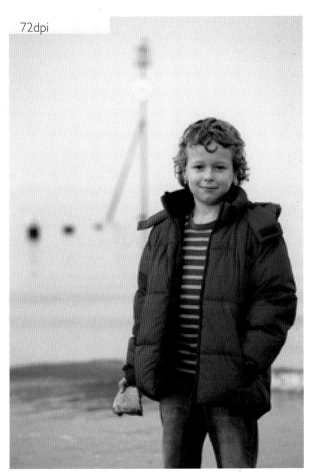

300dpi

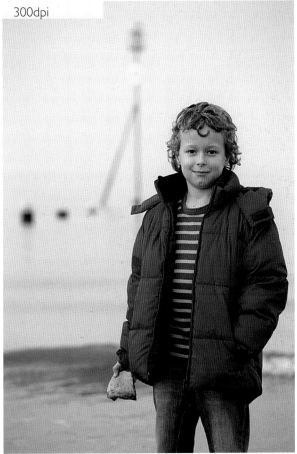

BOY IN RED
Viewed on a computer, these two images would look identical because a monitor has a resolution of 72dpi. However, when printed, the 72dpi image appears pixellated, while the 300dpi image looks perfect. It is important to understand the difference between screen and print resolutions.

DIGITAL IMAGE SENSORS

The image sensor is the light-sensitive device at the heart of a digital camera. Different camera manufacturers use different types, so it is important to be clear how each works.

IMAGE SENSOR BASICS

In very simple terms, an image sensor is essentially a silicon chip featuring an array of tiny light-sensitive diodes, often referred to as 'picture elements', or, in the abbreviated form, 'pixels'. These are arranged in rows on the chip. When the pixels receive light, they create a charge; the charges are processed row by row, with the information used to create the image. Because the information from the rows is joined together, or coupled, these sensors are known as charge-coupled devices, or CCDs. Individual sensors are sensitive to monochromatic light, so to create colour images, colour filters must be placed over them to allow the sensor to record only a particular colour. By using green, red and blue filters placed in a particular arrangement, colour images are formed. There are normally twice as many green sensors as red or blue in an array, as the sensitivity of the chip to light varies, depending on its wavelength.

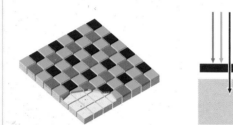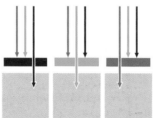

MOSAIC CAPTURE
This is the general basis of how most image sensors capture the image (Foveon and Super CCD are alternative systems). From left to right: In conventional systems, colour filters are applied to a single layer of photodetectors in a mosaic pattern; the filters let only one wavelength of light – red, green or blue – pass through to any given pixel, allowing it to record only one colour; as a result, mosaic sensors capture only 25 per cent of the red and blue light, and just 50 per cent of the green.

IMAGE SENSOR SIZES

The size of your camera's sensor plays a very important part in the quality and characteristics of your images. The general rule is that the larger the sensor, the sharper the images and the lower the noise they produce. With manufacturers trying to cram more and more pixels on a sensor, it's logical that larger sensors can have larger pixels that produce higher image quality. The other obvious effect of sensor size is how they affect the effective focal length of lenses (see Effective focal length explained for further details).

The following are the main types of sensor, their dimensions and the increase in effective focal length.

Sensor type	Sensor size	Effective focal length
Full frame:	36x24mm	1x
APS-H:	28.7x19.1mm	1.3x
APS-C (Canon):	22.3x14.9mm	1.6x
APS-C (Other brands):	23.6x15.5mm	1.5x
Four-Thirds:	17.3x13mm	2x
CX-format:	13.2x8.8mm	2.7x
1/2,3 inch	6.16x4.6mm	5.5x

MAIN TYPES OF IMAGE SENSOR

Although all image sensors have the same purpose – to capture light and convert it into electronic form – the basic principle of how they work varies from one brand to another. While the CCD was once the most popular, CMOS (complementary metal oxide semiconductor) has become the most common type of sensor on high-end cameras, including DSLRs, CSCs and top-end compacts. Despite the dominance of CMOS and CCD sensors, Fuji has its own unique variant, the Super CCD; and Sigma has the Foveon.

CMOS

The CMOS sensor is the most common type of image sensor used in digital SLRs and Compact System Cameras, as well as several of the best-specified compacts. It offers several benefits over CCD, the most important being that it consumes less power, is cheaper to produce and has an amplifier linked to each pixel, offering benefits for transferring the data to the processor. A negative point of CMOS sensors in the past was that it produced more noise than CCD, but this is no longer the case, with better processing allowing CMOS sensors to produce images with low noise, even at higher ISO ratings.

CCD

The CCD may no longer be the most common type of image sensor but it is still very popular, being used in many compact cameras, some digital SLRs and other imaging devices such as mobile phones. It remains one of the cheapest types of sensor to manufacture and delivers excellent-quality results. Although newer types of sensor have appeared – in particular the CMOS – the future of the CCD looks assured, certainly in the short term at least, but much depends on how quickly CMOS sensors progress.

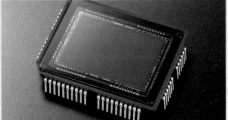

FUJIFILM X-TRANS CMOS

Fujifilm has a history of developing its own imaging sensors for use in its DSLRs and top-end compacts and this tradition has also extended into its range of Compact System Cameras. In the past, it was the Super CCD with its unconventional honeycombed pixels that won many fans, followed more recently by its excellent BSI (Back Side Illuminated) EXR CMOS sensor. Most recently, it is its X-Trans CMOS that is gaining a growing number of plaudits. It uses a similar array of square pixels laid out side-by-side in rows, but the arrangement of colour pixels has been changed to allow the sensor to offer superb quality and be free from moiré, which means no need for the anti-aliasing filter normally placed in front of the image sensor.

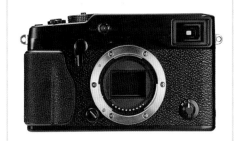

FOVEON X3

This is another variant of the CCD, used in Sigma's range of SD digital SLRs and DP premium compacts (Sigma bought the Foveon sensor company in 2008). The principle behind it closely resembles how a film emulsion works, with three separate layers of photodetectors: blue, green and red. Because all three colours lie above each pixel, the sensor captures red, green and blue light at every pixel. In theory, this system has the greatest potential to deliver the closest possible quality to film. Because there are three colours per pixel, the resolution is normally rated x3, so for instance the Foveon sensor used in the flagship SD1 DSLR is stated by Sigma as 46-megapixels, but is generally regarded to offer a 15 (x3) megapixel sensor.

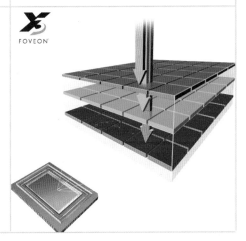

WHITE BALANCE

The white balance settings on a digital camera allow it to produce accurate colours in a variety of lighting conditions. Light has what is known as a colour temperature, which can have a major effect on how accurately colours appear in your images. Measured in Kelvin, the colour temperature of light can make colours in your pictures appear warmer or cooler than they naturally are. By selecting the appropriate white balance setting to suit the conditions you are shooting in, you can ensure that your images have faithful colour reproduction.

Most cameras use a similar set of white balance presets. AWB (Auto White Balance) is the one most photographers select at the start. With this preset, the camera automatically sets what it calculates is the best white balance setting. It is pretty good in most shooting situations at giving a decent colour balance, but for the most accurate colour reproduction, you should set one of the white balance settings designed for particular lighting conditions. These include Tungsten, Daylight, Cloudy, Shade and Fluorescent. You will also find that many cameras have a Custom setting, which allows you to take a reading off a white surface or a grey card and set the camera for a specific lighting condition.

TOP TIP
Shoot in Raw and you are able to set whatever white balance setting you like before converting the image into a JPEG or TIFF.

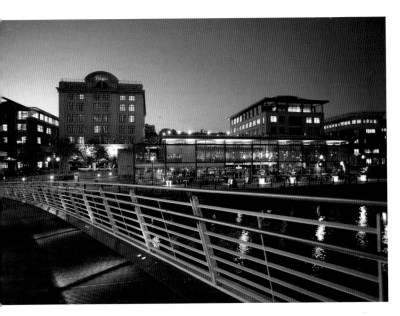

MIXED LIGHTING
It's worth experimenting with White Balance to find the best result when shooting in mixed lighting conditions, such as this late evening scene with artificial light.

WHITE BALANCE SETTINGS
A series of icons makes it easy to change White Balance settings on digital cameras.

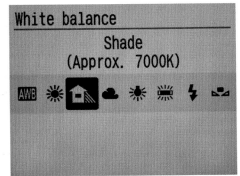

| 1800K | 4000K | 5500K | 8000K | 12000K | 16000K |

COLOUR TEMPERATURE SCALE
This scale provides a visual guide to how the colour temperature of light varies from one end of the spectrum to the other.

WHITE BALANCE BRACKETING

A recent feature on digital SLRs and CSCs is that of white balance bracketing. Much like exposure bracketing (see Metering systems), this facility allows you to shoot a sequence of three images with one frame at the white balance preset you have selected, another frame that is slightly warmer, and another one that is slightly cooler.

EXPERIMENT WITH WHITE BALANCE

On occasion it is worth experimenting with the white balance settings by deliberately setting the wrong preset to see what results you produce. This is a popular technique with outdoor photographers who, for example, might set a Shade setting in daylight to add a bit of warmth to the resulting image. Alternatively, setting Tungsten in daylight results in a cool blue cast, which can work well when shooting moody misty mornings.

Daylight
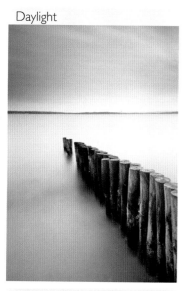

Cloudy
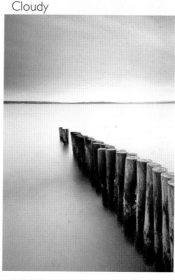

Shade
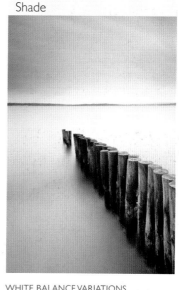

Tungsten
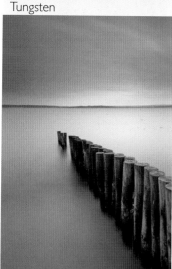

Fluorescent
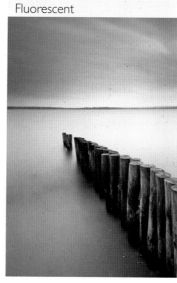

WHITE BALANCE VARIATIONS
By shooting in Raw, it is possible to select any white balance setting before converting the image. As you can see with this shot taken in daylight, the results vary dramatically; often a pleasing result can be obtained even when an inappropriate white balance preset has been selected.

IMAGE STORAGE

Digital images need to be stored in a safe and reliable way that is also easy to access. Digital cameras store the images on removable storage cards. These images are usually transferred to a computer's hard disk and from there to CD, DVD or another form of digital storage.

STORAGE CARDS

CompactFlash
Although CompactFlash was one of the earliest forms of storage card, it has stood the test of time well and remains a popular choice of card format in semi-pro and professional DSLRs. It is larger than most but is still relatively tiny, and has been proven to be robust, fast and reliable. It has very high capacities (up to 256GB) and is inexpensive.

Secure Digital (SD)
The Secure Digital card is now the most popular format used. It originated from the MultiMedia Card, with the main difference being a write-protect facility to prevent accidental erasure of images. As well as being used on a high proportion of compact cameras, it has also become the most popular choice with consumer-level DSLRs as well as CSCs. To allow for larger capacities, the SD format was upgraded first to SDHC (High Capacity) and more recently SDXC (eXtra Capacity). SDHC has a maximum capacity of 32GB while SDXC cards up to 64GB are currently available, with SDXC cards up to 2TB expected in the future.

xD-Picture Card
Although xD (eXtreme Digital) cards offer the advantage of an extremely small size, their popularity has waned in recent years. Developed by Olympus and Fujifilm, xD cards are still used in some digital compacts but are unlikely to survive as a format for much longer, mainly due to the limitations of the 2GB maximum capacity.

MemoryStick
This card format was developed by Sony as a small, portable storage system that could be used not only in its cameras, but also in MP3 players and camcorders. A number of different ranges of the card format have been released to suit different types of equipment, but the main type of storage card for cameras is the Duo, which currently offers storage capacities of up to 32GB. It is relatively large, although a smaller type, the Memory Stick Duo has also been released. While Sony continues with this format, many of its cameras use a dual-format card slot that accepts an SD card as well as a MemoryStick, which suggests Sony is aware its format has not been universally accepted by the consumer.

XQD
This new card format has only just been released and promises incredibly fast data-processing speeds. Designed to meet the needs of professionals shooting fast sequences of high-resolution images or HD video, it currently has a capacity of 32GB but 2TB cards are promised in the near future.

DEFUNCT FORMATS

IBM Microdrive
When CompactFlash cards were first introduced, their memory capacity was very limited. The IBM Microdrive worked in most cameras that accepted CompactFlash, and offered a much higher capacity (up to 4GB). However, its unreliability and the increased capacity of CompactFlash means the Microdrive is no longer in demand.

SmartMedia
The SmartMedia card was one of the earliest card formats. Its main selling point was its wafer-thin construction, but its exposed electronic contacts and limited capacity meant it wasn't popular for very long.

RESCUING LOST IMAGES

A major fear of digital photographers is that their memory card will become corrupted while containing images that they have yet to download. A number of image-retrieval software applications have been released that can recover these 'lost' images. It is well worth getting hold of one of these packages, as they generally work extremely well. Some card brands provide their own image-retrieval software with their storage cards. For instance, Lexar supplies some ranges of its cards with Image Rescue software.

CARD CAPACITY

The following table provides an idea of how many images can be stored on memory cards of different capacity. All figures are approximate and based on a JPEG saved at maximum quality. To estimate the number of Raw files that can be saved, divide the respective figure by four.

Camera resolution	4GB	8GB	16GB	32GB	64GB
8-megapixel	1600	3200	6400	13000	24800
10-megapixel	1200	2500	5000	10100	19500
12-megapixel	1000	2000	4300	8600	16400
14-megapixel	800	1700	3500	7200	14000
16-megapixel	700	1600	3200	6400	12200
21-megapixel	550	1100	2300	4550	8800

DUAL CARD SLOTS
You will find a few digital cameras (mainly DSLRs) sport two card slots that allow a couple of cards to be inserted at the same time. Each slot is for a different card format (usually CompactFlash and SD or xD) and is useful if you have cards in different formats.

CARD SPEEDS

You will find that memory cards have a speed rating, usually stated as a 'figure times' or in MB/second. This refers to the speed at which data is transferred to and from the card. For general use, this isn't so important, but if you plan to shoot a sequence of images, in particular Raw files, the faster the card, the longer the sequence of images you can shoot. It's also important if you shoot HD video on your camera, as faster cards are required to handle the large video files. When it comes to transferring images from the card to your computer, a faster transfer speed can again prove beneficial, especially if you have filled a high-capacity card with hundreds of images. The fastest cards are currently CompactFlash cards boasting UDMA (Ultra Direct Memory Access) technology, which allows it to have a speed of 1000x (150MB/sec), but it's likely that later generations of XQD cards, which currently process at 125MB/sec, will have the fastest processing speeds.

To help standardize data transfer speeds on SD cards, class ratings are used to indicate minimum transfer speeds, with Class 2 indicating transfer speed is a minimum of 2MB/sec, Class 4 is 4MB/sec, Class 6 is 6MB/sec and Class 10 is a minimum of 10MB/sec.

Card speed rating	Data transfer speed
13x	2MB/sec
26x	4MB/sec
40x	6MB/sec
66x	10MB/sec
100x	15MB/sec
200x	30MB/sec
300x	45MB/sec
400x	60MB/sec
600x	90MB/sec
1000x	150MB/sec

LONG-TERM IMAGE STORAGE

The first place you are most likely to transfer your images to is your computer's hard disk, which has a high capacity, is easy to get to and allows you to edit, manipulate and print your images. However, as you take more and more images, you will slowly fill up your hard-disk space. Having all the images in one place may sound ideal, but should your computer be stolen or irreparably damaged, your images could be lost. It therefore makes sense to copy and store images on an alternative medium. Thankfully, there are several affordable options to consider.

EXTERNAL HARD DISKS

These are one of the most cost-effective forms of image storage, offering a number of high-capacity options at affordable prices. As as well as providing a reliable back-up for images, an external hard disk allows you to free up space on your computer. There are a number of factors to consider when choosing external storage of which the most important are covered here.

Capacity

The capacity of your hard disk should reflect the size and number of images you regularly shoot, especially if you plan to store Raw files or TIFFs, which take up considerably more memory than JPEGs. The minimum capacity of your hard disk should be 500GB, with 1TB or even 2TB proving cost-effective and practical options.

Connectivity

External hard drives with USB ports are the most common. However, Mac users should also consider the FireWire 400 (or the faster 800) drives. The latest generation of Macs (and some PCs) use the Thunderbolt port, which offers much faster transfer rates, although the drives are more expensive. Opting for a USB 3.0 drive is the best option due to its near-universal connectivity.

Standard or RAID?

Most external storage devices contain a single hard disk, which is the most cost-effective option, but means that should that drive fail, you might lose all your images. A RAID device has two or more drives, so you can 'mirror' the images on each drive so should one fail, you have a copy of everything on the other.

Mains or portable?

External drives running off mains power are the most popular and affordable. Portable USB hard disks take their power through the USB port and are smaller though more expensive.

Reliability

Don't be tempted to buy cheap brands as they may not be as reliable. Spend a little more on trusted brands such as Western Digital, Lacie and Seagate as these offer better reliability. That said, it's always worth backing up your back-up just to be safe!

ONLINE STORAGE

One of the benefits of the spread of broadband is the development of online photo storage sites that allow you to upload and safely store your images. This has the benefit of allowing you to store images off-site, so should your home be damaged or burgled, your images will be safe. It also means you can access them from anywhere that has a broadband connection and share them with family and friends.

Many internet providers, as well as large computing brands like Apple and Microsoft, offer online storage, which is rapidly being termed 'Cloud'. Some providers offer a free service up to a certain storage limit, such as 5GB, then charge a monthly fee for additional storage space.

RECORDABLE DISCS

A simple and convenient method for copying and sharing images is to burn them onto a disc. There are three main types you can use:

CDs

The recordable CD, or CD-R, is a popular and cost-effective method for storing a limited number of images, with a capacity of around 700MB. Most personal computers include an integral CD/DVD-writer, making it a convenient back-up method. A CD-RW is similar, but has the advantage that it can be rewritten; it is more expensive, however.

DVDs

The higher capacity of DVDs (around 4.5GB) and the general inclusion of DVD burners in PCs means this format is incredibly popular. It is a great way of storing thousands of images and the discs are very affordable.

Blu-Ray

A growing number of PCs include a Blu-Ray drive alongside or instead of a DVD drive, offering an even higher capacity form of back-up. Each disc can hold around 25GB, but as this format is still relatively recent, its popularity is still limited.

Archival disks

There are a number of CDs and DVDs available that offer archival properties – that is, lifespans in excess of 100 years. These are a good choice if you want to create a library of valuable images that you wish to outlive you.

IMAGE STORAGE ON THE GO

There are a variety of storage devices that offer photographers on the move a chance to back up, or in some cases, even view their images.

PORTABLE HARD DISKS

A good option if you post-process images on different computers is a portable hard disk. These offer a very high capacity (usually 500GB or 1TB) but are very small and slimline, so you can carry them in a pocket or bag with ease. They receive power through a USB slot, so can be used out in the field via connection to a laptop. Excellent models are available from Western Digital, Seagate and Lacie to name but a few. If you are travelling in extreme conditions, it's worth considering one of the models boasting additional protection, such as the Lacie Rugged drive.

Portable storage device (PSD)

PSDs have card slots (usually one CompactFlash and one SD slot) for downloading data directly from your memory card and boast a large high-resolution colour screen. As they can be connected to your home computer, you can upload movie and music files too, which makes them a portable entertainment system. They run on mains power but can also provide several hours of operation via their lithium-ion rechargeable battery. Most models offer a capacity of 80–160GB, which should prove more than enough. JOBO and Vosonic offer decent PSDs but the best is the Epson model 160GB P-7000.

USB flash drive

The most portable form of storage is the USB flash drive, which measures just a few centimetres in length, allowing them to be carried everywhere. Most models offer between 2GB to 8GB capacity, but some go as high as 32GB. Many offer encryption that requires a password to allow content to be accessed, but most are simple devices that can be attached to a keyring or slipped into a pocket.

Laptop

More affordable than ever and boasting excellent specifications and memory capacities, laptops are a favourite form of portable memory with photographers on the go. As well as being able to store your images, the ability to edit, organize and send images while out in the field makes them a highly versatile option.

FILE FORMATS

Digital images can be stored in a variety of file formats, each of which has its advantages and disadvantages.

THE IMPORTANCE OF FILE FORMATS

The format of the digital image plays a vital role in the image quality and how much memory space each image takes up on a storage card or computer hard disk. With most cameras, the options are JPEG, TIFF or Raw, while working on computers also allows images to be saved as PSD, GIF and a number of other formats.

The most important fact to remember is that when images are stored, they are usually compressed. There are two forms of compression: lossy and lossless. Formats that use the lossy format compress the image by losing some information from it. This degrades the image, with the greater compression resulting in increased loss of information. However, the lossy format is a useful format when storage space may be at a premium.

Lossless compression, often referred to as LZW, stores images without losing any information, therefore maintaining optimum quality, although file sizes are larger than lossy to compensate.

RAW

The Raw file has often been described as a 'digital negative'. This description relates to the image with no image processing applied. Shooting in Raw is more involved than shooting in JPEG because, once downloaded, the images need to be converted to TIFF or JPEG. Raw is the file format to select when the ultimate in image quality is required, as it is a lossless format, so all information is retained.

When you open a Raw file, you will be presented with several options to tweak the image before it is opened. For example, if you have set the white balance to Tungsten when shooting in daylight and all your images have a strong blue cast, you can set the white balance to Daylight on the software and instantly correct your error. You are also able to work on other parameters such as sharpness, contrast and exposure. Shooting in Raw therefore gives you more fall-back options should you make any mistakes.

Advantages of Raw
• Offers the best possible quality.
• Allows you to tweak settings such as white balance and exposure before converting to TIFF or JPEG.
• Works like a digital negative; you can use it as a 'master' file from which you can make other files.

Disadvantages of Raw
• Takes up memory space and is slower to process.
• Requires compatible software to view and convert.

JPEG

The JPEG (Joint Photographic Experts Group, so called for the people who devised it) is the most common type of file format used by photographers. It is known as a 'lossy' format, so you will lose some image information when you choose to shoot in JPEG or convert a Raw or TIFF file to JPEG. This is because the JPEG image is compressed so that it takes up less space on your memory card (or on your computer). The amount of information that you lose is up to you – you can decide this via the Quality setting that you set on your camera and when saving the image on your computer.

It is recommended that you always shoot at maximum quality, as you will be hard pushed to notice any degradation of the image. Start increasing the compression and you will discard more image information, degrading the final image and leading to unwanted 'artefacts' that spoil the final result.

Advantages of JPEG
• You can fit more images on your card.
• JPEGs are faster to transfer.
• JPEGs are easier to email.

Disadvantages of JPEG
• Compressing the file can lead to image degradation.
• If you make mistakes with something such as the white balance or the exposure, it is harder to salvage the result.

TIFF

The Tagged Image File Format is a popular choice of format when converting a Raw file, because it retains more information than a JPEG. However, for most amateurs, saving as a maximum-quality JPEG produces an equivalent level of quality but with the advantage of taking up less memory space.

OTHER MAIN FILE FORMATS

GIF

The Graphics Interchange Format is predominantly used on the web, as the small file size offers relatively low quality and a maximum of 256 colours.

PSD

This Photoshop file format retains information on how the image has been manipulated, such as Layers and other features.

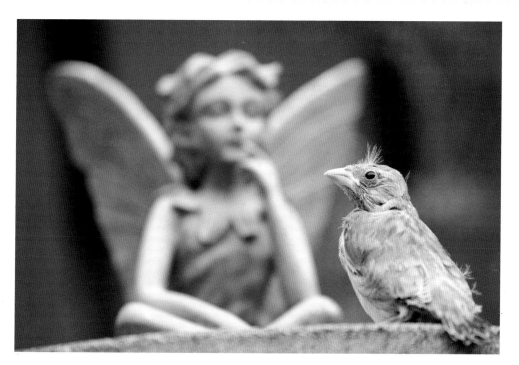

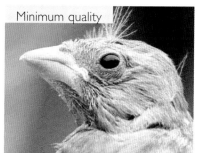
Minimum quality

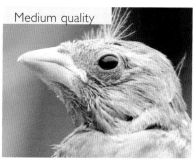
Medium quality

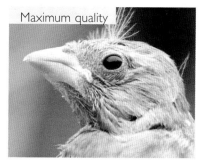
Maximum quality

COMPARISON OF JPEG COMPRESSIONS

These three images show how saving at different JPEG compression ratios can have a major effect on image quality. Saving at maximum quality keeps compression to a minimum and maintains the best quality from a JPEG file. Medium compression loses a fair amount of information and a close examination of the image shows some loss in quality. Saving the image at minimum quality results in the most compression, which leads to a major loss of information and poor image quality, which is most easily seen by magnifying a small portion of the image.

SYSTEM ACCESSORIES

LENSES

Choosing the right lens is just as important as deciding which camera to use. The choice on offer is enormous, from general-purpose lenses to specialist optics, so it is worth knowing what is available and being aware of the advantages and disadvantages of each type.

MAIN TYPES OF LENSES

Considering the large number of lenses on offer to the modern photographer, it is best to start by classifying the main types of lens available and the pros and cons of each.

Fixed lens

Today's modern zooms offer such good quality that most amateurs rarely consider a fixed lens, let alone use one. This is a shame, because fixed lenses still have much to offer. In terms of optical quality, fixed lenses have the edge over zooms, particularly at very wide apertures. Also, a fixed lens normally has a wider maximum aperture, which gives it an advantage in low light and provides a brighter viewfinder image. The obvious disadvantage of using a fixed lens is its single focal length.

Zoom lens

The modern zoom is a marvel of modern optics. We now have lenses covering all sorts of focal lengths, from ultra-wide-angle zooms to super-telephoto zooms. This means photographers can choose from a range of focal lengths at a fraction of the cost of buying individual fixed lenses covering the same range. The professional-class zooms provide a much closer contest in terms of optical quality, and often boast a fast maximum aperture. Zooms are also more likely to exhibit lens aberrations, especially those covering a very wide range.

Wide-angle lens

This lens gives a wider angle of view than the human eye. The most common types range from 21mm to 35mm, with 28mm being the most popular.

Ultra-wide-angle lenses cover a focal length of 11–18mm for digital SLRs and have a very wide angle of view, which is useful for providing unusual perspectives. The ultra-wide-angle zoom offers a versatile choice of focal lengths, usually in the region of 16–35mm. This type of lens has found appeal particularly with travel and architectural photographers.

Standard lens

The traditional standard lens is the 50mm f/1.8. This type of lens gives a similar angle of view to that of the human eye. The standard kit zoom supplied with cameras covers a range of around 18–55mm.

Telephoto lens

Any lens with a focal length greater than 50mm is termed a telephoto, and has a narrower angle of view, making it useful for distant subjects. The 55–200mm and 70–200mm lenses have become increasingly popular with users of digital SLRs featuring an APS-C sensor, while the 70–300mm lens remains a favourite choice for those using full-frame DSLRs. More powerful telezooms include the 135–400mm and the 170–500mm. Fixed telephoto lenses include the 300mm, 400mm, 500mm and 600mm.

SUPERZOOMS

The most versatile zoom ever, superzoom lenses offer an all-in-one package, with most offering a range of 18–200mm, 18–270mm, 28–200mm or 28–300mm. The latest generation are smaller and lighter, boast an image stabilizer and decent optical quality. However, they still cannot match a two-lens combination covering a similar range for overall quality, and also suffer from having a relatively small maximum aperture.

FOCAL LENGTHS

Now the main types of lenses have been established, the next step is to see how the focal length of the lens determines how a scene is captured.

Focal length comparison

The series of images that follows illustrates how changing the focal length of a lens completely transforms the scene that is captured. Here, the images range from 8mm full-frame fish-eye through to 400mm.

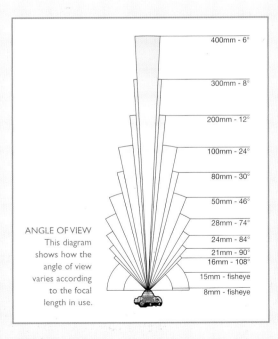

ANGLE OF VIEW
This diagram shows how the angle of view varies according to the focal length in use.

400mm - 6°
300mm - 8°
200mm - 12°
100mm - 24°
80mm - 30°
50mm - 46°
28mm - 74°
24mm - 84°
21mm - 90°
16mm - 108°
15mm - fisheye
8mm - fisheye

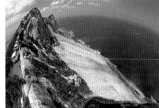

8mm fish-eye 15mm fish-eye

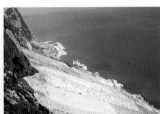

18mm 24mm

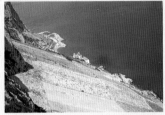

28mm 35mm

50mm 70mm

100mm 200mm

300mm 400mm

EFFECTIVE FOCAL LENGTH EXPLAINED

One of the most confusing aspects of lenses is that its effective focal length changes depending on which camera it's used on – or more specifically the size of the sensor used in your camera. Because 35mm film SLRs were the most popular type of interchangeable-lens camera for a good half-century, the focal length stated on lenses correspond to the 35mm film format. This means that the stated focal length is only accurate when the lens is fitted to cameras with a full-frame sensor, which is the same size as a 35mm film frame. The vast majority of cameras use a smaller sensor size and this leads to the image from the lens being cropped, with the edge of the image falling outside of the area covered by the sensor. This effectively increases the focal length of the lens, so you need to apply a simple calculation to establish what it is.

The increase in focal length is great news for those using telephoto lenses, such as nature and sports photographers, as it gives your lens extra pulling power. However, it is not such good news for wide-angle lens users like landscape photographers, as the coverage is reduced.

The tables that follow provide a quick reference to the multiplication factor that needs to be applied for the most popular camera brands, along with the effective focal length of popular lens types when used with the most common sensor sizes.

Focal length	Sensor type and its multiplication factor				
	Full–frame	APS–H	APS–C	APS–C (Canon)	Four–Thirds
	1x	1.3x	1.5x	1.6x	2x
15mm	15mm	19mm	22mm	23mm	30mm
20mm	20mm	26mm	30mm	32mm	40mm
24mm	24mm	31mm	36mm	38mm	48mm
28mm	28mm	36mm	42mm	45mm	56mm
35mm	35mm	45mm	52mm	56mm	70mm
50mm	50mm	65mm	75mm	80mm	100mm
85mm	85mm	110mm	127mm	136mm	170mm
100mm	100mm	135mm	150mm	160mm	200mm
10–20mm	10–20mm	13–26mm	15–30mm	16–32mm	20–40mm
10–22mm	10–22mm	13–29mm	15–33mm	16–35mm	20–44mm
11–18mm	11–18mm	14–23mm	16–27mm	18–29mm	22–36mm
12–24mm	12–24mm	16–31mm	18–36mm	19–38mm	24–48mm
16–35mm	16–35mm	21–45mm	24–53mm	26–56mm	32–70mm
17–40mm	17–40mm	22–52mm	25–60mm	27–56mm	34–80mm
18–55mm	18–55mm	23–71mm	27–82mm	29–88mm	36–110mm
18–200mm	18–200mm	23–260mm	27–300mm	29–320mm	36–400mm
18–270mm	18–270mm	23–351mm	27–405mm	29–432mm	36–540mm
24–105mm	24–105mm	31–136mm	36–157mm	38–168mm	48–210mm
28–70mm	28–70mm	36–91mm	42–105mm	45–112mm	56–140mm
28–300mm	28–300mm	36–390mm	42–450mm	45–480mm	56–600mm
55–200mm	55–200mm	71–260mm	82–300mm	88–320mm	110–400mm
70–300mm	70–300mm	91–390mm	105–450mm	112–480mm	140–600mm
100–400mm	100–400mm	130–520mm	150–600mm	160–600mm	200–800mm

EFFECTIVE FOCAL LENGTHS
This table lists the most common types of lenses along with their effective focal length when used with different sensor sizes.

MULTIPLICATION FACTOR

This table states the multiplication factor to apply for popular camera types.

Brands/models	Multiplication factor
Canon EOS	
All EOS models (unless stated below)	1.6x
EOS-1D series	1.3x
EOS 5D & EOS-1DS series	1x
Fujifilm	
S1, S2, S3 & S5 Pro	1.5x
Nikon	
All D-series models (unless stated below)	1.5x
D700 and D3 series	1x
Nikon 1 System CSCs	2.7x
Olympus & Panasonic	
All digital SLRs and CSCs	2x
Pentax	
All digital SLRs	1.5x
Pentax Q	5.5x
Samsung	
All digital SLRs and CSCs	1.5x
Sigma	
All SD models	1.7x
Sony	
All Alpha and NEX models (unless stated below)	1.5x
Alpha 850 & A900	1x

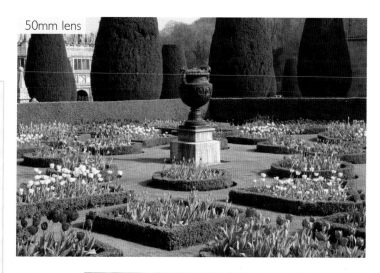

50mm lens

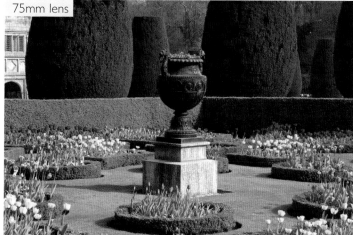

75mm lens

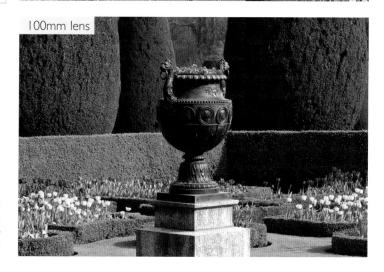

100mm lens

FOCAL LENGTH
These three images, all captured from the same position using a 50mm lens, show the difference made to the effective focal length of smaller sensor sizes.

LENSES AND PERSPECTIVE

Your choice of lens can have a dramatic effect on how perspective in the scene is recorded. This is most obvious when the main subject is much closer to the camera than the backdrop. By choosing the lens you use, you can therefore alter perspective to suit your creative requirements. The easiest way to examine and understand this phenomenon is to shoot a trial set of images and compare how the perspective changes along with the focal length.

Choose a scene where you can clearly see any changes in the background's perspective and place a subject, such as a person, in the centre of the frame. For your experiment to work correctly, you need to move physically as you change focal lengths so that you keep the subject the same size in every image. So either start with a wide-angle and move backwards or use a telephoto and move closer as you choose shorter focal lengths. A good method to keeping the subject roughly the same size and in the same position is to use the focusing points in the viewfinder as a guide.

As you'll discover, to increase perspective and depth in a scene and exaggerate the distance between the main subject and the backdrop, a wide-angle lens is best. You can reduce perspective by using a telephoto lens to give the impression that the subject is very close to the background, even if there is considerable distance between the two.

28mm lens

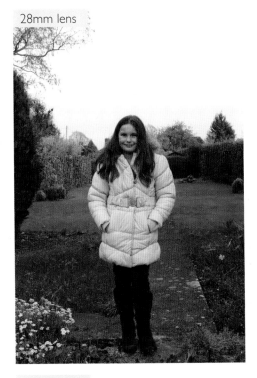

100mm lens

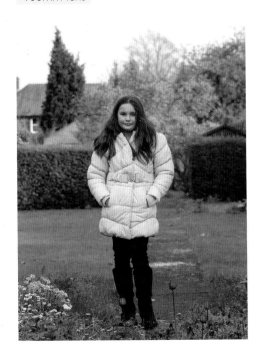

35mm lens 50mm lens 70mm lens

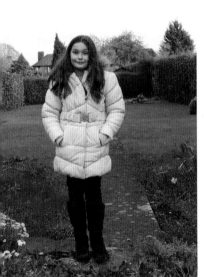
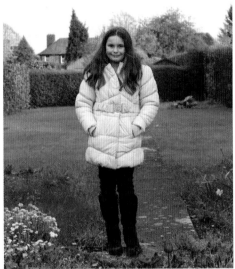
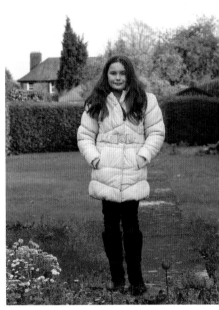

135mm lens 200mm lens

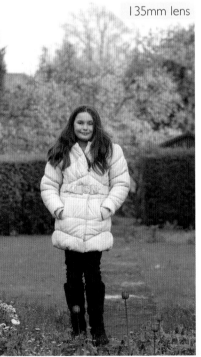
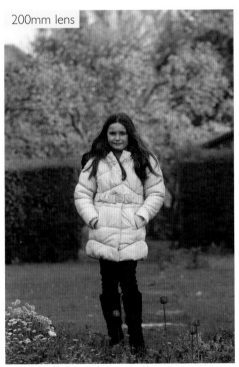

FOCAL LENGTH
This set of images shows the change to perspective when using different focal lengths from ultra wide-angle to telephoto. Keeping the subject the same size in the frame by changing the subject-to-camera distance, these images reveal how the background changes dramatically depending on the lens choice. The background changes dramatically depending on the lens choice.

SPECIALIST LENSES

As well as the more popular lens choices, there are a number of specialized lenses that deserve consideration. As the name suggests, these are designed for a specific use. This is not only their greatest selling point, but also their biggest drawback, as they are often not suitable for other types of photography. However, for their chosen application, there is nothing to touch them.

MACRO LENS

The macro lens is the most useful specialist optic. Most record a life-size image (1:1) on the sensor, while some manage only half life-size (1:2). There are macro lenses at various focal lengths, 50mm, 90mm, 105mm and 180mm being the most common. Go for the longest focal length you can afford, as it allows you a longer working distance from the subject. A 105mm or 180mm macro lens can also be used as a telephoto lens or as a very good portrait lens.

PERSPECTIVE-CONTROL LENS

These lenses are useful in architectural photography, as they allow tilt-and-shift movements, which let you manipulate the plane of focus, control depth of field in unusual ways and correct converging verticals when shooting buildings. The focal length is usually between 45mm and 90mm.

LENSBABY

The lensbaby range is unique – sporting a flexible lens barrel that allows you to capture images that have one sharp 'sweet spot' with the rest of the frame thrown out of focus. There are several models in the range, with the Composer proving to be one of the easier and most versatile. Its effects are an acquired taste but they have found favour with many professionals and legions of amateurs.

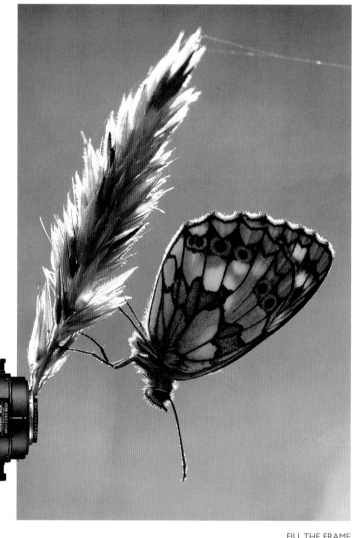

FILL THE FRAME
A macro lens is the best option when you want to capture small subjects in high magnification so that they fill the image area.

FISH-EYE LENS

Fish-eye lenses offer a 180-degree field of view. They are available in two forms: circular and full-frame. The focal length of a circular fish-eye is usually 8mm, while the full-frame fish-eye is around 15mm.

Circular fish-eyes create a circular image in the centre of the frame, with black edges around it, while full-frame fish-eyes fill the frame with a very distorted look on the world.

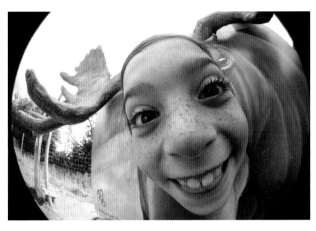

FISH-EYE PORTRAIT
A fish-eye lens has limited uses – quirky 'fun' portraits being one of them!

IMAGE STABILIZATION

Image stabilization, also known as vibration reduction, is found on an increasing number of lenses, in particular telephoto and macro lenses. As its name suggests, the lens incorporates a system of gyro sensors that work to reduce camera shake. Shots taken at slow shutter speeds have proven that the system works, making a difference equivalent to a shutter speed two to three stops faster. Some lenses even offer an image-stabilizing facility that caters for panning shots, as well as for standard shooting.

LENS ABERRATION

Not all lenses are perfect. Some, in particular those at the cheaper end of the scale or those offering the widest zoom range, are prone to one or more of a number of lens faults, or aberrations.

The term 'aberration' describes an image that suffers a number of problems caused by the lens. This includes chromatic aberration, when different wavelengths of light focus at different points, leading to a loss of sharpness.

Distortion relates to the shape of the subject on the image not corresponding to the real thing because of straight lines appearing to be curved. Zoom lenses typically produce barrel distortion at the wide-angle end and pincushion distortion at the telephoto end. Barrel distortion causes straight lines to bulge outwards, while pincushion distortion sees straight lines curve inwards.

Other aberrations include astigmatism, where off-centre points of light record as a line, and spherical aberration, where light at the edges of the lens causes flare to spill over the image, making the image appear soft and exhibit low contrast.

Types of lens elements

A lens is made up of several elements arranged in specific groups. Zoom lenses generally tend to have more elements and groups than a fixed lens. When choosing a lens, it is worth obtaining a brochure from the manufacturer to find out exactly how the lens is made up.

The elements vary from lens to lens. While most use optical glass, some are made from plastic, and others are made from both glass and plastic. Many lenses incorporate aspherical elements, designed to reduce distortion, and some telephoto lenses incorporate fluorite, apochromatic or low-dispersion glass to counter lens aberration.

The 'speed' of a lens

A lens may be termed slow or fast. This relates not to its focusing speed, but to its maximum aperture. It is in fact an indirect reference to how the maximum aperture affects the shutter speed. A fast lens is one that has a faster aperture than is the norm for its particular focal length. For example, a 70–200mm f/2.8 is a fast telephoto zoom, because its maximum aperture is better than the average, in this case f/3.5–4.5. A slow lens is the reference given to lenses with a smaller than average maximum aperture. For instance, a 28–300mm f/4.5–6.3 is slow, as a 28mm lens normally has an aperture of f/2.8, while a 300mm is more often around f/4.5 or f/5.6.

FLASHGUNS

When available light isn't good enough, the trusty flash can be relied upon to rescue the shot. This highly sophisticated piece of equipment does far more than simply fire off a burst of light.

HOW DOES A FLASH UNIT WORK?

In very simple terms, a flash unit is a gas-filled chamber. Pressing the shutter release triggers an electrical current to pass through the chamber and charge the gas, which produces the flash burst.

The actual flash exposure is controlled by the camera, ensuring that the correct amount of light is provided to give a nicely balanced image. Many cameras use a through-the-lens (TTL) system to do this, while others have sensors close to the lens that measure and control the flash output.

CONTROL BUTTONS
These controls allow you to set the various flash modes. The chosen settings appear on the LCD for ease of use.

ANATOMY OF A FLASHGUN

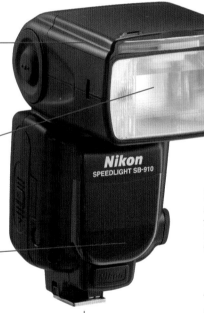

FLASH HEAD
This can swivel from side to side and be raised or lowered for bounce flash. The flash head often has a zoom facility (usually 28–80mm), so that flash coverage is optimized for use with particular lenses.

DIFFUSER PANEL
Some flashguns have an integral diffuser panel that can be pulled down in front of the flash head to diffuse the light when shooting subjects in a relatively close range.

FOCUS ASSIST LAMP
Some flashguns feature an AF assist lamp, which is activated in low light to project a patterned beam that aids the autofocus system to lock on the subject.

HOTSHOE MOUNT
This attaches the flashgun to the camera and has metal contacts for transmitting information electronically between the flash and camera – the more metal contacts, the greater the sophistication of information.

LCD
As with cameras, the LCD provides information on the flashgun's settings.

TEST BUTTON
Press this to test the flash exposure or when you want to fire the flashgun off-camera – for instance, when painting with light (see Painting with light).

READY LAMP
This provides a visual indication of when the flash is charged up and ready to be used.

FLASH MODES

Most flashguns boast a variety of modes. The most common are listed here.

Automatic

This is the most common mode, and its operation is fairly straightforward. If the camera detects that the ambient light level is high enough, it doesn't activate the flashgun. Once the light level has fallen below a certain threshold, it triggers the flash to fire.

Fill-in

Set the camera to fill-in (also called forced-on) mode and the flash fires, even if light levels are high. This is a useful mode when shooting portraits, to remove shadows from the face and add a catchlight to eyes.

Forced-off

This mode switches off the automatic flash and forces the camera to set a longer exposure time to compensate. It is used in situations where flash isn't allowed (e.g. in museums) or when you want to purposely set a long exposure for creative reasons.

Second-curtain sync

Here, the flash fires at the end of the exposure rather than at the start (see Flash synchronization).

Red-eye reduction

This mode fires either a series of short flash bursts or a beam of light before the actual flash exposure to reduce the risk of red eye (see Red eye).

Slow sync

This mode mixes a long exposure with a burst of flash and is useful when you want to illuminate a subject with flash but also record background detail.

Flash compensation

Similar to exposure compensation, but alters the flash's power in relation to the ambient exposure.

High speed

Some models allow the camera to synchronize the flash at any shutter speed. This offers more creative options than being restricted to a particular speed.

Wireless

An increasing number of cameras and flashguns now sport a wireless facility, allowing the flash to be fired off-camera via a wireless signal.

FLASH SYNCHRONIZATION

The duration of a flash burst is extremely short – on average around $1/40000$ sec. With a normal flash exposure, the flash fires at the start of the exposure and is termed first-curtain synchronization.

With second-curtain synchronization, the flash fires at the end of the exposure. The advantage of using this is that any light trails that are visible in the frame will appear natural.

With high-speed synchronization, the flash burst takes a longer period of time (often around $1/1000$ sec), which allows a far faster shutter speed than normal to be set.

LCD INFORMATION
This is the LCD panel from a Canon Speedlite flashgun, with all icons active. It reveals not only the number of features that are available to photographers, but the level of information provided to aid the user.

RED EYE

Red eye is the term given to the phenomenon of the pupils of people's or animals' eyes appearing red due to the flash reflecting off blood vessels at the back of the subject's retina; this is the unfortunate 'demon eyes' effect that often spoils portraits. Red eye is more likely to occur the closer the flash is to the camera and the longer the lens's focal length. To reduce the problem with an integral flash, move closer to the subject and use the lens at a wider setting – and, where possible, use a hotshoe-mounted flashgun.

GUIDE NUMBER

The power output of a flashgun is indicated by its guide number (GN), usually stated in metres at ISO 100. The higher the stated guide number, the more powerful the unit. Before cameras did the calculations automatically, photographers used the following formula to calculate the flash exposure:

Aperture = guide number/flash-to-subject distance (metres).

FILTER SYSTEMS

One of the first accessories film photographers invested in was a filter system. Despite the advent of digital and post-processing packages like Photoshop, filters still represent a worthwhile investment. Although they are modest in cost at the start, building up a comprehensive collection can be expensive, so make sure you invest in the system best suited to your needs. It is possible to replicate the effects of optical filters using image-manipulation software, but many photographers still prefer to use a filter in front of a lens than do the work on computer. I would recommend using optical filters whenever possible, especially because the effects of filters such as the polarizer are impossible to recreate digitally.

SCREW-IN FILTERS
These come in various sizes to fit most lenses.

MAIN TYPES OF FILTER SYSTEM

There are two main types of filter system to consider: screw-in and slot-in. Each has its own advantages and disadvantages.

Screw-in filters

These are filters that attach directly to the front of the lens. Because various lenses have different diameters, a screw-in filter must be a particular size in order to fit the lens – this is usually referred to as the filter thread size. The most common sizes for SLR lenses range from 52mm to 77mm, although sizes as small as 22.5mm and as large as 95mm are also available. If you own a number of lenses all with different thread sizes, you will need multiple filters of the same type to fit them all. For this reason, screw-in filters make most sense if you own only one or two lenses, or if all the lenses you use have the same thread size.

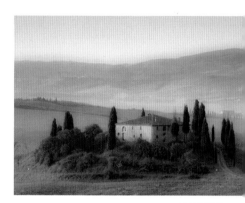

TUSCANY
Filters are essential for making the most of stunning scenes.

Slot-in filters

Slot-in filters, often called square filters, are a better option if you use several lenses. The actual filter slots into a holder, which is fixed to the lens via an adapter ring. Because you only need to buy different sizes of adapter ring to fit different lenses, the cost of building up a comprehensive filter system is far lower. Another advantage of slot-in filters is that more than one can be used in combination without causing any problems. While this can be done with screw-in filters by screwing one into another, there is the risk of vignetting, which results in the corners of the image appearing black because they are obscured by the filter ring.

Slot-in filters come in a range of sizes. Smaller ones are aimed at novice digital camera users; larger ones are suited to medium-format lenses and large-diameter ultra-wide-angle zooms for digital SLRs. The smallest systems are based around filters with a width of 67mm. These can be used with wide-angle lenses as wide as 28mm. This is a relatively cheap option, but you are limited in what lenses you can use the system with. The next size up is 85mm filters. These cost more but are more versatile, as they can be used with wide-angle lenses for digital SLRs up to around 21mm, as well as medium-format lenses. The next step up is 100mm filters. Amateur photographers are unlikely to want to go up to this size, especially as these filters are relatively expensive.

SYSTEM FILTERS
These require the use of an adaptor ring and filter holder.

EXPERIMENTING
Don't be afraid to experiment with filters. These images show a scene photographed with no filter (right) and then with a sepia filter (below right).

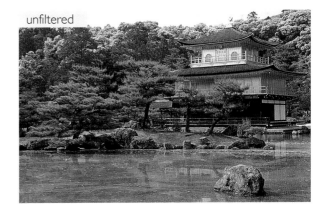

unfiltered

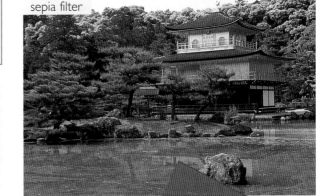

sepia filter

STEP-UP AND STEP-DOWN RINGS

These are rings that allow you to attach a screw-in filter to a lens with a wider or narrower filter thread. A step-down ring allows you to use a filter with a lens offering a smaller filter thread. For instance, a 72–82mm ring allows an 82mm filter to be used on a filter with a 72mm thread. A step-up ring has the opposite purpose, but should be used with great care as vignetting is very likely to occur.

THE TEN-STOP ND FILTER

Over the last few years, the ten-stop ND filter has become increasingly popular, with the B+W and Lee Filters 'Big Stopper' being bestsellers. These filters allow long exposures to be taken in daylight, resulting in creative effects that reveal the motion of clouds and water as a pleasing blur.

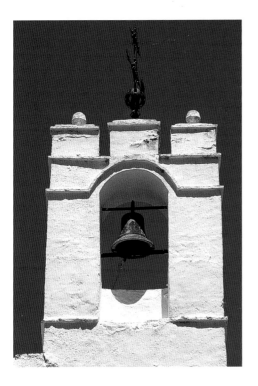

BELL
A polarizer delivers richly saturated skies.

SLOT-IN FILTER
The square slot-in filter cannot be beaten for versatility.

Rear-element filters
Large telephoto lenses and some ultra-wide-angle zooms do not feature a filter thread on the front of the barrel due to the diameter of the lens. Instead, the rear of the barrel has a holder that accepts a very small filter.

STUDIO LIGHTING

For the ultimate in controllable light, there is nothing to beat a studio flash outfit, as this versatile system offers the photographer complete control over every aspect of lighting an image.

ANATOMY OF A STUDIO FLASH HEAD

SLAVE CELL
In multiple flash set-ups, only one head is connected to the camera/meter. When this head is triggered, the slave cell on other heads detects the flash output and fires the other heads.

VENTILATION
The heads generate heat and include a fan to prevent overheating. Be sure not to cover the ventilation slots.

CARRY HANDLE
This useful feature allows you to handle the heads, which may become very hot if used for long periods.

AUDIBLE BEEP
This sounds when the head has recharged and is ready for the next exposure.

SYNC LEAD SOCKET
The sync lead connects the flash head to a camera or meter. Some heads allow various types of lead to be used.

MODELLING LAMP
This links the output of the modelling lamp with the flash power output slider for an accurate representation of the flash output.

ACCESSORY LOCKING RING
Attachments such as a softbox or reflector dish are attached and removed using this ring.

POWER SOCKET
This is where you connect the flash head to the mains power.

FLASH OUTPUT
With top-end models such as this Elinchrom Style 600, the flash output is controlled digitally to give stepless control. The power is shown on the LED display above the power up/down buttons.

MODELLING LIGHT
This is a tungsten bulb that provides a continuous light source, allowing you to adjust the lighting effect.

FLASH TUBE
This ring-shaped tube produces the flash exposure once the shutter is triggered.

MAIN TYPES OF STUDIO LIGHT

Although studio flash heads serve a similar purpose, there are a few variations available.

Monobloc

Monoblocs are studio flash heads that incorporate an integral power source and all controls, allowing fully independent usage. Because everything is built into the head, monoblocs are compact units that are easy to transport and store away. They are relatively cheap, making them particularly popular with amateur photographers.

Powerpack

More common than monoblocs in professional studios are studio heads powered by a large generator pack. This type of system has the advantage that it offers more power and faster recycling times than monoblocs, but is more expensive – and should the powerpack fail, there is no way of using the lights. Controls for the lights are usually found on the powerpack, so it is easy to make quick adjustments to several heads.

Portable studio flash

For studio flash on the move, there are a number of portable flash systems to choose from. These work in a similar fashion to standard powerpacks, but the generator includes a rechargeable battery, allowing it to be used where an electricity supply is unavailable. This is a very versatile system, but an expensive one.

Continuous lighting

An increasing number of amateur photographers looking for their first studio lighting outfit are opting for a continuous light source as opposed to flash. These use bright daylight-balanced fluorescent bulbs that are on continuously, making it easier to arrange the lighting effect to your needs. However, the attachments and the control of the lighting's power are more limited.

FLASH LIGHTING ACCESSORIES

The type of attachment you fit determines the characteristics of the final lighting effect.

Softbox

This is a favourite with portrait photographers as it provides a very diffused light. It is basically a large fabric box with a white front panel, available in various sizes. Although the square type is the most popular choice, other shapes are available, including rectangular (known as strip light) and octagonal.

Umbrella

Often called a brolly, this comes in various effects. Silver brollies give a bright result, while gold adds a warm tone to the subject. White brollies provide the softest effect and are the most popular choice.

Reflector

Also called a dish, this is usually supplied as standard. Reflectors are used to provide direct illumination of a subject, and are available in different depths to vary the coverage of light.

Snoot

This is a long, cone-shaped attachment that narrows the light into a narrow beam. The snoot is normally used as a secondary light, usually to create a highlight around a portrait subject's hair.

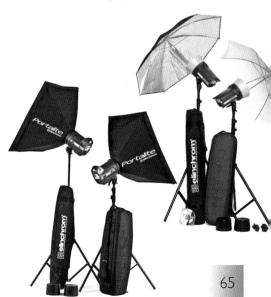

STUDIO AND CAMERA ACCESSORIES

A vast number of accessories are available for the various types of camera on the market. Some of these can be classed as essential items, while others are useful but not always necessary. For optical attachments that aid close-up photography see Close-ups.

SYNC LEAD

With budget studio flash kits, the sync lead is the most affordable way to connect the flash to the meter or camera.

WIRELESS TRIGGER

A far more convenient way to sync the camera with your lighting system is to use a wireless trigger set. Connect a transmitter on your hotshoe and a receiver to the flash head and you're able to trigger the flash without restriction. The Interfit Triton and Pocket Wizards are excellent options.

BACKGROUNDS

Cheap paper backgrounds are plain in colour, with white and black being the most popular choices, and can be rolled up for storage. Fabric backgrounds are available in a choice of plain and mottled colours. As well as rolls of fabric, you can get collapsible backgrounds that fold away into a bag.

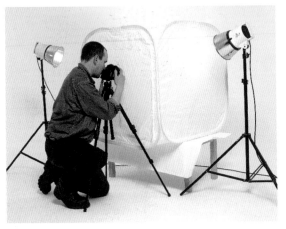

CUBELITE
The portable light tent is ideal for still life photography, providing an efficient means to photograph reflective subjects, such as silverware, without the normal problem of reflections appearing on the subject.

CAMERA STORAGE

One of the first accessories to consider is also one of the most important – where you will store the camera when it is not in use. There are various options to consider, each with its own pros and cons.

Gadget bag

The gadget bag, which hangs over the shoulder via a long strap, is the most popular type with enthusiast photographers. Available in various sizes, gadget bags can be found to suit all types of camera outfit. They are well protected, and thanks to features such as adjustable internal dividers, are very versatile for storage. A major advantage of these types of bags is their accessibility, allowing fast access to your camera. One major disadvantage is that the weight of the outfit is taken by one shoulder, which can prove uncomfortable when you are carrying a full, heavy bag.

Photo rucksack

Also called backpacks, these offer a far more comfortable option

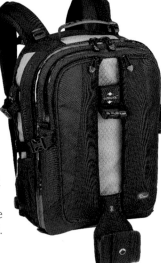

than the gadget bag, as the weight of all your gear is evenly distributed across the shoulders and back. The rucksack comes in various sizes and is particularly popular with outdoor types. Its biggest disadvantage is that you can't get to your gear quickly, as you need to take the pack off your back first.

Hard case

For the ultimate in protection, look for a hard case that is tough enough to stand on. They are made of metal or plastic, with the latter being more popular. These are great for transporting gear overseas, but aren't as practical as gadget bags or rucksacks.

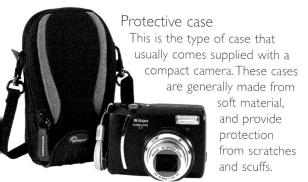

Protective case

This is the type of case that usually comes supplied with a compact camera. These cases are generally made from soft material, and provide protection from scratches and scuffs.

Zoomster

These are designed to hold an SLR body with zoom lens attached. They are a good option if you are travelling light, but the storage space is rather restricted. The zoomster is the modern equivalent of the ever-ready case (ERC), which was the number-one choice before zoom lenses became popular.

Sensor cleaning kit

One of the problems digital SLR and CSC users face is that of dust settling on the image sensor, resulting in black dots appearing on images. The problem occurs when lenses are changed and dust gets inside the camera body. With DSLRs, dust enters the mirror chamber and on taking a picture, the mirror rises and dust is attracted to the static charge on the sensor. The problem is even worse with CSCs, as the sensor is directly exposed as soon as the lens is removed. Various kits have been produced to help remove the dust. Most involve the use of pressurized air or swabs. The most sophisticated is Delkin's Sensor Scope, which allows you to view a magnified image of your sensor to help you detect and remove dust.

Pouch

These are designed to hold either a specific lens, or a particular type of lens, such as a telephoto. Pouches offer good protection, but are somewhat limited in their appeal.

LENS ACCESSORIES

As well as filters, various accessories are available for use with lenses.

LCD SHADE

Using an LCD monitor in bright daylight can be difficult, so LCD shades have been produced to reduce glare and allow a clearer view of the screen. Pop-up shades are available for compacts, DSLRs and CSCs.

LENS HOOD

Possibly one of the most overlooked accessories and also one of the most useful, a lens hood shields the optics from stray light that can create flare and reduce the overall contrast of the image. There is little reason not to leave a hood permanently attached. Although universal hoods to fit various lenses are available, wide-angle users should fit the appropriate hood to avoid vignetting.

CONVERTER

This converts the focal length of the lens. A wide-angle converter increases the field of view, making it useful for interiors or landscapes. A teleconverter increases the telephoto power of a lens, making it suitable for high-magnification shots of distant subjects.

POWER ACCESSORIES

SLR power grips
Some SLRs allow for extra grips to be attached to the base of the camera, which aid handling. There are two main types.

Battery packs
These offer an alternative power source to those used in the camera. These are usually run on AA batteries, which are more readily available than lithium batteries.

Motordrives
Some of the top-end SLRs accept a motordrive, which not only offers an alternative power source, but adds a boost to the frame rate and offers alternative controls for vertical shooting.

Battery types
Alkaline AA batteries have long been the most common type used in cameras. However, with higher levels of power consumption, newer types of battery have now been developed. Rechargeable Ni-Mh (nickel metal hydride) batteries have replaced the older AAs, the older Ni-Cd (nickel

cadmium) types, but most cameras now use Lithium-ion batteries. These are rechargeable cells that have a longer lifespan and are designed specifically for particular cameras. They're much more compact than a pair of AAs, thereby enabling designers to create ever-smaller cameras. Long-life batteries offer extended running time.

CAMERA SUPPORTS
Any photographer looking to take the sharpest possible pictures will sooner or later need to invest in one form or another of camera support.

Tripods
The tripod is by far the most popular type of camera support. Tripods are available in various sizes and are constructed from different materials to suit various different applications.

Small tabletop tripods are designed for film and digital compacts. Some models offer movable heads, making them relatively versatile for snapshots and self-timer pictures.

SLR TRIPODS
These are the most popular tripods. There are three main types.

Standard
The majority of amateur photographers are likely to need nothing more than a standard tripod. With extendable legs, a fitted head and good stability, all obtained at a fair price, this type is deservedly popular.

Studio-based
These tripods are far heavier than the standard types. They are constructed with far thicker legs, which are necessary to provide a stable support for larger and heavier studio-based cameras, such as a medium-format outfit.

Carbon-fibre
For outdoor photographers who are likely to have to carry a tripod around over long distances, a carbon-fibre model is hard to beat. It is 35 per cent lighter than equivalent aluminium models, and offers excellent stability. This comes at a higher price, but landscape photographers all around the world reckon that the initial investment is well worth it.

ANATOMY OF A TRIPOD

It is worth knowing what to look for in a tripod, to be certain you get a model best suited to your type of photography.

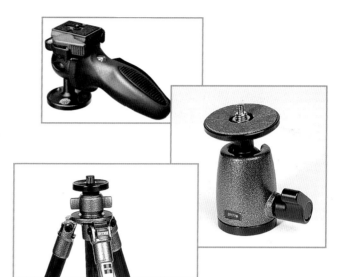

Head

Not all heads are the same. Pan-and-tilt, ball-and-socket and three-way heads all work in different ways to support the camera and adjust its alignment. When buying a tripod, check out the head and make sure you are happy with how it works. Some tripods come without a head, allowing you to fit your favourite type.

Quick-release plate

To make attaching and removing the camera easier, look for models with a quick-release plate, a removable platform that screws into the base.

Spirit level

Landscape photographers find a spirit level useful to ensure that the horizon is completely level for each shot.

Leg locks

Personal preference dictates whether you prefer hinged locks or twisting locks. Try them out before you buy.

Leg sections

The number of leg sections on a tripod varies from model to model, with three or four being the most popular. The general rule is that the more leg sections a tripod has, the higher it extends. But don't overdo it, as stability is compromised the more legs are extended.

Centre column

This can be extended to increase the maximum height the camera can be used at. Some tripods allow the centre column to be removed and attached horizontally for shooting at odd angles.

Feet

Rubber or plastic feet give a good grip on most surfaces, bar smooth or icy conditions. Spiked feet are useful for outdoors on soft or slippery land, but can scratch wooden floors if used indoors. Look for feet that combine both types.

Monopods

Sometimes, one leg is better than three! The monopod is a good choice of support when a tripod is too cumbersome an option. It is particularly popular with sports photographers as support for their large telephoto lenses.

Beanbag

These small accessories can be kept in the boot of the car until needed. They feature a tripod bush that screws into the base of the camera, allowing a firm fitting on which to rest.

Suction clamp

This is used for attaching the camera to smooth surfaces like metal or glass. It is used by some motorsports photographers to clamp the camera to a car bonnet and trigger it remotely.

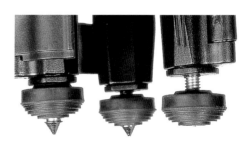

69

REMOTE RELEASES

Optional accessories are available for firing the shutter when the shutter button isn't the best option, such as in low-light photography.

Cable releases

The traditional type screws into the shutter button (or appropriate terminal). When you press the plunger, a metal pin extends from the base of the release and triggers the shutter.

Corded electronic releases

The majority of modern cameras use an electronic release to fire the shutter. These are corded (usually 60cm/2ft in length), and are specific to certain types of camera. Some feature a lock facility, which allows you to lock the shutter open during long exposures.

Long-range transmitters/receivers

These are favoured by wildlife photographers. A transmitter is positioned in direct line of a receiver, fitted to the camera's hotshoe. The shutter is triggered when an infrared beam between the two elements is broken.

Remote trigger

Corded remotes work well but their range is limited so when you want a greater working distance choose a remote trigger set. These comprise of a receiver that sits on the hotshoe or connects to the

remote socket, and a transmitter with a shutter release button. Most have a range of 100m (110yd), making them far more versatile. Some models can also double up as a flash trigger.

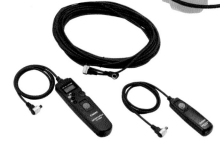

LIGHTING ACCESSORIES

There are a number of accessories that allow you to control the characteristics and direction of light falling on your subject. They can be divided into two main types: reflectors and diffusers.

Reflectors

Reflectors work by bouncing light back on to the subject. The colour of the reflector is important – white provides a soft, diffused light; silver is more efficient but can look harsh; and gold adds warmth.

Collapsible reflectors

For convenience and practicality, there isn't much that can touch this type of reflector. They can be stored away neatly when not required and instantly pulled out when needed. The larger the size, the wider the area of reflected light, so small reflectors are only suitable for smaller subjects, such as close-up photography. Lastolite manufactures a huge range, available in various sizes and colours. The best models feature a handgrip that makes them very easy to use.

California Sunbounces

These huge reflectors are favoured by fashion and portrait photographers who want the ultimate in control. The large size of the panels means they can reflect light onto a full-length subject.

Triflectors

An unusual reflector that is growing in popularity, the triflector has three individual panels that allow for excellent control of reflected light. It is most commonly placed beneath the chin of a subject, but can also be used much like any other reflector.

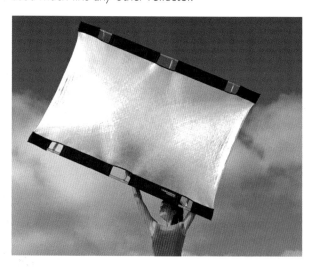

LARGER THAN LIFE
The California Sunbounce is the ultimate reflector.

Diffusers

The aim of a diffuser is to soften the light falling on a subject. It is used predominantly in portrait photography to reduce the harshness of sunlight. Because light travels through a diffuser to reach the subject, they must be white so as not to create a colour cast. The Sun Swatter is a large diffuser popular with professionals, while a diffuser panel is available for the California Sunbounce. If you want to save money, you can make your own diffuser from net curtains or muslin.

EXPOSURE METERS

Although the majority of cameras boast highly sophisticated forms of integral metering, the handheld exposure meter is still a popular accessory. There are three main types of meter: the light meter takes readings of ambient light only; the flash meter measures only a flash exposure; and a combined meter can take a reading of both. Considering the small variance in price between all three, the combined meter is the recommended choice.

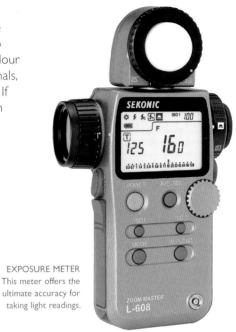

EXPOSURE METER
This meter offers the ultimate accuracy for taking light readings.

ANATOMY OF AN EXPOSURE METER

LCD
The LCD is the information centre of the meter, providing information about the exposure reading.

INVERCONE
This white dome, also known as a lumidisc, is used to take incident light readings. With most meters, a switch or dial raises or lowers the dome to adjust how it takes readings. In its raised position, it is ideal for general use outdoors. In its lowered position, it is better suited for metering for flat objects, such as paintings.

METER BUTTON
This is usually located on the side of the meter for easy use. Press it to take a meter reading and, if connected to studio heads, to fire the flash.

ISO BUTTON
To meter correctly, you must ensure that it is set to the correct ISO rating.

MEMORY
You can store set-ups using the memory function.

MODE BUTTON
Press to change between taking ambient or flash readings.

SYNC SOCKET
This connects the meter to the studio flash via a sync lead.

PRINTERS AND SCANNERS

The emergence of the photo-quality inkjet printer has allowed more people than ever to produce high-quality prints at home. The last couple of years have seen a shift in the popularity of certain types of printer and have also led to a major improvement in quality and speed.

INKJET PRINTERS

The vast majority of prints made in the home are produced on inkjet printers. Most produce prints up to A4 size (21x30cm/8½x11in), while an increasing number produce prints above A3 (29x41cm/11½x16in). Inkjets are capable of photo-quality results. The printers squirt small droplets of ink onto the paper's surface. Each ink droplet is minute, resulting in dots with diameters a quarter of that of a human hair. The inks are produced when nozzles in the printer's head are heated, causing the ink to vaporize and forcing it from the nozzle where, once cooled, it drops onto the paper. The smaller the dots, the greater the amount of detail in the prints.

Image quality is now exceptionally high in terms of sharpness, colour reproduction and tonal quality, with black-and-white prints now able to match that produced conventionally in the darkroom. Where models continue to develop is in providing faster printing speeds and extra features such as Wi-Fi/bluetooth options.

The market for A4 printers is now dominated by 'multifunction' printers, which offer a scanning and copying facility (and often a fax too) as well as photo-quality printing. Those units that offer printing only are usually A3 models at the mid to higher end of the price bracket.

As well as the printers themselves, manufacturers continue to develop inks and papers to provide more realistic results and also better archival properties. As well as the number of colour ink cartridges being used by top-end printers increasing, many how have a set of inks developed exclusively to improve the tonal reproduction of black-and-white prints.

PORTABLE DYE-SUB PRINTERS

While dye-sublimation printers aren't as popular as inkjet printers, they are still in demand as portable printers, producing 6x4in prints directly from cameras or via its card slots. They are supplied with packs containing ink ribbons and paper, making them affordable, fast and easy to use for producing standard-sized prints. However, while capable of photo-quality prints, this niche in the market is slowly shrinking, so their future remains unclear.

Direct printing

The vast majority of home printers can be connected directly to the camera without the need for a computer. The vast majority of them connect to a digital compact, DSLR or CSC via a dedicated lead, although an increasing number connect wirelessly using Wi-Fi or Bluetooth. This Wi-Fi facility can also be used to print directly from Smartphones too. Direct photo printers vary from small, portable models all the way up to A3+ (29x41cm/11½x16in) inkjet printers. Many printers also feature card slots that allow for PC-free use by printing images directly from the card.

SCREEN CALIBRATION

Calibrating your monitor is very important to ensure your images are displayed with accurate colours. This is particularly important if you regularly print your images. There are various colour-calibration kits available, many of which involve a combination of software, a screen sensor and a colour printout. The range of calibration devices from Spyder and X-Rite are among the very best.

LARGE FORMAT

The price for photo-quality large-format printers has dropped to a level that makes it a viable option for use in studios or the homes of the more affluent enthusiasts. These models are capable of producing huge poster prints and offer the benefit of economical ink usage compared to smaller inkjet models. The quality from them is superb; most exhibition prints are produced on these types of printers. Epson and Canon are market leaders in this sector of the market.

WHICH PRINTER?

When deciding on which printer is best for you, consider the following points.
Printing resolution: Printers state their resolution as dots per inch (dpi), with typical figures ranging from 1440dpi to 4800dpi and above. These figures can seem confusing, but as a rule, check that the printer offers photo-quality printing of at least 1440dpi.
Printing speed: How long it takes for a colour photo-quality print to be produced. Some models are far quicker than others.
Printing inks: The number of colour ink cartridges can have a bearing on the quality. Some models house all the colour inks in one cartridge, making it easy to change. Other printers have one cartridge per colour ink, offering the advantage that you only change the colour that has been depleted. For the best print quality, those using individual colour cartridges are the best choice.

SCANNERS

If you have any slides, negatives or prints that you would like to turn into digital files, then you will need to invest in a scanner. Film scanners are suitable for scanning transparencies or negatives but flatbed scanners represent a far better buy. Flatbeds are more affordable, and have the advantage of also being able to scan prints. Many models have film hoods to provide high-resolution scans from 35mm and medium-format film. Opt for an LED model, which provides cleaner scans and instant start-up times. The Epson Perfection and Canon CanoScan models are among the best-value models.

IMAGE MANIPULATION
SOFTWARE FOR PHOTOGRAPHERS

Digital photographers often spend as much, if not more, time in front of the computer as they do behind the camera, so using the most appropriate imaging software is important. The most popular software packages are highlighted here.

ADOBE PHOTOSHOP CREATIVE SUITE

Now in its sixth version (CS6), Photoshop is the ultimate in image-manipulation software, offering endless possibilities for the photographer. Photoshop CS6 is available as a standalone or as part of a larger Adobe Creative Suite package. An incredibly potent editing package in its own right, its versatility can be further bolstered by adding third-party plug-ins, which offer additional tools and functionality.

ADOBE PHOTOSHOP ELEMENTS

As desirable as Photoshop Creative Suite is, it is also an expensive package. Adobe also offers the more affordable Photoshop Elements, currently on version 10. While Elements may appear as a stripped-down version of the full package, it offers a feast of editing features, as well as a brilliant search facility and user-friendly features, including commands that allow images to be uploaded to social network sites like Facebook and Flikr with ease.

Which Photoshop is best for you?

The massive difference in price between the Creative Suite and Elements packages suggests the cheaper package offers a limited range of features but nothing could be further from the truth. The latest version of Elements boasts an extensive range of editing features that will keep all but the most demanding photographers and retouchers happy. Unless you have professional aspirations, Elements is the better choice.

ADOBE LIGHTROOM

This package originally started as a workflow package aimed at professional photographers for organizing large numbers of images. However it has expanded its functionality to now offer a powerful range of editing facilities too, which has made it incredibly popular with photographers from enthusiast-level through to pro.

PHASE ONE CAPTURE ONE (PRO/EXPRESS)

Raw converters are software packages designed to convert Raw files to TIFFs or JPEGs. Your camera will be provided with its own appropriate package and Photoshop offers its own highly capable Raw converter too. However, in terms of reputation, Capture One is regarded by many as the best in the business. It is available in both full 'Pro' or stripped-down 'Express' versions, with both offering excellent Raw conversion and image editing options. A trial version can be downloaded at: www.phaseone.com

High Dynamic Range photography software
Photomatix Pro 4

PHOTOMATIX

Producing images that exhibit High Dynamic Range (HDR) processing to reveal highlight and shadow detail in high-contrast scenes is easy using Photomatix. Available in two versions – Pro and Essentials – this is one of the easiest and best HDR packages available.

APPLE APERTURE

This innovative package (now on version 3) offers a range of features that while aimed at pros, offers much for advanced amateurs too. It supplies an arsenal of powerful image-editing features, excellent browser, library and geotagging options. It is very popular with professional photographers, but is only available for Apple Macintosh computers, so is of no use if you own a PC.

COREL PAINT SHOP PRO X4

An alternative to Adobe Photoshop Elements, boasting a very wide range of editing features, as well as workflow and organizational tools. Choose the standard version or opt for the Pro package that includes extras including Nik Software plug-ins.

SOFTWARE SUITES

A number of software companies produces suites, which are essentially collections of their best-selling software that offer better value than buying individual packages. There are two in particular that are highly recommended as they feature several excellent options.

Nik Software Complete Collection

A brilliant package for creative photographers, Silver Efex Pro is arguably the best software package available for producing black-and-white images, while HDR Efex Pro produces excellent HDR results. Color Efex Pro 3.0 offers 52 photographic filters with over 250 effects, while Dfine 2.0 and Sharpener Pro 3.0 enhance image quality by improving noise and sharpness respectively. Viveza 2 is a specialist package allowing you to control light and colour in your photographs.

onOne Software Perfect Photo Suite 6

This excellent package features no less than seven different software options. Perfect Portrait 1 is a powerful retouching too; Perfect Effects 3 allows you to apply countless effects to images; Perfect Mask lets you replace backgrounds with ease; FocalPoint 2 lets you mimic depth-of-field effects while PhotoFrame 4.6 Pro applies textures, frames and borders. You can also boost file sizes with minimal loss in quality using Perfect Resize 7 or create Layers outside Photoshop using Perfect Layers 2.

PHOTOSHOP TOOLS AND COMMANDS

Adobe Photoshop is the ultimate in image-manipulation software, and it offers countless ways to manipulate and enhance images. Here a few of the most commonly used tools and commands are covered.

TOOLBOX

The Toolbox allows you quickly to select the tools to manipulate and alter your images. Many are used in conjunction with other commands, and each has a set of options for customizing their function.

MARQUEE SELECTION TOOL

Use this to create a selection around a particular area of an image. Choose between Rectangular, Elliptical or Single Row/Single Column selection tools.

LASSO SELECTION TOOL

The Lasso Tool is used to draw a selection around an outline. As well as the standard freehand Lasso Tool, you can also select the Polygonal Lasso Tool, which draws straight-line and freehand selections, and the Magnetic Lasso Tool, which uses contrast differences to help align the selection outline with the edge of objects.

CROP TOOL

Use this to draw a rectangle around part of an image to crop off the unwanted area. If you want to crop to a particular ratio, for example 6x6 or 10x8, you can type these measurements into the width and height settings. Hold the Shift button down to draw a square.

CLONE STAMP TOOL

Possibly one of the most frequently used tools, the Clone Stamp Tool allows you to remove unwanted elements in images, such as dust spots. It works by sampling an area of the frame and pasting its characteristics over another area.

MAGIC WAND TOOL

This is a selection tool that selects pixels based on their luminosity (colour, brightness and tones).

ZOOM TOOL

Use this tool to adjust the magnification of the image on your screen.

ERASER TOOL

As its name implies, the Eraser Tool is used to remove unwanted pixels. It is particularly useful when working with images with two or more layers, as it allows elements of one layer to be visible through another.

HEALING BRUSH TOOL

This works in a similar way to the Clone Stamp Tool but blends pixels from the sampled and target areas. This is a very popular tool for cleaning up skin imperfections and wrinkles.

LEVELS

Found under *Image > Adjustment*, Levels is perhaps the most widely used adjustment tool. Once selected, it provides a histogram of the image and allows you to adjust the tonal range and contrast. The usual tip is to move the left and right points in slightly to the edge of the histogram. If you require more intricate control, select Curves instead (*Image > Adjustment > Curves*).

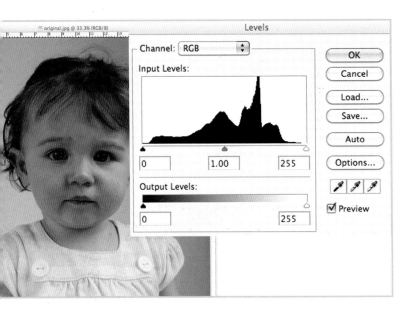

ORIGINAL HISTOGRAM

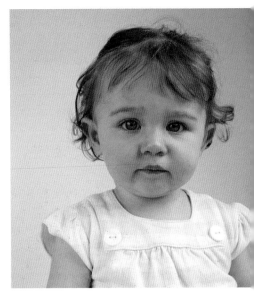

BEFORE

ADJUSTED HISTOGRAM

AFTER

SHARPENING

Digital images require a small level of sharpening before printing. In all versions of Photoshop up to and including Photoshop CS5, the recommended sharpening tool is Unsharp Mark, which offers the user excellent control. There are three sliders under Unsharp Mask: Amount, Radius and Threshold. Amount sets the strength of the sharpening effect – use 50–100 per cent for low-resolution images and between 150 and 200 per cent for high-resolution photos. Radius determines how many pixels around the edges are sharpened, with a low number limiting sharpening to the edges. Too high a value results in over-sharpening and noticeable halo effects. Set 1 for low-resolution images and between 1 and 2 for high-resolution images. Threshold controls which pixels will be sharpened based on differences in brightness. At low values, all pixels are sharpened, while increasing the

value limits how many receive sharpening. Setting the Threshold between 5 and 10 is a good starting point for general images. For portraits and other images that have a large amount of even tones, set between 8 and 10.

CS2 introduced a new sharpening tool, the Smart Sharpen filter. This improves on Unsharp Mask by adding a few extra controls for shadow and highlight sharpening, and improves sharpness for images softened by camera shake. However, it's more involved to use, but well worth learning.

If you have CS5, then it's worth trying out the Sharpen Tool, found on the toolbar. While it performed poorly on versions 1–4 of Photoshop CS, the Sharpen Tool in CS5 is excellent and the fastest, easiest method to use.

TOP TIP
Applying too much sharpening will degrade the image. Telltale signs are halos appearing around the subject, obvious colour/tonal changes and artefacts appearing on the image. Ensure you sharpen with care to avoid these problems.

UNSHARP MASK WINDOW

BEFORE

UNSHARP MASK ADJUSTMENT

AFTER

FEATHER

This command (*Select > Modify > Feather*) is used with selections to blur the edge of an effect by setting a pixel amount. This tool is easily explained by comparing the images shown here when the area around a subject is being darkened. A feather of 1 pixel gives a hard edge, whereas a high feather amount (200 pixels) gives a smooth edge.

ADJUSTMENT LAYERS

When you first open an image, all the information is in one layer. Although you can manipulate the image in this form, creating new layers allows for far more creative manipulations. There are several types of layers; explaining what they are and how they work would take a book in itself, but one type of layer you should get to using is the Adjustment Layer. Creating an Adjustment Layer allows you to make changes to this layer, so that if you're not happy with the results, you're able to delete it and still have the unaltered image. It can be selected via the menu at *Layer > New Adjustment Layer* or by clicking on the half black/half white icon at the bottom of the Layers palette.

TRANSFORM

Found in the Edit drop-down menu, in CS and the Image menu in Elements, this command allows you to rotate an image, as well as alter its scale and perspective. You have a choice of selecting the Free Transform Tool or choosing from options in the Transform sub-menu. The latter is the better choice as using Free Transform can be difficult if you're inexperienced.

A popular use for the Transform command is to correct converging verticals in buildings caused by having the camera tilted backwards. This problem is very easy to rectify. With the image open, select *Edit > Transform > Perspective* and you'll see guides appear around the image. Pull the guide on either side outwards and you'll see the image shape change and the building straighten up. You can make this process more accurate by selecting *View > Rulers* and dragging guides from the ruler over subjects that should be straight. Now, when straightening the image, you have a reference to ensure perfect verticals.

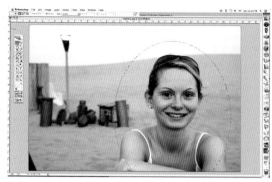

FEATHERING AREA SELECTED

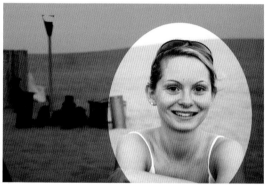

LOW FEATHER AMOUNT

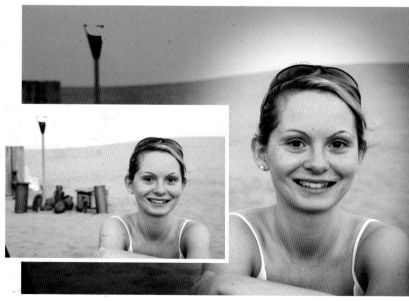

ORIGINAL IMAGE FINAL IMAGE WITH HIGH FEATHER AMOUNT

PHOTOSHOP STEP-BY-STEP TECHNIQUES

Having highlighted some of the most commonly used tools and commands, presented now are some popular Photoshop techniques that will allow you to practise your skills.

CONVERT COLOUR TO BLACK AND WHITE

There are various ways of converting a colour image to black and white in Photoshop. Desaturate and Grayscale are popular choices with novices but the two best methods are using Adjustment Layers, which while involved, will allow you to produce far better mono images. Here are the basics of these different methods.

ORIGINAL DESATURATE GRAYSCALE

Desaturate

Select *Image > Adjust > Desaturate* to convert your colour image instantly into black and white. While fast, this process leads to muddy greys and images that lack contrast and depth, so it's not a recommended choice.

Grayscale

Using *Image > Mode > Grayscale* also instantly converts your image into black and white but gives a far better result. If you're a novice, or looking for a fast method for giving decent mono results, this is a good choice. Use Levels to fine-tune the result.

Black & White Adjustment Layer

Select *Layer > New Adjustment Layer > Black & White* to convert your image to black and white and be presented with a set of sliders that can be used to alter results. This is one of the easiest methods and delivers excellent mono images. You can try using the Auto button as it usually gives good results, or adjust the sliders to boost the tones of individual colours within the scene.

Channel Mixer Adjustment Layer

Select *Layer > New Adjustment Layer > Channel Mixer* and as well as your image being converted to mono, you're presented with a set of sliders. Adjusting these changes tones in the image similar to using red, green and blue filters on the camera. You can adjust the sliders how you like but should aim to ensure the combined total of the percentages adds up to 100 per cent. It's the most involved method but potentially yields the best results.

ISOLATING COLOUR

An effective technique in black-and-white photography is to reintroduce selective areas of colour back into the monochrome image. For this method to work, convert the image to monochrome using one of the Adjustment Layer methods explained earlier, then use the following method.

1 Convert the colour image to monochrome by selecting *Layer > New Adjustment Layer > Black & White*.

2 Choose the Eraser Tool from the Toolbar. To start with, select a large brush size (between 250 and 400 pixels). Click areas where you'd like to reveal colour.

3 Start removing colour from large areas first, being careful not to get close to edges where you don't want the colour to appear. Switch to a smaller brush size for edges.

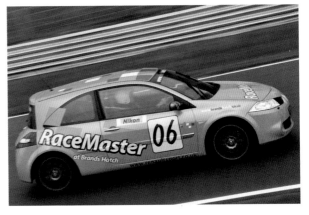

4 The final image now has the bright gold car set against a monochrome backdrop.

TOP TIP

If you accidentally reveal colour where you didn't want it, don't worry. On the Toolbar, make black the foreground colour and you can use the eraser to clean up colour areas and make them mono again. Switch back to white to allow the eraser to reveal colour again.

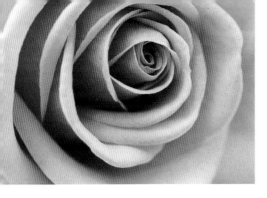

REPLACING COLOURS

It is possible to change a subject's colour with another relatively easily in Photoshop. There are various tools under the *Image > Adjustments* menu, that can be used to change colours, including Hue/Saturation, Color Balance, and Replace Color. This example uses Channel Mixer.

1 Open a Channel Mixer Adjustment Layer via the Adjustment Layer icon at the bottom of the Layers window, or by selecting *Layer > New Adjustment Layer > Channel Mixer.*

2 The Channel Mixer panel opens, with the key controls you'll want to use being the Output Channel tab and the Red, Green and Blue sliders.

3 Select the Green Channel and reduce the amount from 100% to zero.

4 Now choose the Blue Channel and change the amount from 100% to zero.

5 The rose is now red but the tones are too strong. So reduce the Red slightly and raise the Green and Blue saturation sliders to increase detail.

6 You can now fine-tune the contrast by adjusting Levels. Select this via *Layer > New Adjustment Layer > Levels.*

7 Adjust the highlight, midtone and shadow pointers to suit your tastes and click OK. You now have a beautiful red rose.

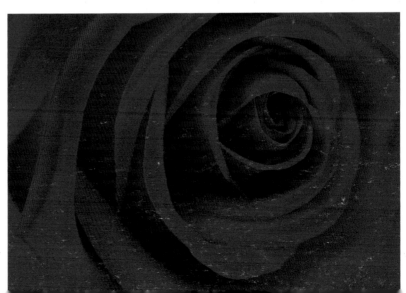

ADDING A LINE
BORDER AND TITLE

A popular and easy technique when printing an image is to add a line border and some text. It's a simple technique that allows you to transform a standard photograph into a work of art that can be printed, framed and hung in the home or given as a personalized gift.

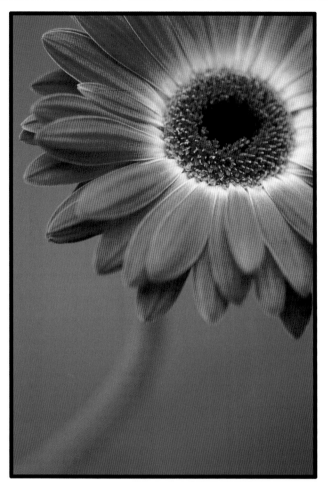

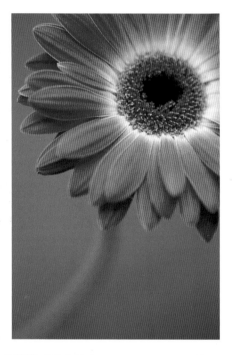

Gerbera 2012

1 The first step is to open up the image in Photoshop and select *Image > Canvas Size*, in preparation of adding the border.

2 By increasing the canvas size, you can create an area around the main image. Decide how large an area you require. The current size is displayed in the window.

TOP TIP

If you decide you'd like to change the colour of the main or stroke (thin line) border, there is a relatively easy way to do this. To change the main border, select the Magic Wand Tool, then click on the Foreground Color box and select a colour. Now select the Paint Bucket Tool and click on the border to change its colour. Repeat step 6 to change the colour of the stroke border.

3 For this image, 5cm (2in) was added to the width and 10cm (4in) to the height to add a white border. The extra depth to the height is to allow text to be added later.

4 Before clicking OK, ensure the Relative box is ticked. Also, click on the Canvas extension color to determine the colour of the border. In this instance white.

5 To add a line border, select the Magic Wand and click it in an area of white. 'Marching ants' appear around the edge of the image and the picture area. Go to *Select > Inverse* so the marching ants now surround only the image. This indicates where the line border will appear.

6 Go to *Edit > Stroke*. Here, you can set the thickness of the line border, its colour and whether it appears inside, outside or centred on the picture's edge. A black border, 20 pixels thick and centred on the edge was used here.

7 To add text click the 'T' text tool in the Toolbar and click the cursor on the white area. You can then type the title, choose the font and size and move it around to your preferred location. Click on Center Text to centralize it in the text box.

MOTION BLUR

Motion blur allows you to add the appearance of movement to a subject that is stationary or moving very slowly. It involves isolating the subject from its environment so that you can then blur the backdrop to give the sense of movement.

1 Use the Polygonal Lasso to surround the outline of the car, then apply a light feather (of around 5 pixels) to this selection. Place the selection in its own layer; choose *Edit > Copy*, then *Edit > Paste*.

2 Select the background layer and choose *Filter > Blur > Motion Blur* and play with the pixel scale to increase/decrease the amount of blur. In this instance, 100 pixels was used and the angle was left at 0.

3 The background is nicely blurred, but the wheels also require movement. Click on Layer 1, which contains the cut-out car. For each wheel, use the Polygonal Lasso Tool, apply a feather of 5 pixels, and go to *Filter > Blur > Radial Blur*. Choose a pixel amount (20 in this case) and apply this to give the wheels the impression of movement. Repeat for the rear wheel, but apply slightly less blur (15 in this case), as it is further away.

4 The motion effect is complete, but to tidy up the image, use the Clone Tool on the background layer to remove the halo effect around the car.

FLOOD PLUG-IN

A plug-in is an additional piece of software that you can buy to increase the capability of an application. The Flood plug-in from Flaming Pear is very popular with photographers and a great way of adding bodies of water to your images. It is available from www.flamingpear.com at a very reasonable cost. Here, an ordinary image of a tree silhouette against a sunset is transformed using the Flood plug-in.

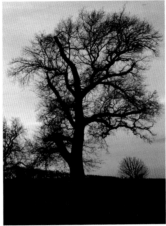

1 Once you have installed the plug-in, open Photoshop and select Flood from the Filter menu.

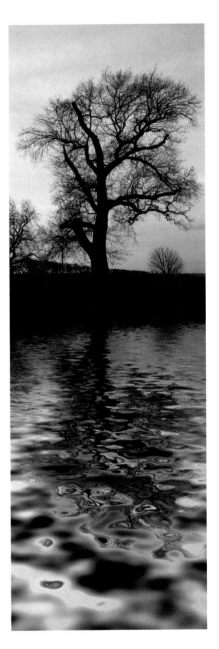

Plug-ins are downloaded from a website and easily installed. Most, including those from Flaming Pear, allow a trial period, so you can install it and try it out for free for 30 days before deciding whether or not you want to purchase it.

2 A window with various options and a preview window appear. You can raise or lower the flood level and adjust the water to give the desired effect.

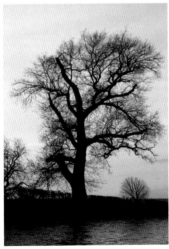

3 The horizon has been lowered and the water made a little choppy by increasing the Waviness and Complexity parameters.

4 This is the finished image, complete with Flood. The watery foreground is far better than the original version.

5 You can easily create a panoramic image by extending the height of the image. Select *Image > Canvas Size* and then double the height of the image (the lower half appears as blank white space). Then, when you open the image in Flood, you need to increase the foreground to make full use of the flood effect.

IN-CAMERA SPECIAL EFFECTS

Like them or loathe them, special effects are here to stay. In fact, with image-manipulation software so readily available, special effects have never been so popular. This section looks at what special effects are available to the photographer using the camera, as opposed to the image manipulator on their computer.

MULTIPLE EXPOSURES

Many cameras offer a multiple-exposure facility, which allows you to shoot more than one exposure on the same frame by superimposing two or more images. Many cameras, can shoot up to 999 exposures on one frame, although it is doubtful that you would require any more than two exposures on a single frame.

Multiple exposures offer endless possibilities, especially if you use a camera with interchangeable lenses. For example, you could use a telephoto to capture a magnified image of the moon, then superimpose this with a wide-angle shot of a landscape. Alternatively, you could photograph someone on one side of the frame, then capture them again on the other side.

While the camera takes care of compensating the exposure, you are free to concentrate on working out how to compose the elements in each exposure to give the best results. With some cameras, you need to shoot the different exposures one after the other, with others you select two images on your memory card to merge together, which is a far better option. Check the instructions to see which system your camera uses.

Multiple exposures may be easy to do in-camera, but facilities such as Layers in Photoshop make them simpler to achieve using image-manipulation techniques.

CROSS-POLARIZATION

Some beautiful effects are usually hidden from the human eye but become visible when a simple technique is applied. In the case of cross-polarization, using polarizing material (such as filters) reveals the stress patterns inherent in plastic objects.

To try out this technique, you need a camera, a polarizing filter, a sheet of polarizing gel (available from major camera dealers) and a lightbox. Place the polarizing gel on the lightbox and carefully arrange the plastic objects on it. Attach a polarizing filter to the lens, set the camera on a tripod and compose the frame so that the objects are positioned where you would like them to be. Switch the lightbox on and the room lights off, then look through the viewfinder and rotate the polarizer until you achieve the desired effect.

Suitable objects include CD cases, school geometry sets and anything else made of clear plastic. Because of the relatively small size, a lens with a decent close focus, such as a macro lens, is recommended for this technique.

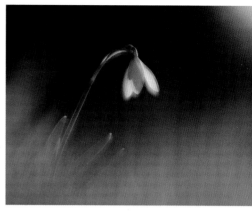

SNOWDROP
Shooting a multiple exposure that combines a sharply focused frame with one that is out of focus produces this beautiful effect.

CUTLERY
Placing cutlery on a polarizing sheet on a lightbox and fitting a polarizing filter in the lense creates this multicoloured result.

TREES
Try zoom burst to take unusual images of everyday subjects. This shot was taken by zooming the lens while photographing a tree.

ZOOM BURST

Dramatic images are possible by zooming the lens during an exposure. This is only possible with SLRs, as compacts do not allow their zooms to change focal length during an exposure.

The basic technique is relatively easy to learn. First set the camera to a relatively long exposure that will allow you enough time to zoom from one extreme of the range to the other – an exposure of around $1/30$ sec is a good place to start – then try longer exposures to vary the results. A tripod or some other form of camera support is recommended to keep the camera steady and free up your hands, so that your zoom movement is as smooth as possible.

Standard zooms of 18–70mm are a good choice, as they offer a decent range from wide-angle to short telephoto. Try a zoom burst from one end of the range to the other, and then work in the opposite direction – the results are very different.

Look for nice colourful subjects, but don't choose a scene that is too busy, especially when you start. Static subjects, such as buildings, signs and flowers are good choices.

PICTURE STYLES

The easiest way to alter the characteristics of an image is to change its Picture Style (also know as Picture Setting or Creative Style). These settings vary the sharpness, colour tone, contrast and saturation and allow you to vary how images are recorded, from exhibiting high contrast and strong colours to muted, subtle tones. The normal default mode is Standard, which provides accurate colours, but you can change this setting to suit certain subjects. The most common Picture Styles found on the majority of cameras include Portrait, Landscape and Vivid, but many models boast more unusual options, so see what's available on your camera.

ART FILTERS

Virtually every camera now boasts a set of art filters, also known as Smart Filters or Art Effects, which can be used to capture images with a certain special effect. Depending on the camera you use, these filters can also be applied to existing images that were captured without effects. There is an incredible array of options, ranging from interesting to bizarre. One of the most popular is Miniaturization, which allows you to make scenes look like small-scale models and Toy Camera, which mimics the 'Lomo' camera effect. Other options include Fish-eye, Sketch, Old Film, High-Contrast Black & White Film and Magic Frames.

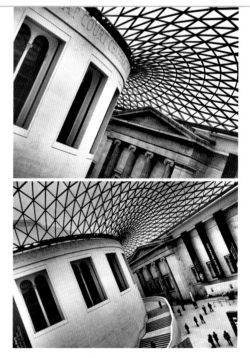

ART FILTERS
The Olympus Dynamic Tone art filter produces very high contrast results.

BASIC TECHNIQUES

COMPOSITION

Knowing where to place different elements in a scene is one of the fundamental aspects of photography, and should be grasped at the earliest opportunity. Successful photography comes from successful composition – the sooner you learn the basics of this essential skill, the quicker your images will begin to show balance and shape.

You often hear photographers talk about how they can 'see' a scene, or 'picture' an image. When doing so, they are usually referring to how they would arrange the various elements within a scene; in other words, how they would compose it. Learning the fundamentals of composition should be one of the first lessons you master.

FUNDAMENTALS OF COMPOSITION

Creating a photographic composition is all about working out where the various elements fit into a scene to create the most pleasing result. The following aspects are key to taking successful pictures.

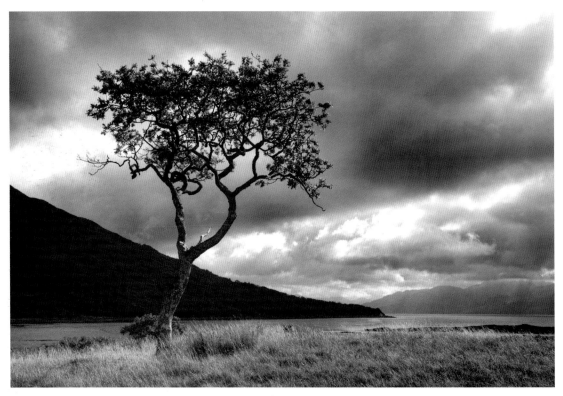

SOLITARY TREE
Although simple in nature, this image demonstrates the use of several compositional rules, including the rule of thirds and lead-in lines.

Focal point

For a picture to work, it usually requires a focal point – a place that the eye is naturally drawn to and an object that adds scale to the overall scene.

For example, take a landscape with a solitary castle in view. Without the castle, the eye would wander around the scene and be unable to settle on any single element. Not only that, it would be difficult to determine the scale of the landscape – are you looking at a small cross-section of land here, or at a sweeping vista?

A focal point helps to brings order and sense to an image, so be sure to include at least one in the frame.

Rule of thirds

This is the perhaps the most important rule of composition. The rule of thirds (also known as the golden section) can be applied to all photographic subjects, although it is used in particular for landscape photography. The rule of thirds should be used regardless of the focal length of the lens that you are using or whether you are holding the camera in an upright or landscape format.

The rule of thirds was originally developed by painters, who would mentally grid a canvas to help achieve balance in their paintings. It is a very easy compositional aid to learn and should be the first thing that springs to mind when you are composing an image.

When you look through the viewfinder or use the LCD monitor, imagine that the scene is split into thirds – in other words, that there are two horizontal and two vertical lines intersecting the frame to create nine equal-sized rectangles. Ensure that the focal point is placed at any of the four points where the lines cross each other for the maximum visual harmony in the scene. Use either the upper or lower line as a guide for where to place the horizon, so that it sits along the lower or upper third of the image. Many cameras allow framelines to be activated on the LCD monitor and/or viewfinder to aid composition.

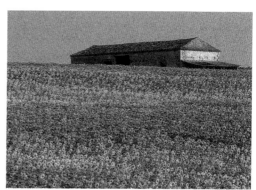

SUNFLOWER FIELD
The merits of using the rule of thirds are perfectly illustrated in this striking landscape image.

Framing the scene

You will often find that you can add an interesting new element to a scene by finding a frame to set it within. This can often be a hole in a wall, a gap in some trees, or an archway. The theory is that you naturally draw the eye of the viewer to look at the scene behind the frame.

If you are using a wide-angle lens, it is best to get close to the frame, otherwise the scene in the distance will be too small to recognize any detail. Using a telephoto lens means you have to stand further back and also results in making the background appear much closer to the scene than it really is.

DISTANT SUBJECT
Using a foreground subject to frame the main point of focus in the distance adds visual interest and depth to the scene.

TAKE A NEW SLANT

Although it is normal to keep the horizon completely level, adding a slight slant to an image can work wonders. Although this isn't a technique to try with subjects such as landscapes, there are times when doing this can add real dynamism to a scene.

Try photographing a car driving along a road normally, then tilt the camera at a slight angle and shoot the scene again. All of a sudden, the picture has far more impact and the car seems to be travelling much faster.

Another interesting area to try pictures with a slant is portraits. Shot at an angle, portraits can take on added dynamism.

TOWERS AT A TILT
Buildings are a good subject to shoot at a slant. Use a wide-angle lens to emphasize scale and shoot against an interesting sky, or use a telephoto lens to reveal interesting architectural details.

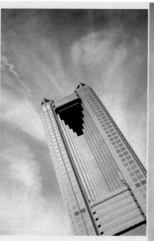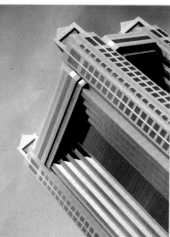

Foreground interest

Another important aspect of composition is the foreground interest – in other words, what you include at the front of the scene. Although it is not essential to include anything in the foreground, you will find that doing so helps to add balance and scale to the scene, as well as helping to lead the eye into the frame.

Including some foreground interest also gives your photographs a sense of depth and distance, especially if you angle the camera down, adopt a lower viewpoint and use a wide-angle lens to stretch perspective and make the foreground more imposing. A 28mm lens is adequate, while using even wider focal lengths will give still more emphasis to foreground subjects.

You can use any subject to provide foreground interest. For example, in landscape photography, rocks along a coastline, a wall or fence leading into the scene or even an interesting pattern on the ground, such as ripples of sand or a limestone pavement, all have potential.

Always bear the foreground in mind, as no matter how stunning the scene in the distance may be, a boring, monotonous foreground can ruin the final result.

Perspective

Although pictures are two-dimensional, our brain uses the elements in the scene to determine scale, distance and depth – in other words, the perspective. Using the correct lenses and learning to arrange the elements of a scene in a particular order can help you to create and control perspective.

For example, use a wide-angle lens to stretch perspective and make subjects in the foreground look far larger than those in the background. In a series of electricity pylons, the one closer to you looks far larger than those in the distance – this phenomenon is termed diminishing perspective and can be used to emphasize depth.

Shots taken with a telephoto lens can compress perspective, making subjects that are some distance apart look as if they are pressed up against one another.

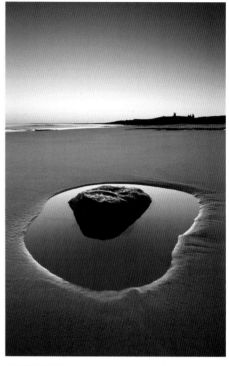

BEACH SCENE
The image is dominated by this rock pool, which acts as a natural starting point for the viewer's eye before it wanders through the frame

NAMIBIAN PANORAMA
The bold colours and simplicity of this scene, along with the very careful composition, are what makes this such a striking image.

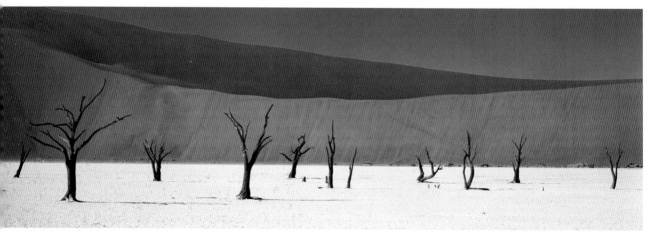

Using lead-in lines

Powerful compositions often have strong lines passing through them. Lines help lead the eye of a viewer through the scene and can also help divide the image into different components. Roads, rivers, walls and coastlines can create strong lines in an image, and their impact varies depending on the direction they take through a scene.

Horizontal lines help divide up a scene – the horizon is the most obvious example, but other examples include a road traversing the scene, or a fence separating two fields. Diagonal lines add a sense of depth to the image and help to lead the eye into the frame. The strongest diagonals tend to run from bottom left to upper right in the frame. Converging lines provide an extraordinary sense of depth to an image. Wide-angle lenses particularly emphasize converging lines, especially when used with subjects like roads or railway lines, which converge at the 'vanishing point' in the distance. Finally, vertical lines are used to highlight height and direction, especially when the camera is used in an upright position. Vertical lines work particularly well with architectural photography.

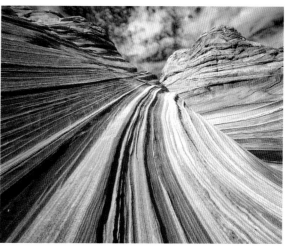

LEAD-IN LINES
The layers within this rock formation provide natural lead-in lines for this scene.

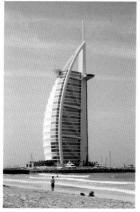

A sense of scale

Although not strictly a compositional rule, it is important to try to bring some scale to your images. Have you ever looked at a scene of something ambiguous, such as a waterfall, then noted a small figure of a person standing in the frame? The presence of the person suddenly brings around a clear understanding of the scale. Although not necessarily the most important element in the frame, something that sets the scale of the rest of the scene is useful to include.

LIGHTHOUSE
Placing the lighthouse centrally in the upper third frame does break the rules a little, but the image still has impact.

PROVIDING SCALE
Placing a person in the frame is an excellent way of providing scale to a subject in the scene. Here, adjusting the composition to include some figures in the foreground adds a sense of scale to the hotel in the backdrop.

BREAKING THE RULES

Of course, rules are made to be broken, as much in photography as in any other aspect of life. So, for example, in landscape photography, place the main subject directly in the centre of the frame rather than along a third and see if it works. Sometimes it will, sometimes it won't. With portraits, use a tight crop on the face so that you crop out one eye for an unusual composition.

Photographic rules are only ever a guideline to help you to develop your style and technique – never be afraid to experiment with any of them, including composition.

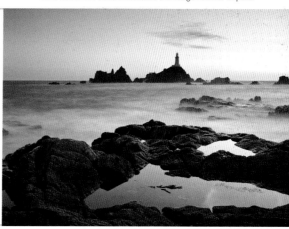

DEPTH OF FIELD

One of the fundamental techniques to master in photography is the control of depth of field. The amount of depth of field in a scene plays an important role in the final result – use it to render the background out of focus and make the main subject stand out, or have the whole scene appear sharp from front to back. It is important to understand how it works and how to control it, regardless of what type of camera you use.

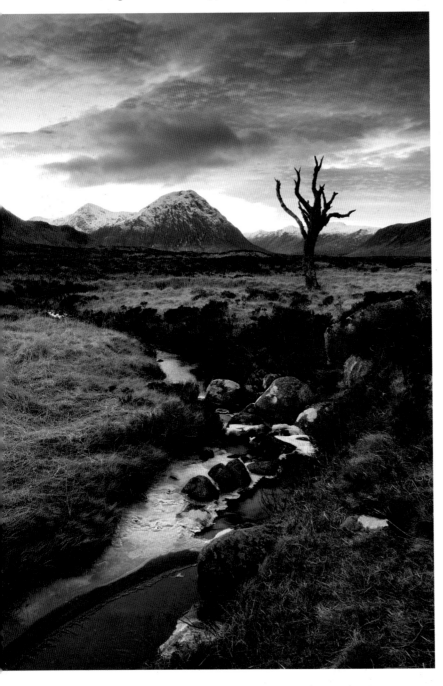

HILLTOP
Use a very small aperture to give front-to-back sharpness in your landscapes.

WHAT IS DEPTH OF FIELD?

Depth of field is the term used to describe the amount of a scene behind and in front of the focusing point that appears sharp in the image. A lens focuses at only one point, which is the sharpest area in the image. However, using depth of field, you can control the perceived zone of sharpness to suit the type of subject you are photographing.

There are three main factors that affect the extent of depth of field: the focal length of the lens, the choice of aperture, and the focusing distance. Each has its own effect on depth of field, so for maximum control, learn to use all three whenever appropriate.

Lens focal length

A wide-angle lens gives the perception of giving much greater depth of field at a given aperture than a telephoto lens. For example, a 28mm lens at f/8 seems to give more depth of field than a 300mm lens at f/8. Therefore, when using a zoom lens, consider how the choice of focal length will affect the perceived depth of field.

APERTURE SETTING

The choice of aperture is the greatest single factor in controlling depth of field. The general rule is that the wider the aperture, the less depth of field produced. For example, selecting f/3.5 will not give as much depth of field as choosing f/22.

BOY
The lens's widest aperture (f/3.5) was used to deliberately throw everything out of focus except the boy's face.

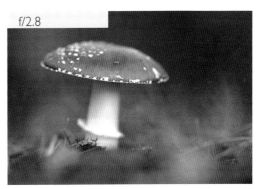
f/2.8

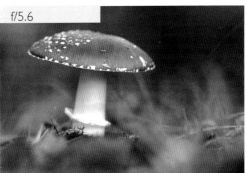
f/5.6

Focusing distance

The distance the lens is focused at is the final factor to consider. For any given lens, the depth of field increases the greater the focusing distance. In other words, the further the subject is from the camera, the more depth of field will be produced.

TOP TIP
Depth of field does not extend equally either side of the focused point. In most situations, it extends twice as far behind as in front. With very close distances, such as macro photography, however, depth of field on either side of the focusing point is more equal.

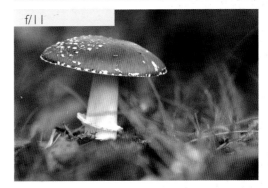
f/11

DEPTH-OF-FIELD PREVIEW

Many SLRs offer depth-of-field preview, also called the stop-down facility, which works by closing the aperture to whatever the current aperture setting is. This is a very useful facility, although some people find that the darkened viewfinder image – a result of the lens stopping down to the required aperture – can be hard to view the scene through.

SUNGLASSES
Selecting a wide aperture to provide shallow depth of field ensures the eye isn't distracted from the main subject by the sunglasses rack in the foreground.

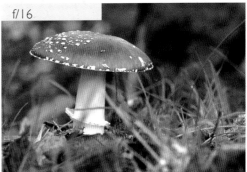
f/16

FUNGI
These images show how a progressively smaller aperture results in increasing depth of field, which ultimately results in the grass and undergrowth spoiling the image.

WHEN TO USE SHALLOW DEPTH OF FIELD

Using a very wide aperture has the effect of throwing most of the scene out of focus – only the distance focused on appears sharp. This is an excellent technique to highlight a particular element in the scene.

Portraits work well especially when a person is isolated from their surroundings and all attention is focused on them. A shallow depth of field is also useful when photographing animals in a zoo or other enclosed environment. The shallow depth of field created by using a wide aperture in this situation helps to remove the wiring or bars from view by blurring them until they are almost unrecognizable.

TOP TIP

If you are using a compact camera and have very limited control over depth of field, a simple way of improving your chances of achieving front-to-back sharpness is to use a wide-angle setting and focus a third of the way into the scene; if you are shooting a landscape, try focusing around 5m (16ft) into the frame.

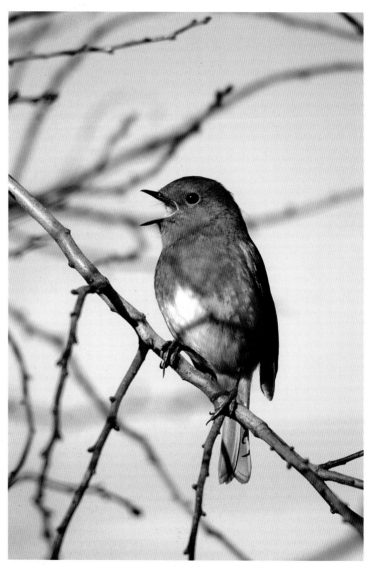

HOW TO CONTROL DEPTH OF FIELD

Minimize depth of field by:
- Selecting the widest aperture.
- Increasing the camera-to-subject distance and using the lens at the telephoto setting.

Maximize depth of field by:
- Selecting the smallest possible aperture.
- Using a wide-angle lens.
- Using hyperfocal focusing.

ROBIN
The bare branches behind this robin would be very distracting if sharply focused but using a wide aperture avoids this problem.

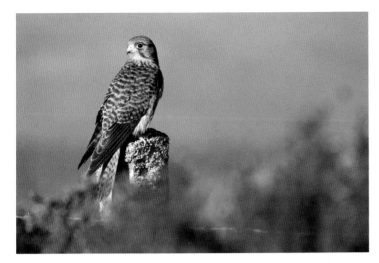

BIRD OF PREY
Don't be afraid to include foreground interest, even if you throw it out of focus, as it adds depth to the image.

WHEN TO MAXIMIZE DEPTH OF FIELD

The most obvious situation for having as much depth of field as possible is when you want to record as much of the scene in focus as possible. A stunning landscape is one example of this, when you want to keep all distances from the foreground to the distance in focus. In a similar way, using a wide-angle lens with a prominent subject close-up, along with a distinctive backdrop, also requires achieving as much depth of field as possible.

Macro photography, which presents its own set of problems, is a specialist area where depth of field is at a premium and using every technique possible to maximize it is required to keep as much of the subject in focus as possible.

HYPERFOCAL FOCUS

SLR users can use a technique known as hyperfocal focusing to provide even greater depth of field than simply using the smallest aperture. This technique is becoming less common, as fewer lenses feature the depth-of-field scale on the barrel that is needed for hyperfocal focusing. The technique involved focusing the lens to infinity, checking the scale to see what the nearest focus distance is that aligns with the aperture you are using – the hyperfocal distance. Set the focus to this hyperfocal distance and you maximize depth of field, which extends from half the hyperfocal distance to infinity. While lenses lack the scale, there are various apps for smartphones that can be used to calculate the hyperfocal distance, such as DOFMaster. A far simpler method used by many enthusiasts and pros is to focus one third of the way into the scene and set a small aperture.

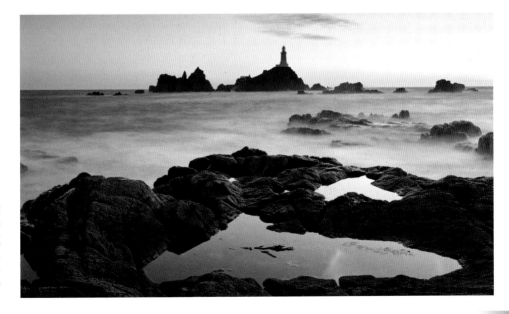

PIN-SHARP LANDSCAPE
Developing your focusing skills along with a strong understanding of apertures are key skills every dedicated landscape photographer should learn.

SHUTTER SPEED

Shutter speed plays a crucial role in the making of an image, working in combination with the lens aperture to give a correct exposure. They are also a vital element in creative photography, so knowing how they work and what effects they create is vital to getting the most from your photography.

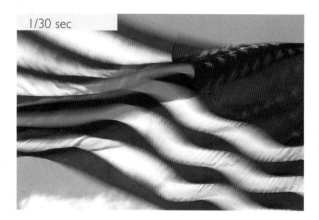

1/30 sec

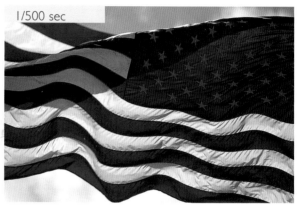

1/500 sec

Most cameras, with the exception of some budget models, offer a range of shutter speeds, from fractions of a second to several seconds or even minutes. These are set via a shutter speed dial or in shutter priority mode. Although their main purpose is to ensure a correct exposure, varying the shutter speed/aperture combination can affect how subjects in the actual exposure are recorded. This in particular applies to moving subjects – adjusting the length of the exposure time determines how motion is recorded.

SLOW SHUTTER SPEED
Lowering the shutter speed to blur a moving subject can work well. These examples show how dropping the shutter speed to $1/30$ sec gives a far more creative result than a 'straight' shot at $1/500$ sec.

Panning

Slow shutter speeds can be used in sports or wildlife photography to depict motion by blurring the background, a technique known as panning. To do this requires setting a relatively low speed, say $1/30$–$1/125$ sec, then following the moving subject through the viewfinder before and during the exposure, so that the subject appears sharp but the background is blurred. A steady hand and plenty of practice are both required.

GAZELLE IN FULL FLIGHT
Using a slow enough aperture blurs this beautiful beast's movement to give a strong sense of speed.

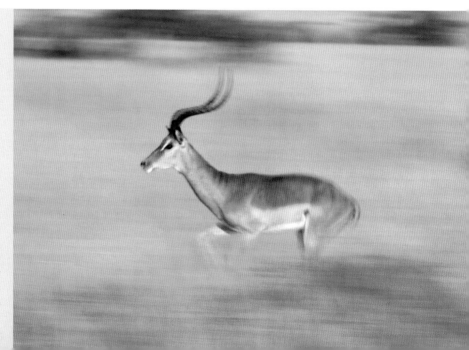

USING SLOW SHUTTER SPEEDS

The most common time to use a slow shutter speed is when the shooting situation dictates it; in other words, when light levels are low, such as indoors or outdoors at night. In these conditions you need to be aware that your biggest problem is camera shake, so:

1. Support your camera on a tripod or any steady surface.
2. Use a remote release rather than the shutter button, which can cause shake when you press it.
3. If you can't use a remote, set the self-timer instead.
4. If handholding the camera, use image stabilization.
5. Make sure you bracket exposures.

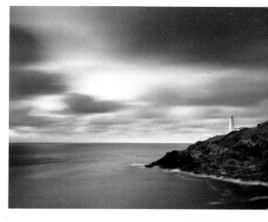

LIGHTHOUSE
A long exposure extending into several seconds blurs the motion of the clouds and water to good effect.

You can use slow shutter speeds in bright conditions. When photographing fast-moving water such as streams, rivers, waves and waterfalls with a typical daylight shutter speed, such as $\frac{1}{125}$ sec or $\frac{1}{250}$ sec, the water will appear dull and still. Drop the shutter speed to $\frac{1}{30}$ sec or lower, and the extra time means that the movement is blurred, adding a real dynamism. Stop down even further so that you are shooting in seconds, and you can blur the movement so that the water takes on an ethereal appearance.

Using slow shutter speeds to record the movement of people is another interesting technique. Set up your camera where there are large groups of people, such as at a railway station, and the motion of people will be captured as a blur, while any static subjects around them are recorded normally. Set a mid-aperture like f/8 and try a range of shutter speeds from $\frac{1}{30}$ sec down to 1 sec.

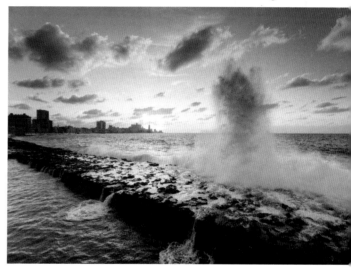

CRASHING WAVES
Using a fast shutter speed has frozen the water in mid-air as it crashes into the rocks to help emphasize the ocean's power.

USING FAST SHUTTER SPEEDS

Selecting a fast shutter speed freezes the motion of a moving subject. This applies particularly to sports and action photography, when you may well want to capture moving subjects in sharp detail, but it can also be used for other subjects, such as water.

Although many cameras boast extremely high shutter speeds of up to $\frac{1}{8000}$ sec, you will find their use very specialized – in fact, $\frac{1}{2000}$ sec or $\frac{1}{4000}$ sec is good enough for most situations.

The shutter speed required to freeze moving subjects varies not only according to the speed, but also according to the direction of travel.

One thing to bear in mind is that fast shutter speeds usually mean the aperture will be very wide, so the depth of field will be very shallow. This has the benefit of making the main subject stand out from the background, but also means that you must take care with focusing.

To increase the maximum possible shutter speed, as well as using a wider aperture, you can also increase the ISO rating.

TOP TIP
Can't reduce the shutter speed to what you need because it's too bright? Then reduce your digital camera's ISO rating to its lowest setting. Still not slow enough? Fit a neutral density filter, which will not affect the colours but will reduce the exposure time.

EQUIPMENT TECHNIQUES

FILTER TECHNIQUES

Learning when and where to use a particular filter can transform your photography and breathe new life into your images. Getting the most from your filters isn't a case of just slipping one in front of your lens — like any piece of equipment, each serves its own purpose and works best in specific situations.

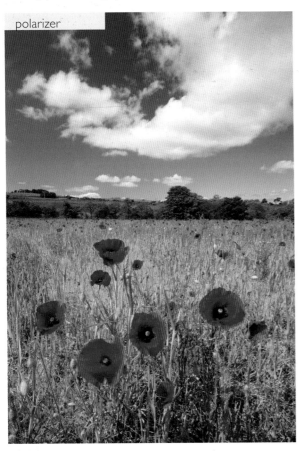

polarizer

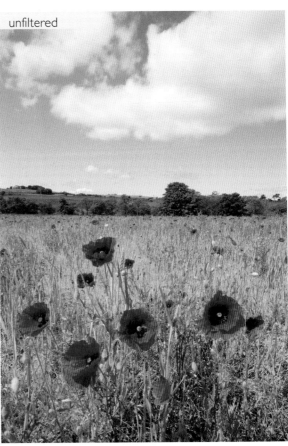

unfiltered

POPPIES
This comparison clearly illustrates the colour saturation provided by a polarizing filter.

POLARIZING FILTERS

The polarizer is without doubt the most useful filter that a photographer can own. Its main use is for landscape photography. The main effect of using a polarizer is to increase saturation, best shown in landscape images by lush greens and deep blue skies. Polarizers also help reduce glare and reflections on shiny surfaces such as water and glass.

There are two types of polarizer: linear and circular. They look identical, but work in different ways. Always use the circular type, as linear polarizers can affect the camera's metering system and are not designed for use with digital cameras.

A polarizing filter is basically two pieces of glass with a polarizing foil sandwiched in the middle. The polarizer works by blocking particular wavelengths of light, so that only certain wavelengths pass through. This is achieved by turning a ring on the polarizing filter, which rotates the foil and changes the extent of polarization.

You can see the effect by looking through the filter and rotating the ring. This is useful if you use high-end compacts, as you can work out where to align the front ring before attaching the filter to the lens. With DSLRs and CSCs, rotate the ring with the filter attached and judge the effect through the viewfinder or LCD monitor. Bear in mind that the fronts of many lenses rotate when they focus, so don't rotate the ring until after you have focused the lens.

For the best results, keep the sun at 90 degrees to the camera to achieve the deepest blue sky. Be careful when using a polarizer with wide-angle lenses, as you can record uneven tones in the sky, with one area much lighter than the others.

Another benefit of a polarizer is reducing glare and reflections, making it ideal for photographing water or architecture. Bear in mind that other subjects, such as foliage, can also suffer from glare, so it is worth trying out a polarizer in various shooting situations to see what benefits it can bring.

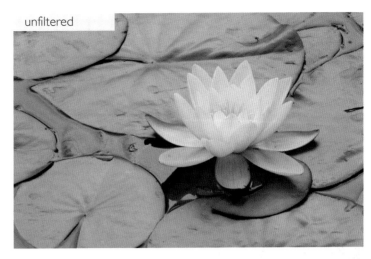
unfiltered

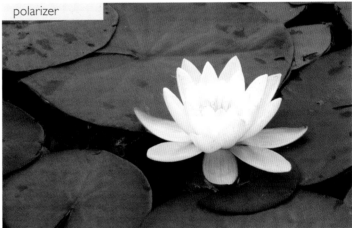
polarizer

LILY PAD
Polarizers are very effective at removing surface reflections off surfaces such as water or glass, so keep one in your gadget bag.

FILTER FACTORS

Most filters reduce the amount of light entering the lens by a particular amount, known as the filter factor. With cameras using TTL metering, this is taken account of automatically; however, with compacts, rangefinders and other cameras using non-TTL metering, you must adjust the exposure accordingly using the exposure compensation facility. The table here indicates the filter factor of the more popular filters, as well as the amount of exposure compensation required.

Filter	Filter factor	Required exposure compensation
Diffuser	×1	None
81A, B, C	×1.3	+$\frac{1}{3}$ stop
81D, E, F	×1.6	+$\frac{2}{3}$ stop
ND 0.3	×2	+1 stop
Blue 80C	×2	+1 stop
Yellow	×2	+1 stop
Polarizer	×4	+2 stops
Blue 80A	×4	+2 stops
Orange	×4	+2 stops
ND 0.6	×4	+2 stops
Green	×6	+$2\frac{1}{2}$ stops
Red	×8	+3 stops
ND 0.9	×8	+3 stops

A polarizer can also be used to create a special effect known as cross-polarization. See In-camera special effects.

GRADUATED FILTERS

A major problem faced by landscape photographers is keeping detail in the sky when exposing for the foreground. Graduated filters take care of this problem, darkening the sky while at the same time leaving the ground unaffected. There are two main types of graduated filter: the neutral density graduate (ND grad) and the colour graduate.

The ND grad is the most popular choice and allows you to darken the sky without affecting its colour. ND grads come in different densities, with 0.3, 0.6 and 0.9 being the most common. These reduce light by 1, 2 and 3 stops respectively, and can be used in combination if required. You must take care when aligning the graduate so that the darkened area matches the horizon. This is relatively easy for SLR users, but users of compact or rangefinder cameras have to take an educated guess.

Colour grads work in much the same way, but add a strong colour cast to the sky. The result can look stunning, but care must be taken not to make the scene look too unnatural. Colour graduates are usually used at sunset or at dusk, with mauve, tobacco and orange being some of the most popular colours.

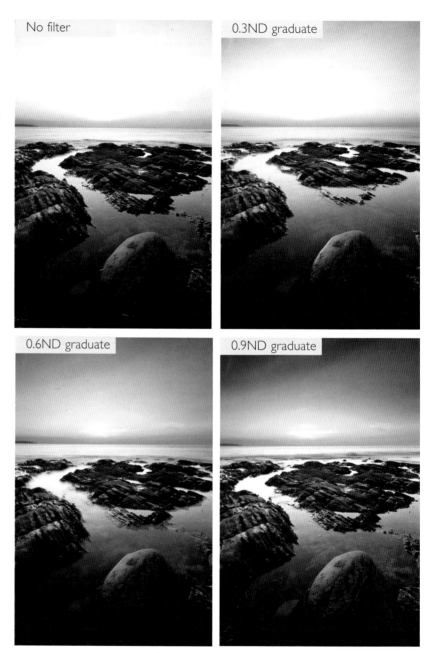

ND GRADUATE FILTERS
Washed out skies are a thing of the past if you use a ND graduate filter. This comparison set shows how the various densities darken the sky to reveal more detail and colours.

NEUTRAL DENSITY FILTERS

These filters do not affect the colour balance in any way – their sole purpose is to reduce the amount of light allowed to pass through the filter into the lens. Neutral density (ND) filters are not something you will need very often, but are worth considering if you want to take long exposures in daylight, most often when you want to record motion. Outdoor photographers use an ND filter when they photograph water, in particular rivers, streams and waterfalls, as it allows shutter speeds to be slowed down enough to record the water's movement as a blur.

ND filters come in a variety of densities, ranging from 0.1 to 4, with 0.3, 0.6 and 0.9 being the most popular.

HIGH-DENSITY ND FILTERS

In the last couple of years, the 3.0ND filter, which reduces exposures by ten stops, has become one of the most popular accessories with landscape photographers looking for creative mono results. It allows you to transform scenes by increasing exposures from a fraction of a second to minutes, which results in moving subjects being blurred to give a mist-like effect. Using this filter is therefore perfect where there are clouds and/or water in the scene, especially if you include static subjects for visual contrast. The most popular 3.0ND filters are the B+W, Lee Filters 'Big Stopper' and the Hitech filter, with other densities also becoming available.

The density of these filters are such that you need to compose, focus and meter the scene before fitting the filter, otherwise you'll get very poor results. Therefore, before attaching the filter, with the camera in aperture-priority mode at your preferred f/stop and ISO rating, note the indicated exposure, then focus and switch the focus mode to manual to prevent the lens hunting when you press the shutter button. Switch the camera to Bulb, attach the filter, set your aperture, then use the following table to establish the shutter speed to set to compensate for the filter's effect. Fire the shutter using a remote release to avoid shake and lock the shutter until the calculated exposure time has elapsed, when you can close the shutter. In Photoshop, convert your image to black and white (see Photoshop step-by-step techniques) and tweak Levels/Curves as you see fit.

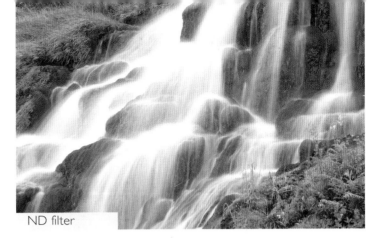

ND filter

unfiltered

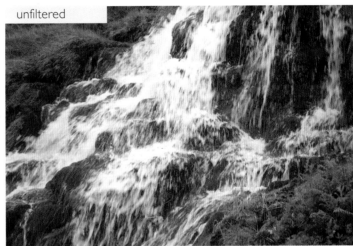

SHUTTER SPEED
On bright days, achieving a slow shutter speed can be difficult. An ND filter is the answer. Here it allowed a slow enough shutter speed to blur the water's motion.

| Exposure settings | |
No filter	With 3.0ND filter
1/250 sec	4sec
1/125 sec	8sec
1/60 sec	16sec
1/30 sec	32sec
1/15 sec	1min
1/8 sec	2min
1/4 sec	4min
1/2 sec	8min
1 sec	16min

DIFFUSERS

Often termed soft-focus filters, these are good to use when you want to add a romantic or dream-like atmosphere to your images. Soft-focus filters are suitable for a wide range of subjects; you can use them outdoors to capture scenes with an evocative mood, and use them indoors to create very moody still lifes. Diffusers are a great choice for portraits when you want to create a romantic feel to the image, which is why they are such a popular choice with wedding photographers.

Diffusers don't work by making the image unsharp – their effect is far more subtle: they blur fine detail, soften edges and blend highlights into shadows, so while pictures appear sharp, there is an obvious softening of the edges.

The effect of a diffuser varies according to the aperture you use; the wider the aperture, the stronger the diffusion. Set your lens to the widest aperture for the strongest effect – don't stop down the lens beyond a mid-aperture setting, otherwise the effect becomes barely noticeable.

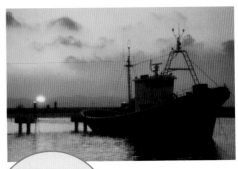

TOP TIP
You can make your own diffuser by stretching an old pair of tights (pantyhose) over the lens.

DIFFUSING FILTER
A weak diffusion filter was used for this harbour sunset image to add to the mood of the scene.

WARM-UP FILTERS

The 81 series of filters, most commonly known as warm-ups, is a range of colour-balancing filters developed to enhance light when it has cool characteristics, such as in dull, overcast conditions. They are amber in colour and come in a range of strengths, with 81B and 81C being the most popular. They are best suited for times when the light is slightly cool – dull weather and shady scenes are some examples. The aim is to add an attractive warmth to the scene without exaggerating the colours. While useful, digital photographers tend to use White Balance or post-production to warm scenes, so these filters are now limited in popularity.

Other colour balance filters include the 80-series (blue) and orange 85-series filters, but these are used predominantly by professionals in specialist fields.

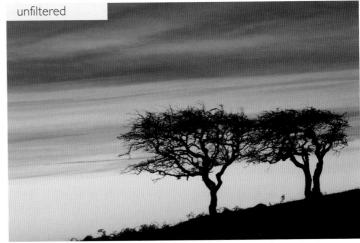

unfiltered

warm-up filter

WARM-UP
A warm-up filter is a simple but effective way to add warmth to an image.

DIGITAL FILTERS

Most digital SLRs, CSCs and digital compacts offer a number of digital filters that allow you to recreate the effect of optical filters in-camera. The most popular type is a set of digital filters that recreates the effect of colour filters in black-and-white photography. So rather than having to carry around a set of optical filters, you can set the camera to monochrome mode and choose to use a digital colour filter such as red, green or yellow. If you are shooting monochrome images, many cameras also offer the chance to apply digital toning such as sepia to the results. The other digital filter that is popular is soft focus, to create results similar to using a diffuser. There are other more creative effects available, see Art filters.

If you shoot in Raw+JPEG, you have an original unaltered Raw file as well as an altered JPEG. Many cameras allow you to apply digital filters to images you have already captured, saving the new version as a separate file so you retain the original image too.

FILTERS FOR BLACK AND WHITE

It is odd to think that colour filters such as red, green and yellow are popular with black-and-white photographers. They are used because they restrict the wavelengths of light passing through them: red allows only red light to pass through, green transmits green wavelengths only, and so on. The effect is that filtered black-and-white images can look very different from unfiltered shots, as the contrast and tonal range is affected.

Red has the most dramatic effect, as it increases contrast, whereas yellow causes the most subtle changes. Many photographers opt for orange as their first choice, as its effects are noticeable but not as intense as that achieved with a red filter.

The effect of applying colour filters to black-and-white images is shown in the following table.

PHOTOSHOP FILTERS

Most filters can be recreated effectively using software applications such as Adobe Photoshop. However, the one filter that cannot be replaced digitally is the polarizer. So if you are tempted not to use optical filters in favour of recreating their effect digitally, the polarizing filter will have to be the exception to the rule.

unfiltered

soft focus

sepia

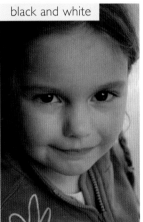
black and white

IN-CAMERA FILTRATION
Many cameras allow you to apply filter effects in-camera. Here you can see how an image is captured normally, then converted into three other variants: soft-focus, sepia and black and white. All variants are saved to the memory card loaded in the camera.

Filter	Effect
Yellow	Lightens yellows and skin tones, slightly darkens blue.
Green	Lightens green, darkens red.
Orange	Lightens orange, darkens red and green, reduces haze.
Red	Lightens red, darkens green and blue (particularly sky); water records as almost black.
Blue	Lightens green, darkens blue and red, strengthens skin tones, increases haze.

LENS TECHNIQUES

Getting the most from your lenses comes from understanding how they capture the scene. The essential points to consider when shooting with the two main focal lengths – wide-angle and telephoto – are covered here.

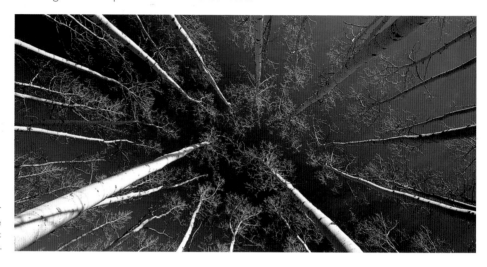

FOREST
You can't beat a wide-angle lens for creating dynamic compositions.

WIDE-ANGLE LENSES

You might think that the difference in coverage between, say, a 17mm and a 24mm lens is not particularly significant, but you would be far from being right. Although both of these are categorized as wide-angle lenses, with a focal length difference of only 7mm, the ways in which they capture a scene need to be seen to be believed.

Wide-angle lenses have a wider field of view than the human eye, making them highly suitable for particular subjects. It also means that they should be used with care to avoid creating scenes where the interest seems a long way away.

Ultra-wide-angles

Ultra-wide-angle lenses covering a range of 15–21mm are capable of the most dramatic images, as they stretch perspective to an extreme. They work very well if you include subjects in the foreground, as their scale is accentuated by the lens's characteristics, which exaggerate distances and lengthen objects that stretch off into the background.

One thing to be very careful with is the foreground. With ultra-wide-angle lenses, it is very easy to create a composition with a vast empty space at the forefront. Always try to include interest in the foreground – if you have a field of flowers or something equally

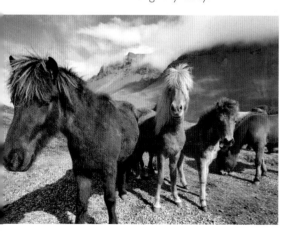

PONIES
Ultra-wide zooms distort perspective and this has been used to great effect with this shot to allow the dark pony to dominate the foreground.

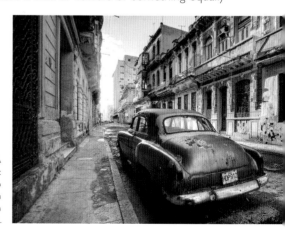

CUBA
Another characteristic of wide-angles is to create strong lead-in lines, as illustrated in this Cuban street scene.

stunning, angle the camera downwards and the foreground will appear to stretch back for miles.

Ultra-wide-angles produce excellent depth of field, even at relatively open apertures, making them the ideal choice when you want the scene to be sharp from front to back. The lenses also cause parallel lines to converge dramatically, so are an excellent option when you want to create images with a defined vanishing point.

These lenses are excellent for shooting interiors, where the very wide field of view allows you to cram relatively small spaces in the frame. These lenses also come into their own when shooting the interiors of churches or cathedrals, as you can work at framing arches and pillars to make the most of the building's curves and straight lines.

Subjects particularly suited to ultra-wide-angles include architecture and landscapes, but don't be afraid to try out the way they stretch perspective on other subjects, including portraits.

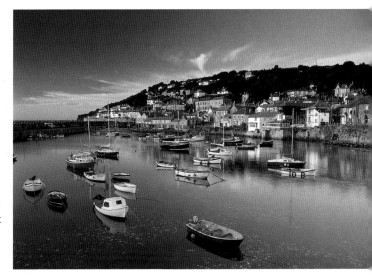

HARBOUR VISTA
Wide-angle lenses allow breathtaking
vistas to be recorded.

WIDE-ANGLES FOR DSLRs AND CSCs

It is worth bearing in mind that the stated focal length of lenses only applies to full-frame cameras, so a multiplication factor needs to be applied. To ensure wide-angle lovers have plenty of options, lens manufacturers have produced several lenses with extremely wide focal lengths. Two examples are the Tamron 10–24mm lens and Sigma's 10–20mm.

A reference table follows, which allows you to see the effective focal length of lenses used with various sensor sizes. The change in effective focal length has more of a practical effect on wide-angle lenses, which is why most landscape enthusiasts save up for cameras with full-frame sensors. That said, there are several very good ultra wide-angle zooms available for APS-C (1.5x/1.6x) and Four-Thirds (2x) sensors.

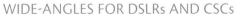

Approximate effective focal length				
	APS-H	APS-C	APS-C (Canon)	Four-Thirds
	1.3x	1.5x	1.6x	2x
15mm	19mm	22mm	23mm	30mm
20mm	26mm	30mm	32mm	40mm
24mm	31mm	36mm	38mm	48mm
28mm	36mm	42mm	45mm	56mm
35mm	45mm	52mm	56mm	70mm
10–20mm	13–26mm	15–30mm	16–32mm	20–40mm
10–22mm	13–29mm	15–33mm	16–35mm	20–44mm
11–18mm	14–23mm	16–27mm	18–29mm	22–36mm
12–24mm	16–31mm	18–36mm	19–38mm	24–48mm
16–35mm	21–45mm	24–53mm	26–56mm	32–70mm
17–40mm	22–52mm	25–60mm	27–56mm	34–80mm

Moderate wide-angles

Moderate wide-angles, which cover focal lengths of 24–35mm, do not exaggerate perspective in the same way that ultra-wide-angle lenses do, so their effect on the photographed scene is not quite as dramatic. Nevertheless, they are better suited to general use, in particular for landscape images. The 28mm lens is probably the most popular with photographers, as its angle of view is wide enough to fill the frame with most scenes, without distorting perspective. Its field of view means that you can include foreground detail to add scale to the scene, while at the same time capturing sweeping vistas in the distance.

Because moderate wide-angle lenses do not overly distort perspective, they make a good choice for architectural photography when you want to include a large building in the frame, but without exaggerating its shape. You will still need to be careful of converging verticals, but the problem is less likely to occur in this situation than when you are using one of the wider lenses.

TELEPHOTO LENSES

A lens with a focal length of over 50mm is termed a telephoto. This means that the lens has a narrower field of view than the human eye, so the subjects you see in the frame are larger than life. This focal length has its own characteristics that make it suitable for a wide range of subjects.

Short telephotos

Focal lengths of 50–135mm are termed short telephotos, because their pulling power is not great. However, this is a particularly versatile range of lenses that are suitable for a large number of photographic applications.

Short telephotos, in particular 80–135mm, are an ideal choice for portraiture, as they give a flattering perspective. Before telezooms like the 70–210mm became available, no self-respecting portrait photographer would be seen without a 135mm lens in their gadget bag. Because most compacts sport a zoom range that extends into the short telephoto territory, there's no excuse not to use it for taking decent portraits.

Short telephotos are also good for general close-ups of relatively small subjects, allowing you to pick out detail in architecture or photograph still lifes. Although they are not capable of macro standards, you should easily be able to fill the frame with subjects such as flowers.

> **TOP TIP**
> Increase the focal length of your telephoto lens by fitting a teleconverter. A 1.4x converter increases the focal length by 1.4x, so a 70–200mm lens becomes a 98–280mm. A 2x converter doubles the focal length, so a 70–200mm becomes a 140–400mm lens.

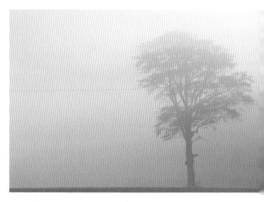

TREE IN THE MIST
Using a telephoto zoom allows you to compose the scene carefully to exclude everything except your intended subject.

Medium and long telephotos

Medium telephoto refers to focal lengths of 135–200mm, while long telephotos cover the 200–300mm range. These focal lengths are perfectly suited to filling the frame with distant objects, making them a great choice for a number of very different types of photography.

Wildlife photographers swear by their telephoto lenses, which allow them to capture frame-filling images of animals that would not be possible to obtain if they had to get closer to their subjects. Candid photographers also use telephotos for a similar reason. Action and sports photographers use telezooms when they can't get close to the action, so if you're a keen sports fan and own a DSLR or CSC, consider investing in a 70–300mm zoom.

Bear in mind that the shutter speed must be kept relatively high to avoid camera shake. Remember the general rule: use a shutter speed that is the reciprocal of the focal length – 1/200 sec for a 200mm lens and so on. Also remember that depth of field is relatively shallow, even if you stop down the aperture. This is great news when you want to isolate the main subject from the background, as it makes the focal point stand out.

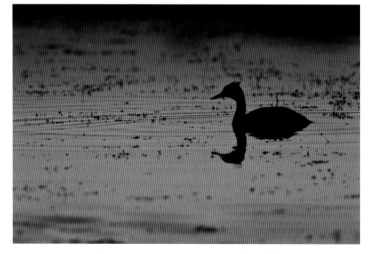

LONE SWIMMER
Adopting a low angle and using a long telephoto lens has allowed this solitary bird to be isolated from its surroundings.

Although telephotos may not seem like a good choice for landscape photography, they are very good for isolating areas of a scene. They work particularly well in misty or foggy conditions, where you can use them to create more abstract images. Telephotos also have their place in architectural photography, when details of a building, rather than the whole structure, can be isolated and recorded.

Super-telephotos

Telephotos that cover a range of 400mm and above are termed super-telephotos. Due to the relative expense of lenses that cover this range, they are sought after in the main by professionals and keen enthusiasts. Sports and surveillance photographers in particular opt for these types of lenses, as well as some bird and wildlife photographers. A few 'bridge' compacts reach this type of focal length, boasting a powerful zoom that extends from moderate wide-angle to super-telephoto. The Olympus SP-810UZ for example, has a 36x zoom covering an effective focal length of 24–864mm!

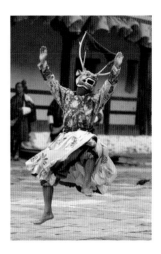

BHUTAN DANCER
The pulling power of a telephoto is ideal when you're physically unable to get close to your subject, such as at a festival.

PERSPECTIVE COMPRESSION

A major characteristic of telephoto lenses is perspective compression, also known as foreshortened perspective, stacking or foreshortening. This effect results in elements of a scene at different distances appearing much closer to each other than they really are. The effect increases the greater the focal length, so for maximum effect with a telephoto zoom, extend the lens to its maximum setting. Perspective compression is particularly effective when you want an element in the background to impose itself on the foreground subject.

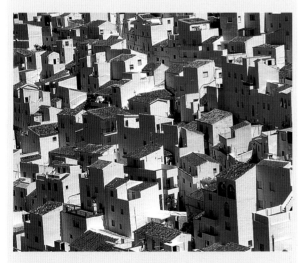

ROOFTOPS
Telephoto lenses compress perspective, which results in subjects at varying distances appearing much closer to each other than they really are.

MOUNTING A TELEPHOTO LENS

Large telephoto lenses are usually supplied with a mount that features a tripod bush at its base. This allows the lens to be mounted on a tripod, rather than the camera, to provide a balanced set-up and reduce strain on the lens mount.

TELEPHOTOS FOR DSLRs AND CSCs

While users of cameras with APS-C and Four-Thirds sensors are restricted with wide-angles, the opposite is true with telephoto lenses. Because of the magnifying effect on the effective focal length caused by image sensors smaller than a film frame, telephotos are even more powerful when used with smaller sensors. The following table provides a guide to the effective focal length of popular telephoto settings when used on digital SLRs and CSCs with smaller sensor sizes.

Approximate effective focal length				
	APS-H	APS-C	APS-C (Canon)	Four-Thirds
	1.3x	1.6x	1.5x	2x
50mm	65mm	80mm	75mm	100mm
70mm	91mm	112mm	105mm	140mm
85mm	110mm	136mm	127mm	170mm
100mm	135mm	160mm	150mm	200mm
200mm	260mm	320mm	300mm	400mm
300mm	390mm	480mm	450mm	600mm
400mm	520mm	640mm	600mm	800mm
500mm	650mm	800mm	750mm	1000mm
55–200mm	71–260mm	88–320mm	82–300mm	110–400mm
70–300mm	91–390mm	112–480mm	105–450mm	140–600mm
100–400mm	130–520mm	150–600mm	160–600mm	200–800mm

FLASH TECHNIQUES

There is far more to flash photography than just pointing and shooting. Most integral flash units and external flashguns offer a wide range of features to provide sophisticated flash control capable of producing amazing results.

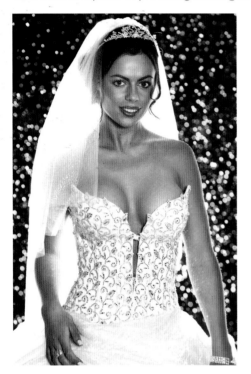

BEAUTIFUL BRIDE
A diffused main flash source provides a flattering key light while an off-camera flash creates a backlight that illuminates the veil.

Thankfully, there is no need to calculate how to achieve this effect – the camera does it all for you. However, there are some practicalities to consider. The first is that a long shutter speed means that the camera will need to be kept steady – so you should use a tripod, or rest the camera on a wall, table or other stable surface. Also bear in mind that movement in the frame will be recorded as a blur. So ask your subject to remain still during the exposure, or use this effect creatively to produce an unusual result.

MULTIPLE FLASH SET-UPS
Set up several off-camera flashguns with different colour gels for flash pictures with added impact. A low power flash aimed back at the camera can add a spotlight effect.

FLASH MODES

The modern flashgun offers a variety of modes for the photographer looking to create more imaginative results than the standard autoflash is capable of achieving. The following flash techniques are relatively easy using built-in flash, as well as with external flashguns.

Slow synchronization

This is the common term for mixing a slow shutter speed with a burst of flash. On some cameras it is also termed 'night portrait' mode. Slow synchronization (or slow sync) allows you to expose a nearby subject correctly, while at the same time recording detail in the background. The burst of flash is used to illuminate the main subject, while a long shutter speed means that the background scene is also captured.

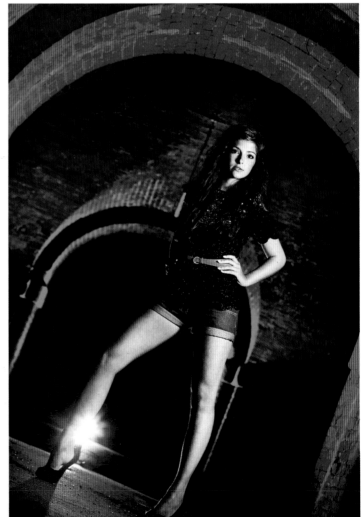

Second-curtain synchronization

With a normal flash exposure, the flashgun fires at the start of an exposure. Second-curtain synchronization (also known as rear-curtain sync) means that the flash fires at the end of the exposure. This provides a more natural result when using a long exposure with flash, such as in slow-sync mode. Set your flash to this feature to include movement in the image, as the flash-exposed subject appears at the end of a light trail.

Fill-in flash

This term relates to firing the flash in daylight portraiture to 'fill in' the subject's face. This has the effect of removing shadows from the face, while at the same time adding a catchlight in the eyes. This technique is taken for granted by modern photographers as it is all handled automatically by the camera. Before modern electronics however, the photographer needed to calculate fill-in flash manually, by balancing the flash and ambient light to give a daylight-to-flash ratio of around 1:4.

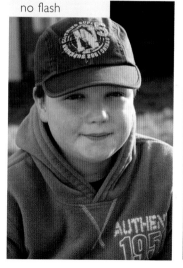 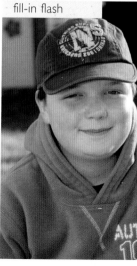
no flash / fill-in flash

CASUAL PORTRAIT
Fill-in flash can be set to fire automatically on most cameras and is useful for eliminating harsh shadows on a subject's face. Here you can see its effect compared to a shot taken with no flash.

Flash compensation

This feature allows you to control the balance of flash and ambient light. The exposure for the ambient light remains the same, but the amount of flash exposure can be varied to give flash more or less emphasis on the scene, with a scale of +/-2 or 3 stops, adjustable in third- or half-stop increments. Use this mode when you want the flash exposure to appear stronger or weaker in the image.

WIRELESS FLASH

Many cameras and external flashguns allow wireless, or slave flash. This allows multiple flash set-ups without the need for leads – the flashguns are triggered by radio or infrared. This is a very specialized area, used in the main by photographers on the move who want a portable 'studio' set-up.

FLASH ACCESSORIES

Various flash accessories are available to help reduce the harsh effects of direct flash.

Flash diffusers

Flash diffusers or mini-softboxes are effective at softening direct light when bounce flash isn't an option.

Flash gels

Placing colour filters over the flash head illuminates the subject in that particular colour. When used in conjunction with a multiple exposure facility, or with a very long exposure in pitch-black conditions, it is possible to change the colour of the filters and illuminate various parts of the scene. Alternatively, using a flash gel on an off-camera flash allows you to colour a background while the on-camera flash perfectly exposes the subject.

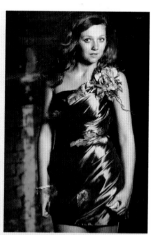
FLASH GELS
Using a colour gel on an off-camera flash adds interest to what would otherwise be a dull backdrop.

Bounce flash

Using direct flash can give harsh and unflattering results. A way around this is to use bounce flash, where an external flash is fitted to the camera and the flash is bounced off a ceiling or wall so that the light is diffused and softer. Because of the longer distance the flash must travel, you need to be within a few metres of the 'bouncing' surface. There is no need to worry about the exposure if you are using a dedicated flashgun. One thing to be aware of, though, is that the bounced light will take on the colour characteristics of the surface it is bouncing off – so you should aim for a white wall or ceiling.

STUDIO FLASH TECHNIQUES

A studio flash system offers the photographer complete control over the lighting of the subject. It is particular useful for portraiture and still lifes, with various accessories available to ensure that the subject is lit exactly how you would like it to be.

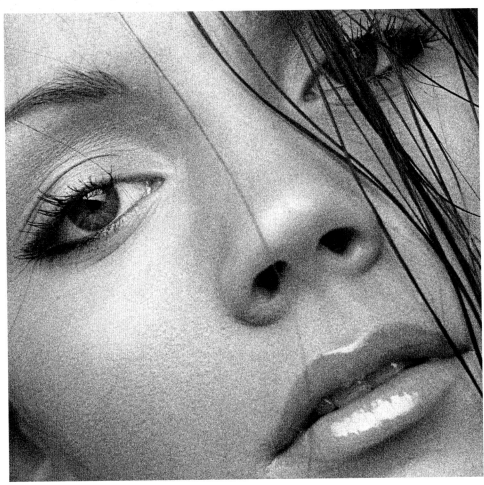

CHARLOTTE
The lighting here was nothing more sophisticated than one light with a softbox and a triflector reflector placed beneath the chin. The image was later manipulated in Adobe Photoshop to adjust colours and add grain.

PORTRAITS

Many photographers believe that taking studio portraits requires the use of several flash heads and a multitude of accessories. This is far from the truth – in fact, many studio photographers often work with just one or two flash heads. The fact is that you can achieve decent portraits with as little as one light and a reflector. Adding an extra light offers benefits, but is not essential.

The key to good studio portrait lighting is making sure that the position and quality of the light are flattering to the subject.

The most popular lighting accessory for portraits is the softbox, which provides an even, diffuse light. Where you position the flash head is all-important: the further back from the subject it is, the softer the light. Placing the softbox high and in front of the subject provides what is termed butterfly lighting, due to the shape of the shadow that appears beneath the nose. Placing the softbox at an angle to the side lights one side of the face while casting the opposite side into shadow.

Adding a reflector is a very easy way to help fill in those shadows. By varying how close you bring the reflector to the face, you can control how much light is bounced back at the shadows. With this simple one-light, one-reflector set-up, you can achieve a wide range of results.

Often, a photographer will use extra heads, not to illuminate the subject, but to light the background. This is used especially when the background needs to be pure white. By setting the background light two stops higher than the subject light, the background records as white.

By angling a studio head towards the rear of the subject's head and using a snoot to provide a narrow, direct beam onto the head, it is also possible to add an attractive highlight to the subject's hair.

The easiest way to explore studio lighting is to invest in a budget studio flash head and one reflector. Then, with the help of a notebook and a willing subject, you can try out different combinations of light/reflector arrangements and develop your studio portrait technique.

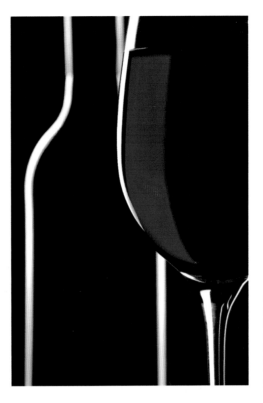

WINE
A black card placed in front of a softbox with a narrow slit to allow some light through was all that was required for this stunning still life.

Cubelite

Light tents have always been a regular fixture in the studio of still life and product photographers, providing an easy method to achieve even, diffused lighting to illuminate small objects. The Cubelite has largely replaced the light tent, because its collapsible design means that it is easy to set up and pack away in a small bag. Different colour backgrounds can be clipped inside, or the rear removed to allow scenery to be included in the background. The result is a highly portable, effective method of achieving professional results.

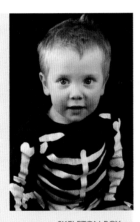

SKELETON BOY
The Cubelite is ideal for photographing small children. They fit perfectly inside and have their attention held by the unusual surroundings, which results in perfect portrait lighting.

STILL LIFES

Many still life photographers prefer to use studio flash rather than daylight, as they can more readily control the power and direction of the light (as well as being able to work at night, of course).

Those dedicated to product photography invest in a white still life cove, which is a curved background that makes it easy to shoot an object against a white background.

For most people, however, all that is required is a tabletop, a suitable subject and a single flash head with a softbox. For most still life set-ups, positioning the softbox above the subject and pointing straight down gives a nice, even illumination. Often, pointing the softbox slightly backwards means that any shadows will be directly behind the subject and therefore out of view.

Indoor still lifes can also be taken with the softbox positioned high and to the side of the subject to mimic daylight. This works particularly well with subjects that are usually found near a window, such as a vase of flowers placed on a side table.

Again, using studio flash is a case of experimentation and experience. By using different lighting head accessories, such as softboxes, snoots and barndoors, and reflectors of various colours, you can create still lifes to be proud of.

SUBJECT TECHNIQUES

COLOUR

Although colour is not often interpreted as a particular subject in itself, it forms an integral part of photography. Knowing how best to take advantage of colours, how they affect a scene and how they work or clash with each other is an important lesson to learn.

HOW WE INTERPRET COLOURS

Everyone has a favourite colour, and it is a common belief that you reveal a part of your personality through the colours that you favour. Each colour represents a different emotion or mood, and plays different roles in pictures.

What is colour?

Colour is formed from the way in which objects absorb and reflect different wavelengths of light. An object takes on the colour of the wavelengths it reflects; for example, grass absorbs all wavelengths of light except green. Where more than one colour is reflected, the wavelengths combine to create other colours – for example, orange is the result of yellow and red light.

Receding and advancing colours

Warm colours, such as red, yellow and orange, are said to advance as they stand out in a scene, while cooler colours such as blue and green are said to recede. Try to include receding colours in the background and advancing colours in the foreground.

Red

This is the most powerful colour in photography, and can dominate a scene. Red represents danger and passion, and grabs your attention, so be careful how you include it in a scene – it can prove a distraction if you are not careful.

Green

This is a very calming colour that signifies health and life – lush forests and rolling landscapes spring to mind. Green is, however, easily dominated by other colours – red in particular.

MISTY MORNING
The dominance of blue in this scene gives the impression that it's a very cool morning.

Changing the colour saturation

Digital cameras allow you to control how they record colours via the Picture Styles settings, which let you vary the colour saturation to produce images with faithful tones, vivid colours or to suit particular subjects like landscapes or portraits.

COLOUR COMBINATIONS

When capturing scenes with more than one colour, it is important to know which colours clash and which work together in harmony. The colour wheel provides a quick reference guide. Primary colours (red, green and blue) sit equidistant from each other and form a relationship with other colours on the wheel. Contrasting colours (also called complementary colours) sit on opposite sides. When included in the same scene, they clash, adding impact and drama to the image.

Yellow

This is another strong colour that is often seen to represent nature – the sun, corn and flowers are dominated by yellow – as well as health and purity. Yellow works particularly well together with blue.

Blue

This is the colour that can represent both good and bad. Blue can portray negative emotions, such as coldness, sadness and loneliness, but can also represent positive emotions, such as serenity and tranquillity.

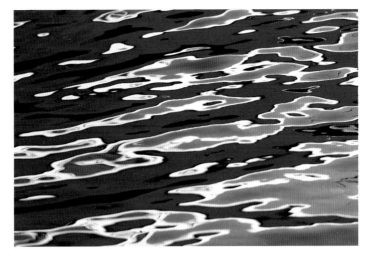

BOAT REFLECTIONS
Harbours with brightly painted boats offer great potential for reflections with reds providing the most impact.

MINIMIZE COLOURS

Using colours in photography isn't all about making them as bold or as brash as possible. Creating colour images with muted, weak colours can create evocative images that give the impression of peace and romanticism. Still lifes and portraits can benefit from the soothing effect of muted colours, especially when taken under very diffused lighting. Keep strong, bold colours like reds and yellows out of the frame, using shades of whites, with very weak colours like pinks or pastels or subtle, cool blues and greens. Select low saturation via the Picture Styles settings or alternatively adjust the colours when processing the image on your computer.

AUTUMN LEAVES
Autumn (fall) provides a wonderful opportunity to capture colourful images with the golds and reds of leaves making great subjects for close-ups or in landscapes.

MAXIMIZE COLOURS

To make your pictures really stand out, fit a polarizing filter to maximize saturation and remove reflections – a polarizer is as suitable indoors for subjects such as still lifes as it is outdoors for landscapes. When shooting still lifes or portraits, use a bold colour backdrop to maximize impact, but bear in mind the cultural perception that we tend to associate with particular colours.

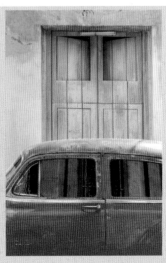

CUBAN COLOUR
Use contrasting colours imaginatively in compositions to create striking images.

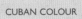

STAINED GLASS
Stained glass windows are excellent subjects for colour photographs. Use a polarizing filter to provide extra saturation.

BLACK AND WHITE

Taking pictures in black and white is as popular now as it has ever been. Despite the demise of film and the chemical darkroom, monochrome remains a magical form of expression.

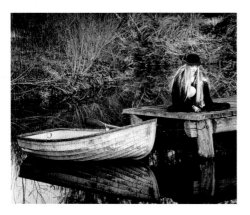

AT THE JETTY
The mood and atmosphere of monochrome make it the perfect choice for images like this.

WEDDING DRESS
Black-and-white images have a timeless quality and a sense of romance.

WHY SHOOT IN MONOCHROME?

This is a question that most photographers face at one time or another. With so much technology invested in producing sophisticated sensors and White Balance systems, why would anyone want to shoot in black and white? The simple truth is that there is something special about a black-and-white image: to many people, the lack of colour instantly gives the image more weight, more truth and more credit. A monochrome image is somehow more serious than a colour one. This is perhaps because by removing colour we also take away many of the distractions that hold us from picturing the real subject.

WHAT SUBJECTS SUIT BLACK AND WHITE?

Any subject can be shot in black and white, although some work better than others. Portraits have traditionally been photographed in black and white, and many photographers prefer this medium over colour, as they believe that a monochrome image reveals more of the personality and character of a subject than a colour image ever could.

Landscapes look amazing in colour, but can look equally impressive in monochrome. Bad-weather pictures in particular look strong in black and white, as this medium is particularly effective at conveying mood and atmosphere. It is worth bearing in mind that black and white cannot capture the intricacies of light as well as colour does – for instance, the warm light of mornings or the glow of late afternoons – but this comes down to learning to see in monochrome.

Mood and emotion are further aspects where black and white clearly has the advantage over colour. In particular, monochrome photography can be used to evoke strong negative emotions – images of social injustice, war and loneliness are often far more powerful when rendered in black and white.

While low noise is usually the order of the day with colour images, using a high ISO rating to make noise evident is a popular course of action for black-and-white photographers, especially when photographing extremely poor weather conditions, such as storms. High noise levels can also work well in portraits and still lifes. Ultimately, black-and-white photography offers as many, if not more, avenues for interesting, creative photography than colour.

If you prefer, you can shoot scenes using a low ISO rating to maximize image quality, then apply noise in post-production. The easiest way to do this is by applying Noise in Photoshop by selecting it under the Filter menu. The advantage of adding noise in Photoshop is that you have total control over its effect.

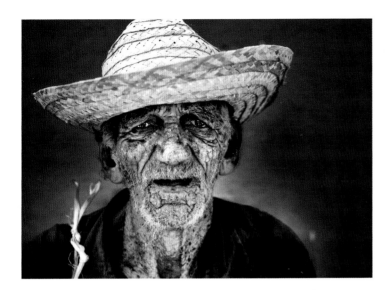

MONO PORTRAIT
The lack of any colour allows the viewer to concentrate on the age and character of the subject.

SEEING IN BLACK AND WHITE

A major hurdle to overcome when first starting to shoot in black and white is learning how to 'see' in monochrome. Because black-and-white photographs represent different colours as various shades of grey, learning how colours will appear in the image takes some time to become accustomed to. Red and green, for example, are very different colours, but come out in black-and-white images as a similar shade of grey.

The easiest way to learn is to shoot a scene in colour, then also take it in black and white. Include as many colours as you can, as this will give you a visual reference for future use. As well as the three primary colours (red, green and blue), include colours such as orange, purple, yellow and brown, and also include as many shades of each of these as possible.

A technique that many photographers use is to carry around an orange filter to view through. Although looking through the filter won't provide a black-and-white image, the result is monochromatic in that it is made up of various shades of one colour (orange), which gives a relatively close interpretation of how the black and white image will be recorded. Another visual aid to consider investing in is a small accessory called the monovue. This is essentially a small hooded filter, which, when held up to the eye, gives a black-and-white representation of the scene.

TOP TIP
When shooting in artificial lighting conditions, don't worry about the effect of artificial lighting, as any casts are lost when converting colour images to black and white.

Filters
Use optical filters or the camera's digital colour filters to radically affect the result. Colour filters such as red or yellow allow only their respective wavelength of light to pass through, altering how colours are recorded (see Filter techniques).

SHOOT MONO OR CONVERT IN POST-PRODUCTION?

While cameras offer a monochrome mode that records images in black and white, you are better off shooting in colour and converting images later, as you'll find you get much better tonal reproduction. If you shoot in Raw + JPEG, you have the advantage of seeing the mono JPEG image on the LCD monitor, while also having the colour Raw file that can be converted to monochrome on your computer.

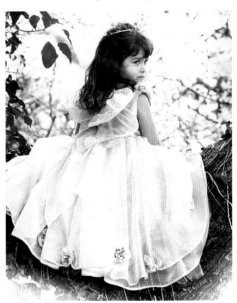

BRIDESMAID
The defined grain of fast black-and-white film can be recreated using Photoshop.

Colour to black and white in Photoshop
The easiest way to create mono images is to convert them using Adobe Photoshop (see Photoshop step-by-step techniques).

WILDLIFE AND NATURE

We live on a planet burgeoning with life. Animals and plants are found in all but the harshest of environments, so capturing them on camera is simply a case of getting out there and doing it. This section covers the more popular subjects and techniques for photographing the natural world.

KEEP YOUR DISTANCE

By their nature, wild animals are usually nervous of people and will not hang around if they are aware of your presence. Therefore, your best chance of capturing an image is to keep your distance. A powerful telephoto lens is your best ally for capturing images of wildlife. Digital compact users with zooms offering a maximum range of 135mm or thereabouts will struggle to fill the frame with wild animals, but will find that they are well equipped for capturing close-up images of insects and flowers.

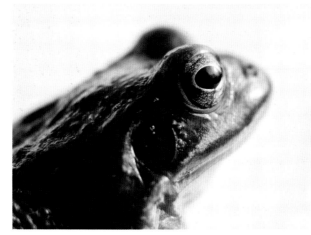

FROG
A garden pond is home to many photogenic animals, including common amphibians.

INSECT
Precise focusing is critical in close-ups due to extremely shallow depth of field.

DSLRs and CSCs with telephotos or telezooms are ideally suited for wildlife photography, especially if they use lenses offering a focal length of at least 300mm, which can really pull in distant subjects. A macro lens is another optic that wildlife photographers should add to their collection, as there is as much variety in capturing insects, fungi and flowers as in photographing larger animals.

GARDEN LIFE

You don't have to stray far to find the right subject – there is plenty of potential to be found in your garden, where birds, small mammals, insects and flowers offer interesting photographic opportunities.

The fact that you are relatively close to garden wildlife has both advantages and disadvantages. On the plus side, being closer means it is easier to frame the subject, and because you can prepare the scenery to your own preference, you can ensure the background is uncluttered and prepare particular spots where you want the animals to visit. A good method for luring animals to a predetermined point is to leave out some food that will tempt them. Bread, nuts and fruit will attract all sorts of wildlife from birds to squirrels. If you set yourself up inconspicuously and bide your time, you should be rewarded with some excellent opportunities. You can also attract particular birds by growing certain species of bush that produce berries, on which the birds feed.

On the downside, being so close to your subject means you need to be far more inconspicuous to ensure you don't frighten away potential subjects. Some methods to get around this are to shoot from cover, such as through an open window or from a shed. If you are really keen, you could invest in a camouflaged hide. Whatever option you try, it is vital to remain quiet and out of view and, above all, to be patient.

CLOSE-UPS

Taking close-up pictures of small insects is a tricky business, and a macro facility is a must here. The main considerations are the composition, limitations of depth

of field and camera shake, all of which are interlinked. To get as much of the subject appearing sharp you need to set as small an aperture as possible, which means a relatively slow shutter speed requiring some form of support (monopod or tripod) for the camera. Even with a small aperture, the depth of field will extend only for a few millimetres, so when you compose the image, you need to keep the subject as much at right-angles to the camera as possible. In addition, try to keep the background as plain as possible – the less distraction behind the subject the better. Whether or not you use the flash depends on the subject; in some situations it works, in others available light is preferable. Experiment with and without the flash to determine which best suits the situation.

Most insects stay on the same spot for only a few seconds, so you will need to work quickly. Try to avoid moving around from one spot to another, as you will scare away your subjects – instead, remain in one spot and try to be patient.

TREES

When wandering through parks and woodland, don't ignore the trees as a potential subject. Winter may be a barren month in terms of foliage, but you can still take close-ups of the pattern of the bark. In spring and summer, try shooting intricate close-ups of leaves to reveal the patterns of veins, and capture the blossoming flowers that grow around the forest floor. Autumn proves to be the most colourful, as leaves turn various shades of red and gold. In addition to the leaves on the trees, try capturing still lifes of the layer of leaves covering the ground.

IMPRESSIONIST PARK
Be creative with your focusing to capture the trees in your local park in an imaginative and refreshing way.

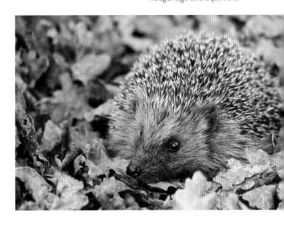

HUNGRY HEDGEHOG
Your local park is home to many photogenic animals such as hedgehogs and squirrels.

PARK LIFE

Head for large parks, where you have the potential to photograph large mammals, such as deer. This is possibly as close to going on safari as many people get, and demands similar skills.

First, be prepared to get a chance to photograph animals from a distance only – you will need a lens with a minimum of 300mm to be able to record your subject in any great detail. Before leaving home, ensure you are wearing drab, neutral clothing (browns and greens are good choices), as these will help you blend into the scenery. If you spot deer, don't race straight towards them. Instead, walk slowly in a zigzag direction, stopping at intervals to look through the viewfinder/LCD monitor and determine how much closer you need to get. If you are spotted, remain perfectly still and wait until the deer lose interest in you.

When you are close enough, you may be a little excited, but don't forget the basics. If your subject is backlit, adjust the exposure accordingly. Make sure your shutter speed is high enough for handholding, and your focusing is precise. Don't waste the opportunity by neglecting the fundamentals, and you will be rewarded with excellent images.

BIRDS

Apart from the garden, the best place to photograph birds is at waterways, such as ponds, lakes, streams, rivers or canals. Ducks and swans are commonplace in the summer months, and their plumage and shapes make them attractive subjects. A focal length of 135mm should be good enough to fill the frame, especially if you have enticed the birds closer with some food. Bear in mind that swans' white feathers may cause the meter to underexpose, so shoot at the indicated exposure and +1 stop.

If you live near the coast, you can also try photographing seabirds, such as gulls, gannets and terns. If shooting a bird in flight, add 1 stop to the indicated exposure to avoid underexposure.

Birds of prey, such as eagles and owls, are extremely photogenic, but finding these impressive birds in the wild is difficult. Instead, find out where your nearest bird of prey sanctuary is located, and head there instead. This will offer you an ideal opportunity to get close and take some brilliant images. Zoom in close on the head, and use a wide aperture to throw the background out of focus.

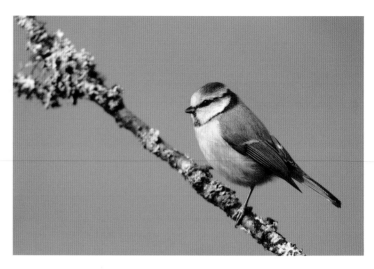

GARDEN BIRD
Bait areas in your garden and you'll be able to tempt various attractive species of bird to visit, making for great photos.

SAFARIS

If you are lucky enough to go on a safari, you will be presented with some fantastic photo opportunities. Large animals, such as elephants and rhinos, make superb photographic subjects, while smaller animals, such as gazelles and zebras, are just as photogenic.

A powerful lens is in order and, because of the bright light levels, rating your camera at ISO 100 or 200 should still give you handholdable shutter speeds. Avoid shooting in the middle of the day, when the sun is high and the lighting is harsh; instead, aim to get your pictures in the first and last two hours of the day, when the light has a warmer cast. At sunset, look to take silhouettes of animals against the setting sun looming large in the sky. Your local guide will know where animals are to be found during the course of the day – waterholes are often a popular retreat.

During the hottest hours in the day, animals will be at rest. Use this opportunity to capture classic images, such as big cats resting on the branches of trees or sheltering in the shade.

If you are brave enough to venture out on foot to photograph less dangerous animals such as zebra, make sure you are downwind – if not, they will catch your scent and make off in the opposite direction immediately. Also wear neutral 'earth' colours to avoid being spotted.

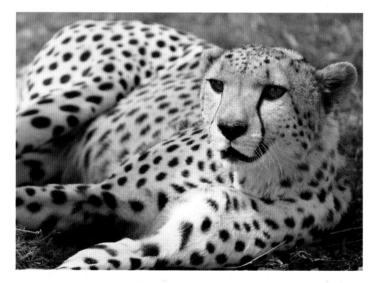

ON WATCH
Good safari images aren't simply a record shot of a wild animal. Instead, they reveal something about the animal's way of life and its environment.

ZOOS

Photographing captive animals has the advantage that you can get close to dangerous species like big cats without any danger of harm. However, the bars and fences that protect you from the animals can also prove a problem when it comes to photographing them. There are techniques that allow you to shoot through these obstructions and, in some instances, eliminate them completely.

The secret to shooting through cages or bars is to get as close as possible to the obstruction (without breaking any rules or antagonizing the animal) and set the lens aperture to its widest setting. The result is that the fence or bars are completely thrown out of focus and the shallow depth of field means that the background will be blurred, helping the animal stand out. You may find that the lens keeps focusing on the fencing or bars, so switch to manual focus if possible to avoid this problem.

Some enclosures don't have any obstructions, which should make your life easier. In these situations, your aim should be to try to make the scene look as natural as possible, so it isn't obvious that the animal is in captivity.

Shooting through glass presents the problem of reflections. You can get around this by fitting a lens hood, using a polarizing filter and getting as close to the glass as possible. You won't be able to use flash, so a tripod or camera support may be necessary.

TOP TIP
Find out the feeding times of animals – these are often the best chances to take pictures, as the animals are most active at these times.

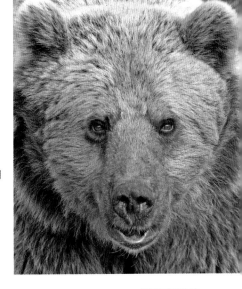

BROWN BEAR
Zoos and animal parks allow you to take great shots of animals you would normally rarely get a chance to get close to.

DELICATE FLOWER
Woodland, meadows and open countryside are home to many beautiful flowers.

FLOWERS

The intricate shapes and colours of flowers make them a popular subject for photographers. The small size of the subject means that you need to have the equipment necessary for close-up photography. If shooting flowers outdoors, take full advantage of days that are overcast, as the light is bright enough yet has a far softer effect than in sunny conditions.

On sunny days, look for flowers, ferns and leaves that are backlit. Keep a water spray bottle handy, and lightly spray the subject – the droplets will pick up the sparkle of sunlight and add an extra element to your images.

Colour plays a vital factor – look for pictures with strong colour clashes or several hues of the same colour. Patterns are also very attractive – look for intricate shapes in leaves, petals and ferns.

As well as close-ups of individual plants, don't forget to use a wide-angle lens and capture sweeping views of colourful fields. In spring, head for forests and woodlands to capture bluebells, and in summer look to create powerful compositions from bright yellow sunflowers set against a deep blue sky. Pack a polarizer, and make full use of the colours on offer.

In windy conditions, you need to be patient and take full advantage of a lull in the breeze. Consider how the colours of the subject work with the background, and try different viewpoints to find which gives the best results. Experiment with differential focus to create images that have only a small part of the subject in focus.

PEOPLE

More photographs are taken of people than of any other subject. From the simple snapshot to the professional studio set-up, the walls and mantelpieces of homes around the world are adorned by portraits of friends and family.

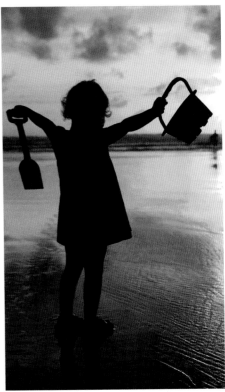

PERFECT PORTRAITS
People make for wonderful subjects, whether they are captured posing for the camera, as a candid or as the subject in a creative image.

THE COMFORT ZONE

The key to successful portraiture is not related to a photographic skill or a piece of equipment; it is all to do with the personality that you, as a photographer, manage to bring out from the subject.

Very few people enjoy having their picture taken – whether it is by someone they know or a complete stranger, the thought of having to pose for a picture can be a frightening prospect. Unless the photographer can relax their subject and make them feel comfortable, the result will be portraits that exhibit nervousness, tension and anxiety. This is not good news at all.

Successful portrait photographers are those who can put their subject completely at ease, both before and during the photo session. The key is to make the subject feel completely comfortable and natural and be almost unaware that they are having their picture taken.

Before even getting the camera out of the bag, you should sit and have a chat with your subject. Talk about their interests over a coffee, find out a little about their lives, and generally make them feel as relaxed as possible. Have some fashion or lifestyle magazines available so that you can run

Clothing tips

Always allow your subject to wear clothing that they're comfortable in, rather than force them to dress up 'smart'. While plain, neutral garments often work best for teenagers and adults, colourful and patterned outfits, such as striped T-shirts or spotty dresses, help add extra visual impact to photographs of children.

through them and select poses and styles that you both like the look of. This is particularly useful if your subject is not used to being photographed.

When you start taking the picture, behave confidently about what you are doing; any nerves you have will be picked up by the subject. Give them encouragement as you work. Don't snap away and bark out instructions; tell them they are doing well and ask them to change poses. What you will discover is that the more subjects relax and enjoy the session, the better the pictures become, as their natural expressions begin to break through and the nervous fixed smiles and taut, tense shoulders start to disappear.

All this may sound straightforward, but you will find there is a skill involved in developing the relationship between photographer and subject. Master this, and you're on the road to taking great portraits.

Focusing tips for portraits
While multi-point AF is a good choice for candids and group shots, when shooting a single subject, switch to single-point focus so that you can ensure you focus on the eyes. In multi-point AF, you run the risk of the camera focusing on the nearest point in the frame, which is usually the nose, spectacles or the brim of a hat.

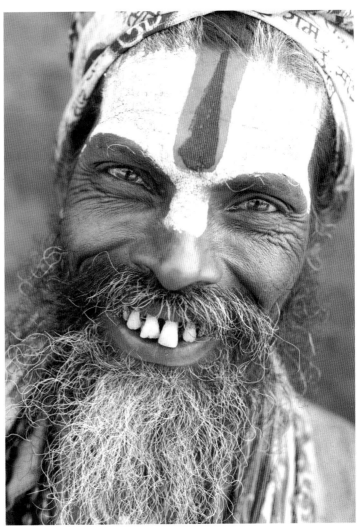

TRAVEL PORTRAIT
Keep your camera with you at all times on holidays so as to capture interesting travel portraits.

PORTRAIT LENS CHOICE
When shooting portraits, be careful to use the correct lens; if your camera has a zoom, set it to the appropriate focal length. Wide-angle lenses are a definite no-no if you are trying to capture a flattering image, as they will exaggerate perspective, making noses look like beaks and distorting the shape of the face. A standard focal length, such as 50mm, is better in terms of perspective, but for a tight head-and-shoulders shot, you will need to stand quite close to the subject, which may prove intimidating.

A short telephoto, 80–135mm, is the ideal choice. Your working distance is far enough from the subject for them to be more relaxed, while not too distant that you have to shout instructions to them. Better still, the perspective of this focal length provides good portraits by flattening the facial features.

ZOOM
The standard zoom is one of the cheapest optics available, yet is one of the most versatile.

CREATING A 'LOOK'

It is important that both you and the subject have a clear idea of how they would like to be photographed. This involves not only their expression or pose, but the location where they would like to be photographed, their clothes, make-up, hairstyle and so on. This is where having fashion magazines on hand comes in very useful. Looking through these allows both parties to get a better understanding of the pictures that will be taken, and this helps the photo session to run more smoothly.

There are no hard-and-fast rules about what the subject should wear or how they should pose – this is determined in particular by how the subject wishes to look in the photographs. There are literally hundreds of different poses and styles that the person you are photographing could adopt to portray their personality best.

One thing to be aware of is that fashions change very quickly – bear this in mind when determining what sort of clothes your subject wears for the shoot. A good guideline to adopt is to have the subject wear clothes that are timeless: casual clothing, such as jeans, T-shirts and plain woolly jumpers, usually works best.

Eye contact
The general rule with portraits is that there should be strong eye contact, as this grabs the attention of the viewer. Although this is often an important aspect of portraiture, don't imagine that it is always required; this is another rule in photography that is meant to be broken. Having the subject looking away from the camera can add mood to the portrait, while obscuring an eye, perhaps with strands of hair, can invoke a sense of mystery to the subject.

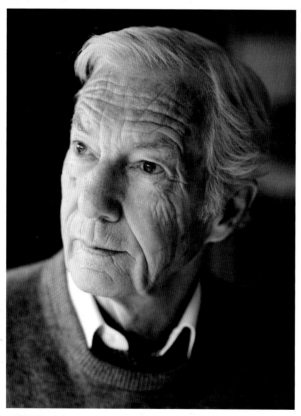

LESTER PIGGOTT
Window light provides a very flattering form of illumination for portraits.

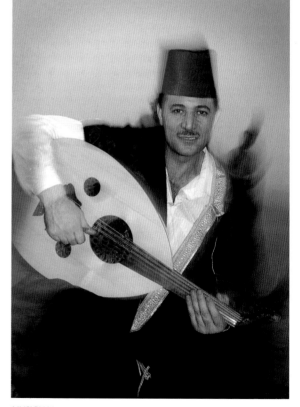

MUSICIAN
The unusual streak effect here was created by combining a slow shutter speed with flash and rotating the camera during the exposure. This technique can be hit and miss, but provides an effect that is far more pleasing than just taking a 'straight' flash exposure.

PORTRAIT STYLE

It is generally accepted that there are two main types of portrait: formal and contemporary. Formal portraiture is the style that professionals have used for countless decades. With formal portraits, the sitting is very well planned out. Studio flash is used, the photographer has a set regime of poses for the subject to adopt, and the backdrop is usually a part of the home, such as a fireplace or a mottled background. For timeless portraits, this approach works well and remains popular today.

However, a newer, fresher style of portraiture has become increasingly popular since around the 1980s; that of contemporary portraiture. As the title suggests, this is a far more relaxed approach for both the subject and the photographer, and aims to add a contemporary, 'lifestyle' feel to the portrait. Unlike formal portraits, where the camera is usually mounted on a tripod, studio lights are used and the whole exercise is planned, contemporary portrait photographers have the opposite approach, choosing to handhold the camera and foregoing studio flash completely for available light, or possibly a flashgun. In addition, the location is less planned, with almost any location inside

Candid photography

Because the subject is unaware that you are taking their picture, candids are a good way of capturing their natural behaviour. The best chance of success is to use a decent telephoto lens, which allows you to fill the frame with the subject, while at the same time keeping a good distance away, so that you are unnoticed by the subject. The secret to candid photography is not to make it obvious you have a camera, so keep it hidden until required, and work fast.

OLD FRIENDS
These men were too deeply engrossed in reading to notice their picture being taken.

the home or outside being suitable. The result is that portraits are far more relaxed and informal, mainly because everyone has more fun doing them. Contemporary portraiture is certainly a method you should attempt to adopt, as the results are far more modern and justifiably popular.

One area where contemporary photography has become very popular is for weddings, where the photographs take on a far more relaxed style than you would find in a traditional wedding portfolio. Gone are the formal group shots, to be replaced by candids of the wedding couple, guests and bridesmaids. The result is a far more informal set of pictures that can record the emotions of the special day far better than traditional images do.

ENVIRONMENTAL PORTRAITS

Often the best way to reveal part of the character and personality of a subject is by photographing them in their favourite surroundings; this is known as environmental portraiture. This type of portrait could feature the subject's place of work or their home – the location depends on where the subject feels most comfortable. For example, if you know the subject is a keen gardener, you could shoot them in their garden or shed; if they run a market stall, photograph them at work. Use a wide-angle lens to fill the frame, and make sure that the subject looks natural and relaxed.

The important thing to remember is that, in this instance, the surroundings become as important as the person, so be sure that you take this into account in the composition.

THE MODEL MAN
Environmental portraiture is all about revealing an aspect of the subject's life.

LIGHTING FOR PORTRAITS

Lighting plays a vital element in all types of photography, but is particularly important in portraiture, as how a subject is lit will completely determine their appearance. Both natural and artificial lighting are suitable for portraiture; the essential factor is that you know how to control and use lighting.

PLAYING IN THE PARK
The soft, gentle light from a heavy overcast day
was perfect for this naturally lit portrait.

Reflectors and diffusers

These are vital accessories for controlling available light, and should be high on your shopping list for portraits.

When to use reflectors

Reflectors allow you to bounce light back on to a subject. Place the reflector on the opposite side of the subject to bounce light in their direction. With sunlight, the chin and neck may be in shadow, so place a reflector at waist height to even up the lighting. If the light source is behind the subject, place a reflector between the subject and camera (making sure it is out of view) to bounce light back on to the subject. Bear in mind that you can also use elements in your environment, such as white walls and lightly coloured sand, as reflectors.

When to use diffusers

Place the diffuser between the light source and the subject to produce a much softer light. In strong sunlight, for example, the diffuser needs to be placed above the subject. Diffusers work well with reflectors, so be ready to use them together for the same image.

DIFFUSED LIGHT
This shot was taken on a sunny day. However, a diffuser placed above the model's head meant the light was diffused, while a reflector to the side added some highlights to her hair.

DAYLIGHT PORTRAITS

Many photographers regard daylight as the best way of lighting portraits, as they feel that studio flash can't match their ability to create a natural feel to the portrait. Learning how to master daylight won't come quickly and easily – even professional photographers claim they have much to learn about using available light! This may have something to do with the fact that the characteristics of daylight are different not only from one country to another, but from one day to the next, and from hour to hour. Therefore, learning how to use daylight comes from experience and practice.

The first thing to understand is that the weather conditions that suit portrait photography are not what you would normally expect. Overcast conditions may be a hindrance for the landscape lover, but are ideal for the portrait photographer. When the sky is filled with cloud, the light becomes soft and diffuse, which is perfect for taking portraits. Although the sun is obscured, the light during overcast conditions changes during the day, with the best times being mid-morning and mid-afternoon.

Bright, sunny days give a harsh light for portraits and cause the subject to squint. Diffusers and reflectors can be used, although the light is more difficult, and sitting the subject in the shade works well, although it does limit your choice of locations.

Using daylight means that you are at the mercy of the weather conditions, and should it be too wet or windy to be taking pictures outdoors, another option is to shoot indoors. This may sound like a poor alternative, but as long as there is a reasonable amount of light to work with, you should still be able to take great portraits using window light. If you set up the picture properly, it need not be obvious that the portrait was taken indoors – if the lighting is good enough, a non-descript background will not give the location away.

Alternatively, you could use the indoor surroundings to your advantage and incorporate them into your picture – for instance, have the subject looking out through the window.

Incidentally, using window light should not be restricted only to occasions when the weather is bad outside. This is also a good option when the light is particularly bright outside, as you can set the subject against the window and bounce light back on them to create romantic portraits with a soft light and perhaps a pure white backdrop.

TOP TIP
By using reflectors and diffusers, you can increase or decrease the amount of light on your subject, but leave the background unaffected. This is a creative technique known as key shifting.

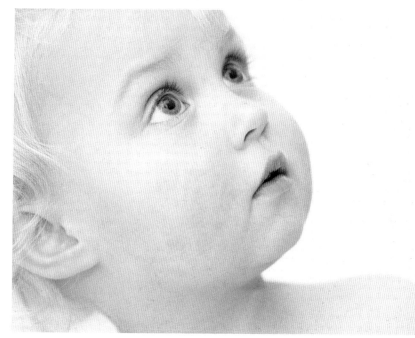

BATHTIME FUN
A white bath reflects lots of daylight and can be used quite literally to bathe your subject in light.

For details on using studio flash for portraits, see Studio flash techniques.

CHILDREN

Never work with kids? Rubbish! Photographing children can be fun and highly rewarding. It can also be very tiring and frustrating, so make sure you go about it the right way.

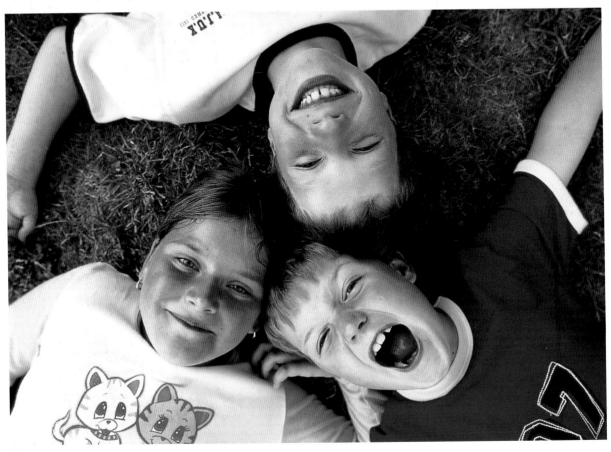

Babies, along with puppies and kittens, win every cutie contest, so be sure to capture lots of pictures of them. Newborns are too young to do anything particularly interesting, but their frailty alone makes them lovely subjects to capture. Include a parent in the picture to add a sense of scale to the image. From six months on, babies start to make expressions and react to sounds, so take advantage of this and capture some great shots.

The first thing to remember is that children have a very short attention span, so you need to work fast and keep them interested for as long as possible. Digital photographers have a real advantage when photographing children – they can show the kids the pictures straight away on the back of the camera. The result of this is that a group of reluctant young grumps almost invariably becomes a boisterous bunch of buddies, all clambering to be the next to be photographed. Use their enthusiasm and excitement to your advantage while you hold their attention.

The next thing to bear in mind is that kids rarely do what you want them to do. Ask them to sit and they stand, request a smile and you are rewarded with a frown. Rather than get annoyed, keep taking pictures – you might not be getting what you want, but they will still be great shots!

FRIENDS
You won't hold a child's interest for long, so catch kids while they're playing with friends for natural, lively portraits.

TOP TIP
Always ask permission from a parent before photographing any child.

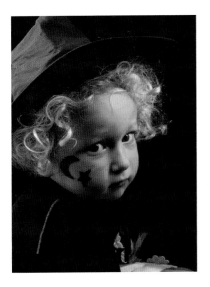
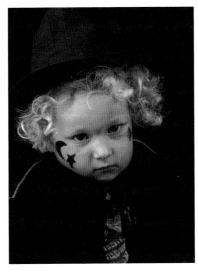
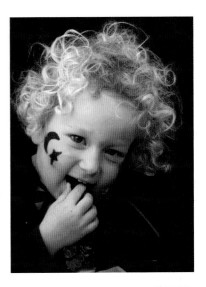

LITTLE WITCH
Most children go through a range of emotions in a very short space of time. Each of these images works well, even though the girl is displaying three very different moods.

Props
Adding simple props can transform a portrait. Get the child to prop sunglasses on their head, mix and match jewellery, wear a hat or hold a flower. Sometimes it works, sometimes it doesn't – but it is always good fun.

Make sure you have plenty of toys to hand, as they will keep the kids occupied. Frame a picture, call their name and grab the shot when they look up.

Because children rarely sit still, you will have to work on your feet. Zoom lenses come in really useful in these situations, as they allow you to shoot a group of children playing with the wide-angle setting, and then zoom in tight to capture an individual's expression.

Clothing for children is usually brightly coloured and full of patterns, so make full use of this to create colourful compositions. Children look extremely cute when wrapped up in coats and hats, so take them outside and grab some pictures in the garden.

Finally, it is worth remembering that a child's mood can change in a split second, so keep the camera ready at all times – a sad-looking child can make a poignant image.

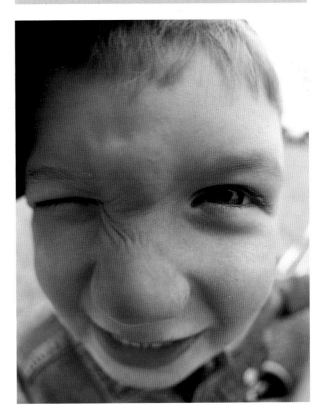

BIG NOSE
Kids like having fun, so take bizarre portraits – here the photographer used a fish-eye lens.

LANDSCAPES

Taking pictures of landscapes is a favourite choice of a great number of enthusiast photographers. Every country – and in most cases, every region of every country – has a countryside with its own unique identity. No matter how many countries you visit, you will always find a different landscape to capture, from the beautiful subtle greens of the English Lake District to the tropical paradise of a Caribbean island.

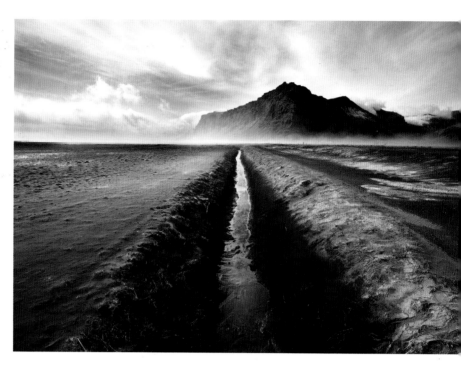

ICELANDIC VOLCANO
Strong lines converging from the centre of the image make for powerful lead-in lines.

LANDSCAPE GEAR

If you are heading into the great outdoors, ensure that you have everything you need, as you won't be able to go back home to stock up. However, as you will be trekking over relatively long distances, you won't want to take unnecessary items with you. So before setting out, decide carefully what you need.

TOP TIP
Keep an eye on the weather forecast. When a storm is predicted, head to your location with time to spare to allow for proper preparation.

Gear checklist

Spare batteries: Are the batteries loaded inside your camera (and other items such as a flashgun) fresh? Do you have a spare set?

Lens choice: For landscapes, the focal length of choice is a wide-angle. SLR users may also want to pack an ultra-wide zoom and possibly a short telephoto zoom.

Filters: Essential for taking premium landscape images.

Tripod: You'll be setting a small aperture to give plenty of depth of field, so a tripod is essential to cope with the long shutter speeds. A lightweight model makes the most sense, as you will be carrying it over long distances.

Remote release: Ensure you minimize the risk of camera shake by firing the shutter remotely.

LANDSCAPE COMPOSITION

Composition is discussed in the section on composition (see Basic techniques), but it is worth highlighting here the most important aspects of composition specifically in relation to landscape photography.

The first is the rule of thirds, which dictates where important elements of the scene should fall in the frame to provide a balanced result. This rule not only relates to individual elements, such as a tree or a farmhouse, but also to lines running through the frame. The most common of these is the horizon, which should be placed along the upper or lower third of the frame. Other common lines include rivers, walls or boundaries of fields. The lines need not only run horizontally – vertical and diagonal lines also work well, the latter in particular leading the eye into the frame.

Watch where the sun is in relation to the camera. Having it to the side is preferable, as it will cast attractive shadows in the scene from objects such as trees, fences and hills. With the sun behind you, the shadows are hidden from view, while shooting into the light (contre-jour) creates strong silhouettes but runs the risk of lens flare.

FOREGROUND INTEREST

Taking pictures with the camera in the upright position can result in very strong images, in particular where there is good foreground detail. While landscape-format shots can show off foreground interest, the extra depth created by an upright image can provide a sense of distance and scale to the scene.

By using a wide-angle lens, getting very close to the foreground subjects and adopting a low viewpoint, you can accentuate these elements and give them a prominent, larger-than-life appearance that dominates the image. Ideal subjects to use as foreground interest include rocks, fences, flowers and boats.

SHOOTING IN BAD WEATHER

Landscape photography isn't all about taking pictures in brilliant sunshine – shooting in bad conditions can result in strong, moody images. In particular, the onset of a storm can produce the most dramatic clouds. Skies filled with dark grey clouds provide a fantastic backdrop to a landscape. If you are lucky – and prepared – you may be blessed with a parting in the clouds that allows a golden streak of sun to break through and provides a split-second opportunity to capture a truly dazzling scene.

Taking great bad-weather pictures involves a lot of waiting. You never quite know what the elements will do – one minute the scene may be dull and lifeless, while the next could result in a brilliant image. Capturing a magical moment requires dedication, patience and preparation. If you are willing to take the time, the rewards can be extraordinary.

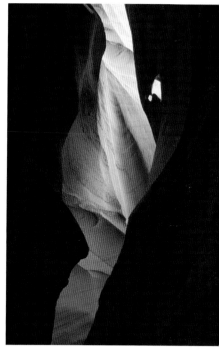

DESERT CREVASSE
When shooting rocky outcrops, create compositions that lead the viewer to search for visual clues to determine the scale and nature of the subject.

Breaking the rules

Once you have learned all the rules, don't be afraid to break them. Photography is not an exact science, so rules can be broken yet give a pleasing result. If you find a scene that you think merits, for example, placing the subject in the centre of the frame, don't be afraid to try it.

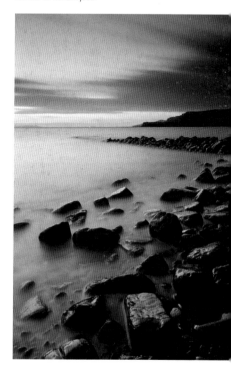

ROCKY SHORE
Rocky coastlines make for dramatic landscapes. An exposure of 30sec at f/16 ensures excellent depth of field and a beautifully blurred sea.

FILTERS

Perhaps with landscape photography more than any other subject, knowing when to use the appropriate filter can turn a good image into a fantastic one. Although there are dozens of suitable filters, the essential shortlist follows.

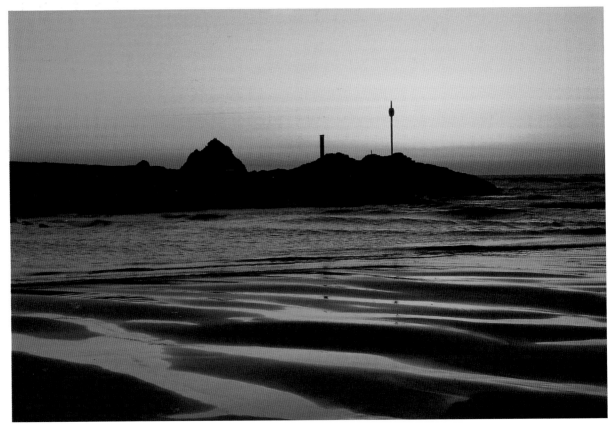

SUNSET

If the colours of a sunset lack impact, consider using a warm-up filter to add extra warmth to your image.

Polarizer

A must-have for landscape photography, the polarizer increases colour saturation, bringing out the greens of foliage and grass, as well as providing a deep blue sky as a backdrop. A polarizer also helps with water, as it minimizes reflections off the surface.

Warm-up

When the light is a little cool and needs warming, use the 81-series warm-up filter to inject a soft golden glow into the scene. The warm-up is also a good choice for enhancing the colours of sunrise or sunset.

Neutral density graduate

Specialist landscape photographers won't leave home without the humble neutral density graduate (ND grad). Bland, pale skies are a thing of the past with the ND grad, which darkens the sky while leaving the foreground unaffected.

Neutral density filter

An ND filter increases the exposure time when shooting in daylight, which is useful when you want to blur the motion of water or clouds in the sky. The ten-stop ND filter has the most pronounced effect.

OPTIMUM SHARPNESS

For a sweeping landscape scene to work best, the image should be sharp from the foreground to the furthest reaches of the frame. To do this, the depth of field must be as deep as possible. Setting a very small aperture is one technique for increasing depth of field, while for SLR users, using hyperfocal focusing is another.

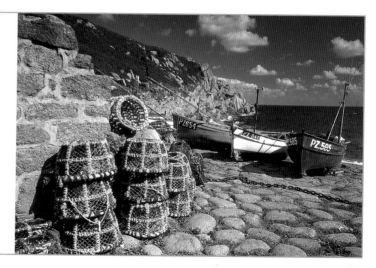

LOBSTER POTS
A small aperture used with a wide-angle lens ensures enough depth of field to record the entire scene in sharp focus.

TIME OF DAY

The appearance of a landscape varies radically over the course of a day as the characteristics of light change. Around sunrise and sunset, the light has a very strong warmth that looks extremely attractive, so these are very good times to be shooting landscapes.

During the colder seasons, the sun doesn't rise fully into the sky, so you can shoot all day long – weather permitting – as the light never becomes particularly harsh. This isn't the case during the warmer periods of the year, in particular in summer, where the hours from midday to early afternoon see strong, harsh light that is not particularly good for capturing beautiful landscape scenes.

Mornings are also particularly good for landscape photography in valleys and sheltered areas, where ground mist forms into a blanket over the ground. You need to work fast, as the rising sun will quickly make the mist evaporate.

STORMY DAY
Using an ND graduate filter allows the detail of the clouds to be recorded in the image rather than being burnt out.

Colour saturation

The level of colour saturation that you prefer in your images will have a major effect on the mood and atmosphere of the landscape. Digital users should set the colour saturation at different values to provide vibrant colours or very subtle tones. This can be done by selecting different Picture Styles, such as Landscape or Vibrant, or alternatively the colours can be adjusted in post-production on your computer.

EXPOSURE ADVICE

With most landscape scenes, much of the frame is filled with sky, so there is a risk of underexposure. Using an ND grad filter can help overcome this problem. Another way is to take an exposure reading from the grass and lock this setting. Greens in a landscape are a good midtone from which to take a spot-meter reading or make an autoexposure lock (AE-L).

THE FOUR SEASONS

In temperate climates, the change of seasons completely alters the landscape. The same scene looks completely different depending on the time of year. Each season has its own unique characteristics that make outdoor photography an all-year-round proposition.

WINTER

Winter is often perceived as a barren period, but there is still plenty of scope for photography. This is particularly true when there is a sequence of winter days and nights with little cloud, as this brings with it various natural elements that make great pictures and demand that you get up early to spend the whole day capturing them.

Winter mornings bring plenty of opportunity to capture beautiful misty landscapes. Head for the hills and use a telephoto lens to isolate ghostly trees, or seek the shore of a lake or river and use the colours of sunrise to mix with the mist over the reflections on water to create an ethereal-looking result. As the day brightens, seek out leaves and vegetation covered in frost, as these make stunning natural still lifes. Use a telephoto lens to isolate leaves and try close-up techniques to capture frosty leaves in fine detail.

If you are really lucky and it has been snowing, you could be blessed with a winter wonderland. If you are early enough, the landscape should be free from human footprints and the snow will not have melted from the branches of trees, allowing you to capture incredible winter scenes.

Use a polarizing filter not only to deepen blue skies but also to reduce the glare and reflection from snow. Some photographers also like to experiment with White Balance settings to remove some of the coolness from the snow or alternatively add a blue cast for extra mood.

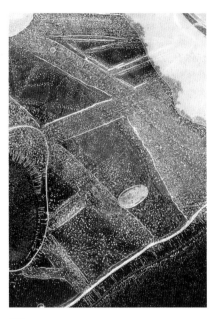

ICE
Frozen water can make a great still life image as intricate patterns appear.

EXPOSING FOR SNOW

Correctly exposing a winter scene can be very tricky if you are not sure what to do. The predominance of white in the scene fools camera meters into underexposing the scene. There are various ways around this:
1. Leave the camera in automatic but bracket over the indicated reading by +1, +1½ and +2 stops.
2. Set the camera to 'snow and sand' mode if it has it.
3. Take a handheld meter reading. Bracket by +½ stop to be sure.
4. Take a spot meter reading from a midtone, such as green vegetation.

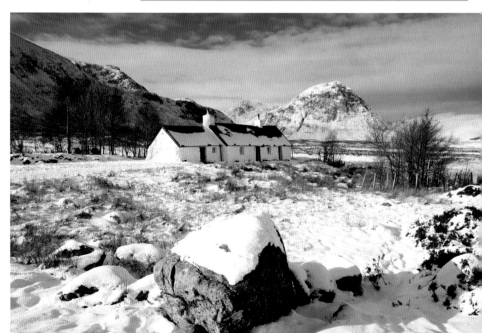

BLACK ROCK COTTAGE
Landscapes take on a whole new look when covered in snow so be sure to head out after a heavy snowfall.

SPRING

An explosion of colour greets us in spring, when plants, flowers and trees that have been lying dormant during the winter months emerge in a glorious multicoloured invasion of life to announce the arrival of a new season. The spring season provides nothing short of a metamorphosis in the landscape, making it a dream season for photographers, particularly those looking to exploit colour.

Spring days are longer than winter ones, which is great news for photography, as is the fact that the days tend to be filled with more blue skies and less cloud. Saying that, spring is often prone to sudden bursts of rainfall. However, this can be a positive thing as you might have a good opportunity to capture rainbows, which are most common in this season. With rain also comes dew, so look to capture dewy still lifes in the morning – spider's webs are a favourite with many photographers. You will need a lens capable of close-ups to capture the best result. In addition to webs, look for beads of dew on grass and leaves, shooting so that the subject is backlit, which will add a lovely sparkle to the dewdrops.

A drive through most rural areas should reveal potential scenes. Fields will be filled with flowers, be they poppies, buttercups or tulips. Woodland will also have its own vegetation springing up, such as snowdrops and daffodils. Use a wide-angle lens to include wide expanses of scenery, as well as for getting in low and close to blossoming flowers to emphasize their colours and blooms.

To bring out the colours of flowers, the lushness of green vegetation and the blues of a spring sky, you will need a polarizing filter. Although colours will probably look great without it, using a polarizer will add that little extra bit of saturation to make your pictures really stand out.

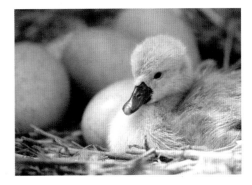

DUCKLING
Spring sees a new generation of many types of animals.

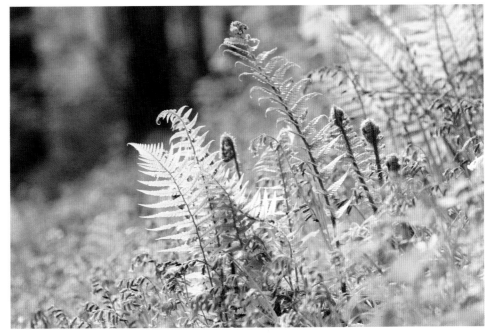

THE START OF SPRING
Spring is the season when the landscape literally bursts into life and offers nature photographers a wealth of photographic opportunities.

SUMMER

For most landscape photographers, summer is the season to go out and take pictures. The weather is at its finest and most predictable, the days are at their longest, and the whole countryside is teeming with life and colour.

The polarizer comes into its own in this season and should become a semi-permanent fixture on the front of your lens. The summer is an excellent time to fill up your album with landscapes – the grass will never be greener and thicker, and the trees are at their glorious peak. As well as general landscapes, look for fields of colour – try to locate a field of sunflowers, as the bright yellow of their petals contrasts brilliantly with a clear blue sky.

In summer, the middle part of the day, when the sun is highest in the sky, is not usually the best time for landscapes, so use this time to shoot still lifes and other subjects, and save your landscapes for the earlier and later parts of the day.

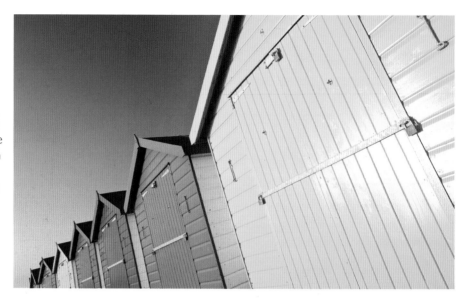

BEACH HUTS
Summer isn't all about beautiful, green landscapes. Always look for other subjects that indicate the summer theme, such as these colourful beach huts.

BEACH SCENE
Summer provides a great opportunity for candids on the beach or any other typical summer activity.

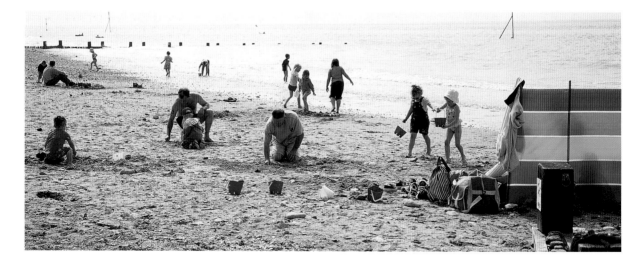

BODMIN MOOR
In early autumn, head into woodland and capture it while the green of later summer is joined by the gold of autumn.

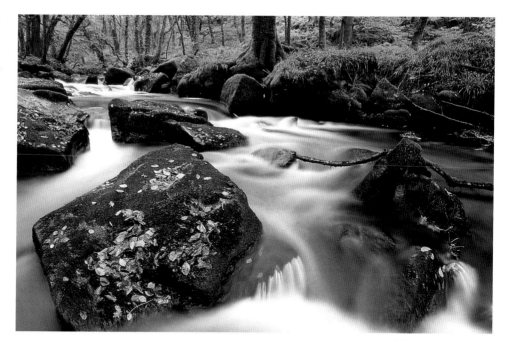

AUTUMN (FALL)

The prelude to winter is met with an amazing burst of colour as the landscape changes from green to gold. Autumn is a favourite season with many landscape photographers, who use the relatively short time when autumn's golden glory is evident to capture images worth their weight in gold. Although the autumn season lasts the same as any other, the actual time that the glorious colours of the changing leaves remain on trees and plants is very short – sometimes only a couple of weeks. Keep your eyes open for the changing colour of the landscape and join in with the gold rush.

In temperate climates, the best time to capture autumn is from mid-October to mid-November. Aim to visit areas of natural beauty that are home to deciduous trees and vegetation, as these are the types that change colour. The actual technique for photographing them is the same as for shooting landscapes at other times of year, but because you have less time to work, you should plan ahead and be prepared.

The warm glow that is associated with shooting in the early morning or late afternoon is even more accentuated in the autumn, when the warm light adds further colour to the reds and gold of the autumn foliage. The long shadows cast by a low sun work well in wooded areas, so be sure to head into woodland as well as shooting it from the periphery.

AUTUMN LEAVES
Placing autumn leaves of different colours against each other produced this simple yet effective still life image.

Although the colours of the scene will already be warm, consider using a warm-up filter or adjusting the White Balance to add warmth, as well as the trusty polarizer, which will add a complementary deep blue background to the scene.

In this season more than any other, the vegetation that has fallen off the trees is as important as that remaining on it. The bed of golden leaves that you will encounter in woodland makes its own images. Shoot natural still lifes of leaves carpeting the ground, as well as other objects, such as chestnuts and acorns.

WATER

We live on the blue planet, with two-thirds of its surface covered by water, so we shouldn't really have any trouble finding inspiring water-based subjects to photograph. There are plenty of creative options available.

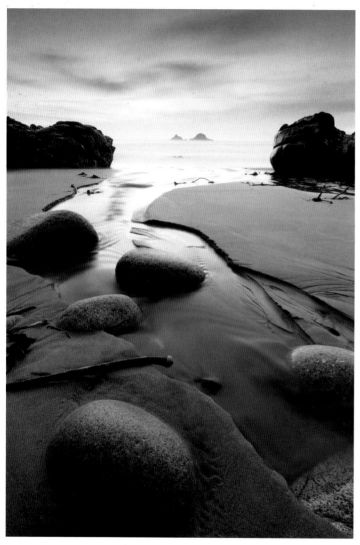

WATER IN THE LANDSCAPE

You should not need to travel far to find water in landscapes. In the countryside you can find streams and rivers meandering through the scene, while in mountainous or hilly areas, waterfalls are fairly common. All of these subjects can be used as an important element in a scene, or, by getting closer, can become the main subject of the image.

Even in urban areas, you should be able to find suitable subjects – in addition to rivers, many towns and cities have canals, while fountains are also commonly seen.

Rain can be a great subject for photography, and once a rainfall has died down or stopped, abstract images can be taken of subjects reflected in puddles. The impact of reflections in water shouldn't be ignored; scenes with lakes, rivers or other large water bodies gain an extra dimension through reflections, especially when strong colours are evident in the scene, such as during sunsets.

Coastlines arguably provide the photographer with the greatest number of options, as the sea can be used as a backdrop to a sandy beach or a rugged, cliff-filled coastline. The sea looks even more dramatic in rough, stormy weather, when crashing waves can bring turbulent life and energy to the scene.

No matter where you live, or whatever the time of year, look out for the potential of the earth's greatest resource as the subject of your photography.

ROCKY COAST
Channels of water make effective lead-in lines, providing a natural path for the eye to follow through the image.

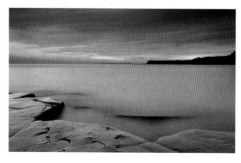

SUNSET
A long exposure allows the beautiful colours of the sunset to reflect off the water's surface for added appeal.

TOP TIP
A polarizing filter is very useful for photographing water, as it can be used to remove surface reflections.

ICY WATERS
When visiting very cold locations, look for chunks of ice and use them as an unusual choice of foreground interest.

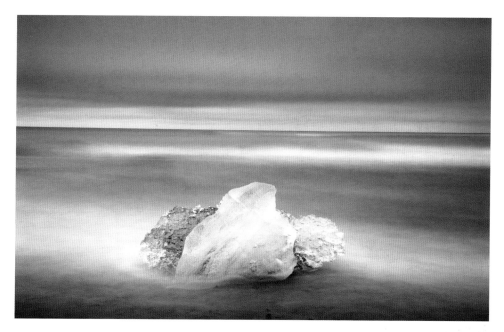

WATER IN CLOSE-UP

You don't need huge volumes of water for great shots – a single droplet of water can create an interesting close-up image. You can also use a water spray to create a multitude of droplets on a surface. After a rainfall, head out into the garden in search of rain droplets dripping from leaves or flower stalks, which can also make gorgeous close-up images.

FREEZE IT

Many photographers have discovered that freezing a subject in water can produce very interesting results. It's a simple process – place a recognizable small object in a bowl or tray of water and freeze it. Then take the chunk of ice out of its container, wait for the outer surface to defrost enough to reveal the subject, and photograph it.

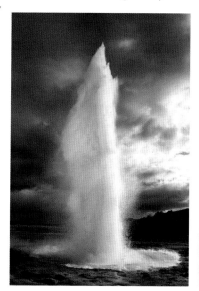

GEYSER
A fast shutter speed is required to freeze very fast-moving water such as this geyser.

Shutter speeds

The choice of shutter speed can have a major impact on how water appears in your images. A fast shutter speed can freeze movement – this is useful if you want to record individual droplets. Use a slow shutter speed, and the movement of water will be recorded as a blur. This can result in water taking on an ethereal appearance similar to fog or mist. A neutral density filter is a useful accessory if you want to use slow shutter speeds in bright light.

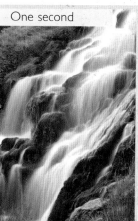
One second

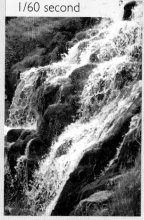
1/60 second

WATERFALL
These two images demonstrate the different effects that are possible by using a slow or fast shutter speed.

ACTION

One of the hardest techniques to master is photographing a moving subject. Taking great shots of sport and action demands patience, skill and a small degree of luck.

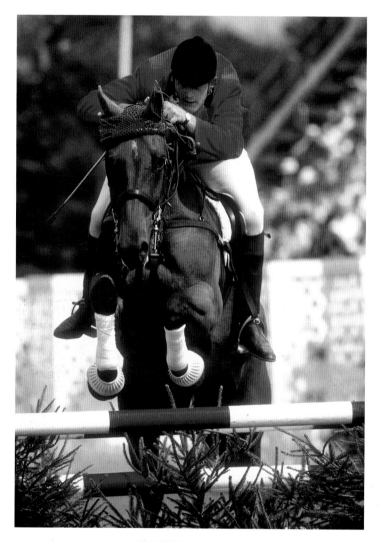

THE KEY IS TIMING

Whether taking pictures at a major sporting event or of family and friends at play in the local park, the key to capturing fast and frenetic moment comes down to mastering one key skill: timing. While some subjects, such as landscapes or portraits, require the photographer to work relatively slowly, action photography demands fast thinking and fast working. The perfect moment may last for only a fraction of a second, so being ready to grab the moment is vital.

Mastering timing comes with practice and experience: you need to get the vital elements of exposure, focusing and composition working together for that split-second opportunity. It is not easy, but with practice you can greatly increase your rate of success.

SHUTTER SPEED TECHNIQUES FOR ACTION

How you capture action depends in particular on the shutter speed you set. You must decide whether you want to freeze the action, in which case select a fast shutter speed, or use a slow shutter speed in order to create more of a sense of movement in the image by adding blur to the subject, the background, or both.

SHOW JUMPING
Pre-focusing is a useful technique when subjects take a particular course. Here, pre-focusing on the jump meant the photographer could concentrate on timing the exposure.

GET EQUIPPED FOR ACTION

You will probably be some distance away from the subject, so you should use a camera that either has an integral lens with a good telephoto setting or fit a telephoto lens – a good choice is the versatile 70–300mm zoom.

Always leave some space in the frame around the subject, otherwise you run the risk of cropping them should they move erratically. Take a careful note of the shutter speed, to ensure that pictures aren't ruined by camera shake. You can increase the shutter speed by raising the ISO rating, with recent generations of camera delivering excellent results with no major noise problems at up to ISO 1000.

The success rate for action photography is relatively low, but you increase your success rate by shooting a sequence of images. Use a continuous shooting mode if you have one. When shooting sequences, you're best shooting in JPEG rather than Raw otherwise the frame rate can slow down.

Freezing action

Freezing movement is the easiest technique to master, as essentially all you have to do is set a fast enough time to freeze any movement. Make sure to set your camera to a high enough ISO rating to handle the conditions. The following table provides examples of what shutter speeds you should set for particular subjects, depending on whether they are travelling across the frame or towards the camera.

Recommended shutter speeds

Subject	Across frame	Towards camera
Runner	1/250 sec	1/125 sec
Trotting horse	1/250 sec	1/125 sec
Sprinter	1/500 sec	1/250 sec
Galloping horse	1/1000 sec	1/250 sec
Car (60mph)	1/1000 sec	1/250 sec
Motorsports	1/1000 sec	1/500 sec

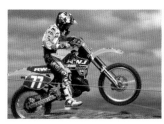

WHEELIE
Practise panning with a telephoto lens to capture images like this.

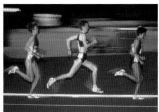

RUNNERS
Panning works well with slow-sync flash.

USING FLASH IN ACTION

For subjects that are relatively close to you, it is worth experimenting with adding flash to your images. By combining slow-sync flash with panning, you can create very dynamic images where the subject leaps out of the frame due to the extra exposure. This technique is widely used in cycling and motocross photography, and is well worth considering. Take care not to startle your subjects when using it, though!

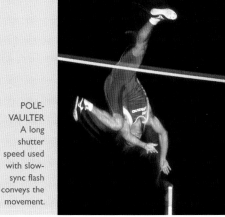

POLE-VAULTER
A long shutter speed used with slow-sync flash conveys the movement.

Panning

Another technique worth trying is to set a slower shutter speed and capture a real sense of movement. This is far more difficult, but is well worth persevering with, as the results can be very dynamic and exciting.

Panning involves keeping the moving subject in the frame, following its movement in the viewfinder, then firing the shutter release while continuing to track the subject. Get it right, and your image will show a sharp subject set against a blurred background. Even with relatively slow-moving subjects, the result can look extremely effective. The secret is to have a very smooth panning movement, so that the direction and speed at which you move the camera matches that of the subject. For motorsports, try speeds of 1/250 – 1/500 sec. For athletics, anywhere from 1/30 sec for long-distance runners to 1/125 sec for sprinters is a good starting point.

BATSMAN
Use a wide aperture to throw distracting backgrounds out of focus.

SPORTS TECHNIQUES

Motorsports

For maximum impact, always shoot cars or bikes coming towards you, rather than going away from you.

Athletics

Rather than try to keep up with the action, pre-focus on part of the track and press the shutter just before the subject reaches it.

Tennis

Players usually have a style of play that means they tend to stick to particular parts of the court, such as the baseline. Exploit this by pre-focusing on these areas.

Football

This is a very difficult sport to photograph, so take advantage of set pieces like corners or free kicks, when the action is less frenetic.

STILL LIFES

This term refers to photographs of static objects, usually arranged. Form, shape and colour are key ingredients to still life photography, but a keen eye to spot potential subjects is very important.

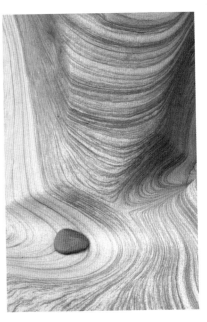

FOUND OBJECTS
Found still lifes, such as this small stone settled on a stripy outcrop of rock, can make for very interesting still lifes.

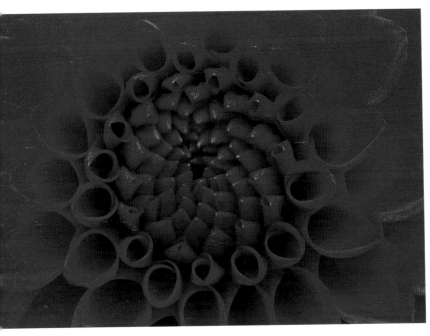

BOLD AND BEAUTIFUL
Choosing to use only a single colour in a composition is a bold move but can be very effective, such as in this close-up of a flower.

WHAT SUBJECTS ARE GOOD FOR A STILL LIFE?

You don't need to look far for inspiration; every home is filled with objects that can create very interesting still life images.

The kitchen is often a great place to start. Fruit and vegetables offer huge scope. You can arrange a group of identical fruits or mix and match them. Experiment to find potential images.

Almost any household item can be used to create a still life. Bottles and jars are promising subjects, whether full or empty, while standard tools, such as a hammer, some old paintbrushes or a pair of scissors, can succeed if you work with them imaginatively.

Step into the garden, and another assortment of subjects presents itself. Flowers are particularly popular, thanks to the many shapes and vibrant colours they come in: shoot one individual flower or set up a bunch in a jar – your options are endless. Rummaging around in the undergrowth can reap rewards, as leaves, acorns, chestnuts and berries all present themselves as intriguing subjects.

When you start to think of what is available for the still life photographer, it becomes clear that the creative options are endless. And because you can try this type of photography indoors, it is a good subject to try on cold or wet days when venturing outside is an unappealing option.

COLOUR OR BLACK AND WHITE?

The vast majority of still lifes are shot in colour. Although shape and form are important, the contrast of colours between subjects can be very effective.

That said, monochromatic images can also look very powerful, especially if they feature subjects with strong textures, or if the images have been made to look nostalgic, such as a shot of old toys.

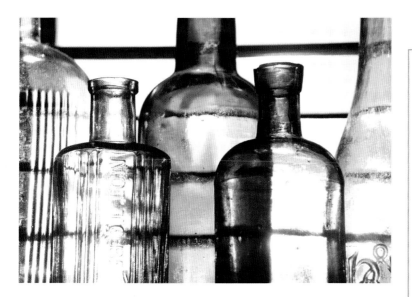

STILL LIFE TIPS

• A macro lens/facility is ideal for still life photography, as it is invaluable for close compositions of smaller still life objects, such as flowers, fruit and so on. That said, the range of a standard zoom is good enough for a wide variety of still lifes.

• More often than not, you will shoot your still lifes indoors. This means that using a tripod is a good idea, as shutter speeds will be relatively slow. While setting up a still life, check your composition through the viewfinder, knowing that the composition will not change. This is particularly useful when you are working with an intricate tabletop arrangement.

• Window light is ideal, but studio lights are more controllable and always available, so it is worth investing in a one- or two-light outfit. You don't need anything powerful, so look at budget heads on offer.

BOTTLES
Look around for everyday objects in your home and use them to capture creative results.

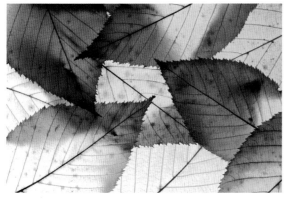

LEAVES
Arrange translucent objects such as leaves on a lightbox for imaginative still lifes.

BACKGROUNDS

The background of a still life plays a major part in its success. Keep it simple wherever possible, or use a background that complements the subject.

Found still lifes

This term refers to still life images that are created using subjects that have been found, rather than set up. This is a more difficult discipline to master, as finding suitable subjects with appropriate lighting isn't easy, but it is worth testing yourself to see what you can achieve.

BACKLIGHTING
Backlight lightly coloured flowers by placing them next to a window to capture clean, bright and effective still lifes.

FINE ART

Is photography an art form or a science? This argument rages on and on. Any picture that is taken as a creative exercise can be said to be an art form, in the same way that any painting or drawing can be classed as such. However, although it is impossible to define fine art, it is possible to point out subtle differences that allow some pictures to be clearly categorized as fine art. The first is that, invariably, fine art pictures are intended to be displayed and sold. The second is that fine art images are creative pieces of work that usually have a distinctive style, developed by the photographer. Finally, the production values of a fine art picture are high.

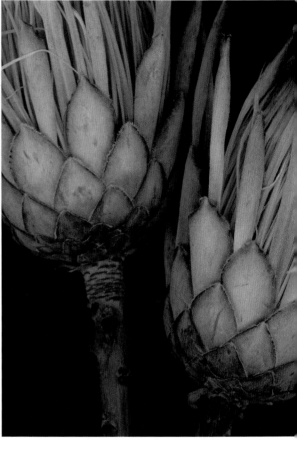

MINIMALIST LANDSCAPE
Using a ten-stop ND filter to give exposures lasting several minutes produced this simple yet effective fine art image.

DEVELOPING A STYLE

As with any art form, developing your own style is crucial. There is nothing wrong with looking at the work of photographers you admire and adopting their style as a way to develop your own approach, but if you want to become a fine art photographer in your own right, you must develop your own style. This could be in your choice of subject matter; how you compose, light or print your images; or how you decide to present your work. The key factor is that, to be recognized as a fine art photographer, you must be confident in your own style – if your heart is really in what you are doing, your chances of success are higher.

Look for a particular theme and work around this, rather than trying to cover many different subjects. Decide whether you want to take a very classic approach or create your own abstract way of working. The key to success in fine art is to be individual and unique in your approach. You also need to be aware that your style may not be universally popular and so not commercially successful, but as long as you are satisfied with your work, you have achieved your aim.

SEPIA STILL LIFE
It's amazing how with a little imagination and craft, simple everyday objects like fruit, vegetables, plants and tools can make for wonderful fine art images.

What subjects suit fine art?

Any subject you can photograph has the potential to become a fine art image. Your imagination and creativity are what will ultimately determine the standard of your fine art work, not the actual subject matter. The most common subjects in the past have been portraits, nudes and still lifes, but you should not be afraid to experiment – by doing so, you will be able to discover which areas are your strongest.

DIGITAL OR DARKROOM?

Traditionally, fine art photographers also had a major part to play in the darkroom – in fact, some saw printing an image as being more important to the final result than actually taking the photograph. Producing exhibition-quality prints from inkjet printers or via specialist digital printers is now the most common process. The advantage to the photographer is that once the image has been digitally manipulated, the final print is much easier to achieve. From some collectors' point of view, however, prints produced in the darkroom still hold more value, as each one is unique.

Something that is very important to remember is that fine art prints have traditionally been produced to be archival in quality – in other words, to last more than a lifetime. When producing fine art prints, it's important to ensure that the process provides archival properties.

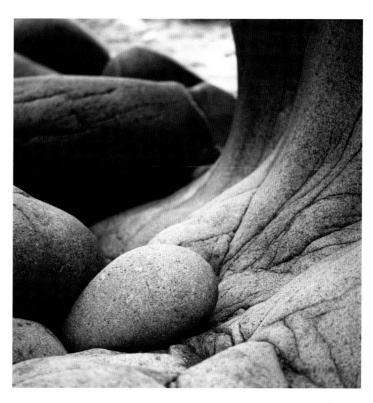

STONY COASTLINE
The best fine art photographers are able to create captivating compositions by concentrating their attention on looking at the shape and form of objects and how they can be composed within the image frame.

SELLING YOUR WORK

Some fine art photographers take pictures with commercial interests in mind; for others, making money from their art is a secondary consideration. If you wish to pursue a career in fine art photography, or simply wish to make extra money from your work, there are some considerations to be aware of.

Having an exhibition of your work is a little like the chicken-and-egg scenario: to be exhibited, your work needs to be well known and respected, but to become well known and respected, your work has to be exhibited.

Having your work displayed in a gallery is the ultimate exhibition. However, there are other ways to have your work seen by a larger audience. One tried-and-tested method is to send your work to a specialist photography magazine. Many of the popular magazines showcase the work of aspiring, as well as established, photographers in every issue. Sending your images to a magazine is also a good way of gauging the standard of your work, as only the very best is published.

For a global audience however, your best option is to set up your own website and exhibit your work on the internet. Once it has been set up, a website is relatively easy to maintain and update – getting potential customers to visit your site in the first place is a different matter, but it is a good credential to own.

Finally, for your work to receive any form of praise, it must always be presented at the highest standard. The quality of the print and how it is mounted and framed are all crucial elements. If you neglect these areas, all the hard work and effort that you spent on producing the image will be wasted.

Colour or black and white?

Fine art photography was for a long time the reserve of black-and-white prints, but colour work is becoming increasingly popular, in particular in the abstract market. Choosing between colour or black-and-white work is the prerogative of the photographer, and should be determined by the style and approach of the photography and the subject matter.

DOCUMENTARY PHOTOGRAPHY

Some of the most recognized names in photography have been associated with the field of documentary photography or its associated discipline of photojournalism. In almost all cases, they worked exclusively in black and white.

PHOTO STORY

Good documentary photography usually comes not from one image, but from an entire series. It is worth bearing this in mind and thinking about your theme. It could be as simple as photographing people at your local market, or even capturing life in your own household over the course of a year. A good photo story works by having a strong link between the pictures, be it a character, a location or an ideology.

 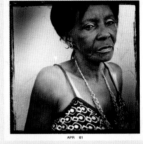 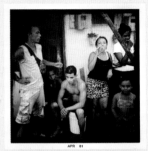

 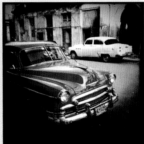

CUBAN CULTURE
When documenting an event or a way of life, look to capture a variety of everyday moments that can be combined to form an effective photo story.

If there was ever a need to demonstrate the merits of black-and-white photography, it would have to be documentary photography. Almost without exception, photographers throughout the decades have captured true-life moments of our lives through the medium of monochrome. Black and white is the perfect medium, because it tears away any distractions that might be imposed by colour and leaves us with the basic ingredients of the scene.

Documentary photography is one of the hardest disciplines to master, as you need to have a good eye for observation as well as composition, and you need to be very aware of what is happening around you. Most people go about their daily business without paying too much attention to

what is happening around them. A good exercise to test your observation skills is to sketch your street. What shapes are the windows? How many cars are parked outside? Are there any lampposts, chimneys, pillarboxes or trees? When you start to think about it, it becomes clear that we see only what we need to see to get from A to B. To be a documentary photographer, you need to be aware of everything that is going on around you.

Another reason why documentary photography is not for the faint hearted or impatient is the amount of effort you need to be prepared to go through to achieve great results. This isn't the type of photography you can do in a day, a week or even a month. Documenting life takes

time, so any projects that you undertake will need to last some time.

In addition, because you will usually be photographing strangers, you need to be prepared for some people expressing their dislike of having their picture taken.

If you are willing to make these sacrifices, particularly with regards to the time required to cover a theme properly, then you have the potential to be a good documentary photographer.

Shooting great documentary images is all about working quickly. Although digital compacts can be suitable, digital SLRs or CSCs are the best cameras for this type of work. In particular, you should consider models designed to be lightweight and compact. The Panasonic Lumix GH2, Canon EOS 550D and Olympus PEN E-P3 are ideal choices, offering responsive autofocus and excellent quality.

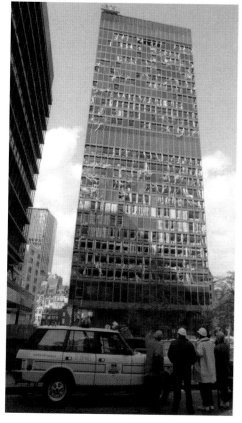

AFTERMATH
Major incidents are the 'bread and butter' of the photojournalist. This image was taken in central London after a bomb explosion.

'The decisive moment'
This term is associated with legendary French photojournalist Henri Cartier-Bresson, who coined the phrase to describe capturing a particular moment in time.

MARCH
Political marches are always worth covering, as the chance to capture historic protests is not to be missed.

POPULAR THEMES
Any sphere of life is suitable for documentary, but there are some themes that are particularly popular. They usually centre around people and how they interact with others.

Local life is a good starting point. Many photographers have documented their street or local area over a period in time to illustrate the local characters and their way of life. This is an interesting exercise, especially if you return to the same scene over a number of years, as you can build up a strong picture of how the society and environment changes over time.

Great documentary photography often stems from moments in time that are particularly terrifying or exciting. Political unrest, which results in rallies and protests, is ideal for the photojournalist to document, while capturing excitement or disappointment on faces watching a major sporting event is another classic observational moment. Be aware of when your subjects are likely to do something out of the ordinary, and be prepared to exploit it.

Although social documentary can be rather depressing, there is often a lot of humour to be found too. This may involve spotting quirky or mismatched and incongruous subjects, such as a small person walking a Great Dane, or a scruffily dressed person looking at smart suits in a shop window. As with other types of documentary photography, observation and working quickly, as well as a sharp sense of humour, are vital.

ARCHITECTURE

Although buildings are constructed to serve a functional purpose, architects try to create as attractive a design as possible for both the interior and exterior. Old and new, big and small, industrial and residential – buildings come in many forms, each offering the photographer their own personality to capture. Taking pictures of buildings, or more specifically architecture, is an easy practice for most photographers to take up; and because buildings are static, you can take as long as you like to photograph them and return at your convenience to record their changing face during the course of the day.

TOP TIP
Churches and cathedrals make strong subjects, particularly when floodlit at night.

CLASSIC BUILDINGS
Some buildings are only suitable to shoot during the day, as they're not floodlit at night.

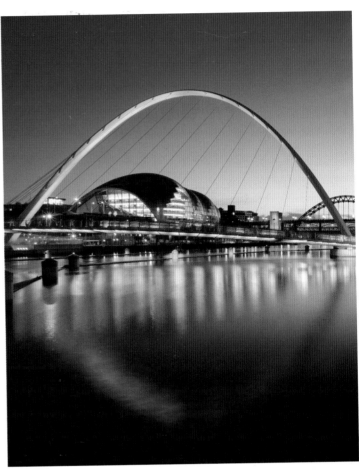

NEWCASTLE BY NIGHT
Shooting at night can transform locations so be sure to visit a scene that you've captured during the day at night too.

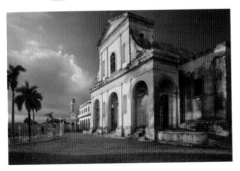

MOSQUE
Architecture varies from culture to culture, so when travelling, always check out buildings – places of worship are particularly intricate and interesting.

DAY AND NIGHT

The most important point to remember about photographing architecture is how the appearance of buildings changes over 24 hours. During the course of the day, the changing light not only means that the scene looks warmer at some times than at others, but also affects the direction and length of shadows. Depending on which direction a building faces, it could be in shade from neighbouring buildings for many hours of the day; east-facing buildings receive light in the morning, west-facing in the afternoon. When a building receives direct sunlight, you need to observe how the shadows cast by balconies, structural protrusions and other features help or hinder the scene.

At night, the scene takes on a completely different appearance. Street lamps, light shining through windows and other forms of artificial lighting – in particular floodlighting – all help to give a completely different look to a familiar structure.

CONVERGING VERTICALS

This term is used to describe how a building appears to be falling backwards in a picture, with the verticals converging towards the top, due to tilting the camera upwards when shooting the scene.

Converging verticals can add drama to an image, but you can minimize the problem. Standing back and using a telephoto setting works well with strong foreground interest. Shooting from a higher viewpoint reduces how much you need to tilt the camera. Some SLR lenses offer perspective control, which provides a solution, but they're very expensive. A far more affordable alternative is to correct converging verticals in post-production, which is relatively easy with Photoshop and most other popular image-editing packages.

STRAIGHTEN UP
You can use software like Photoshop to straighten up buildings in a matter of minutes.

CHURCH
When shooting interiors, try to rely on the ambient light rather than flash, as the results are more natural and attractive.

INTERIORS

The interiors of buildings can provide great photographs. With churches, the interiors make for stunning images, while the character of older buildings can be captured by a keen eye. If the location is artificially lit, shoot in Raw and use Auto White Balance, adjusting colour balance on your computer later if required. Due to limitations of space, the wider the focal length of the lens, the better.

Use a polarizer
A polarizing filter reduces reflections in windows and increases colour saturation – dark blue skies make good backdrops.

BOOTS
Look for unique or unusual details that could make an interesting image.

DETAILS

It's not only the building as a whole that you should consider photographing; take a look at architectural details, too. The arrangement of windows, pillars, arches, staircases and brickwork can all be used to form strong photographic compositions. Although a wide-angle lens is more suited to capturing whole buildings, you will find that the telephoto end, along with a close-up facility, opens up new possibilities.

Take care!
Never photograph government-owned buildings or sensitive areas such as airports without asking for permission first. In some countries, you can be imprisoned for doing so.

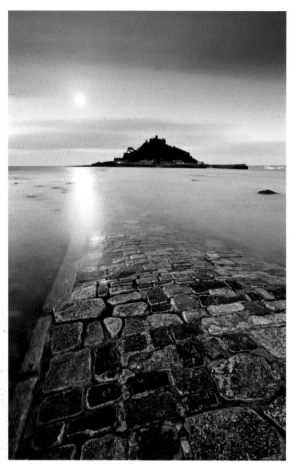

NIGHT PHOTOGRAPHY

They say that the fun really begins after dark. The world takes on a different dimension when night falls, so be sure you know how to exploit it.

Photography at night requires a different set of skills, as well as the right photographic equipment, to perfectly capture the nocturnal mood. Familiar scenes can take on a whole new feel and atmosphere at night, when artificial light sources mix with what little natural light is left to create some unusual and dazzling results. The long exposures that result from shooting in such low light conditions bring with them their own challenges, but if you are prepared for what is required, you will be able to bring the night to life.

COASTAL NIGHTSCAPE
After sunset, hang around and use the moonlight to capture a coastal scene packed with mood.

WHAT TO SHOOT AT NIGHT?

Although rural localities offer great scope for photographers during daylight hours, it is urban areas that hold the most potential for taking nighttime pictures. Buildings take on a completely different appearance at night, with artificial light creating bright, colourful images. Floodlit buildings can often look very impressive at night. Other forms of artificial lighting that can contribute to eye-catching images are neon signs: these will present you with a vivid display of reds, blues and greens. It is a good idea to head anywhere that has large expanses of water, such as rivers, ponds or lakes – the reflections of artificial lights can add an extra dimension to such images.

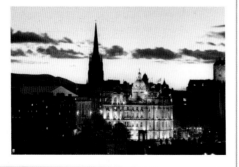

URBAN NIGHTSCAPE
Floodlighting allows cities to take on a new lease of life at night.

ESSENTIAL NIGHT GEAR

Tripod
Due to very long exposure times, use a sturdy model that isn't going to shake in the wind or when heavy traffic passes nearby.

Remote release
Pressing the shutter release with your finger can result in slight (but potentially disastrous) camera shake at the start of the exposure. A remote release prevents this problem.

Torch
It may be difficult to see the controls at night, so keep a small torch in your gadget bag.

Warm clothing
Night brings with it a drop in temperature – make sure you wrap up warm.

NIGHT TECHNIQUES

The most important thing you need to bear in mind is that you are going to be working with long exposures of several seconds. This means you need to ensure that the camera remains completely still while the shutter is open. If you are using a camera with an automatic flash, make sure it is switched off or the effect will be ruined. You can leave the camera to work out the exposure, but bracket it by +1 and +2 stops as it is a very difficult lighting situation for the camera to handle. Better still is to work in aperture priority mode. Set a mid-aperture such as f/8 or f/11 for optimum sharpness, then let the camera take care of the shutter speed. Again, use the exposure compensation facility and shoot extra frames at +1 and +2 stops.

Stick to a low ISO rating of ISO 100–200 to minimize the risk of noise. With shutter speeds exceeding 15 seconds, consider using the Long Exposure Noise Reduction facility if your camera has it. Don't worry about compensating for the colour casts from the artificial lights – these create the unusual colours you are looking for.

Finally, don't ignore the backdrop of the picture. If you shoot shortly after dusk, when there is still some colour left in the sky, this will appear on the image.

FLOODLIT CASTLE
Shooting buildings at dusk allows you to combine ambient and artificial illumination for creative effect.

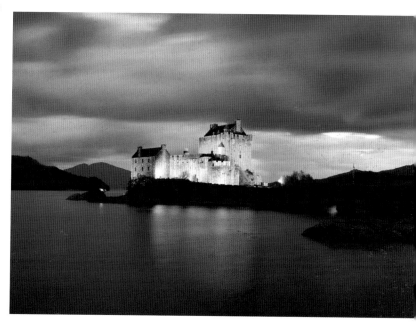

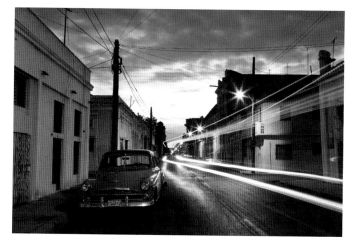

TRAFFIC HEADLIGHTS
A long exposure of two seconds allowed the headlights of traffic to be captured as streaks of light.

TRAFFIC TRAILS

The trails of light that emanate from car headlamps and rear lights can be used to add an extra creative element to night photography. Traffic trails are relatively easy to achieve: all you have to do is to ensure that you include a road or two in the frame. The longer the exposure, the longer the trails will be, and the more traffic there is, the more trails that will be recorded. Follow the technique guidelines you would use for a normal night shot, but bear in mind that you will need to take up a decent viewpoint to capture the trails well.

A high viewpoint always works well, so look for a building, hill or bridge that you can shoot from. Whenever possible, have the traffic running into the frame, as opposed to across it, as the trails will be more defined this way.

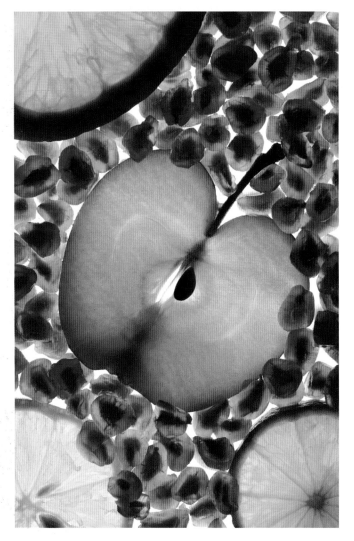

FRUITY STILL LIFE
Arranging fruit on a lightbox has resulted in a colourful and attractive image.

CLOSE-UPS

Get into close-up photography and you will discover a world within a world. Familiar objects take on a completely different appearance, while new, undiscovered subjects are revealed. Close-up photography is an area where having the proper equipment for the job is particularly important.

MACRO PHOTOGRAPHY

Macro photography involves recording an image at least life-size. In this way, a coin that has a diameter of 10mm (⅜in) will appear on the sensor as the identical size in diameter. The reproduction ratio refers to how the subject's size on the image relates to its true size. A 1:1 ratio means life-size; 1:2 means half life-size; 1:4 a quarter life-size, and so on.

WHICH MACRO LENS?

Many lenses boast a macro setting, but their reproduction ratios fall far short of life-size. True macro lenses have at worst a reproduction ratio of 1:2. The 105mm macro lens is the most common, with 50mm, 70mm and 180mm lenses also being popular.

There are a small number of zooms, such as the Sigma 70–300mm, that offer a 1:2 ratio. These won't match a true macro lens for quality, but are a worthwhile consideration if you have a small budget.

Although different focal lengths may give the same reproduction ratio, they do offer one major difference: their working distance. This refers to the distance required to give the maximum reproduction ratio, referred to as the minimum focusing distance or working distance. The general rule is that the greater the working distance (in other words, the further the lens is from the subject to achieve the maximum reproduction ratio), the better. There are two main reasons for this. The first is that when photographing small insects, the further away you are, the less likely you are to frighten them away. The second is that you are less likely to obscure the subject from the light or to cast a shadow across it.

WHAT SUBJECTS MAKE GOOD CLOSE-UPS?

Almost anything is suitable. Close-ups of familiar subjects can reveal textures, patterns and shapes that you wouldn't normally notice. Try photographing natural objects such as flowers, wood or leaves; small animals like insects; or close-ups of small parts of larger subjects, such as fruit or feathers.

CLOSE-UP TECHNIQUES

Depth of field is far more limited in close-up work than in general shooting conditions, so focusing and the correct choice of aperture are vital.

Autofocus systems can struggle with the very short focusing distances involved, so if the option is available, set your camera to manual focus or single-point AF. Confirm the camera has focused by checking the AF confirmation (usually a green circle in the viewfinder).

If you can choose the aperture setting, choose the smallest f/number to maximize depth of field. Even this may provide only a tiny zone of sharpness, which will result in a slow shutter speed, so set the camera on a tripod or monopod. If shooting subjects like flowers outdoors, try to shield them from wind, as any movement will blur the result.

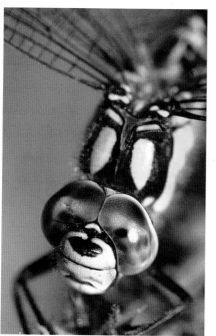

THE EYES HAVE IT!
A macro lens allows you to get close to very small subjects and capture them in amazing detail.

THORNY ABSTRACT
Being able to crop closely on subjects allows you to turn everyday objects into abstracts.

CLOSE-UP ACCESSORIES

Various accessories allow photographers to increase the close-up capabilities of their outfits.

Extension tubes

These fit between the lens and camera. By increasing the distance between the lens and the sensor, the magnification is increased. This is a relatively low-cost option and well worth considering. Be sure to choose an 'Auto' extension tube set, which has electronic links to retain communication between lens and camera.

Close-up filters

These screw to the thread of a lens and serve to increase the lens magnification. Various strengths are available, with the most popular being +1, +2 and +3. Close-up filters can be used together to combine their magnifying power, but quality can suffer.

Bellows

These are not so popular as they were a few decades ago, due to their size and limited features, but offer even higher magnification than extension tubes can manage.

Reversing rings

These rings allow lenses to be fitted back to front to provide high-magnification photography. The lack of communication between lens and camera gives the rings limited appeal.

Ring-flash

Due to the small working distances involved in close-up photography, lighting presents a major problem. Integral or hotshoe-mounted flashguns aren't suitable, so specialized flashguns, with tubes that circle the lens, have been developed. Similar models boast independent bulbs that can be positioned to provide precise directional light.

PATTERNS

The world is full of patterns, and you can find them everywhere you look. Some may take a little more searching for than others, but with a trained eye, you will soon be able to spot them with ease and use them in your photography. Broadly speaking, you can divide patterns into two main types: the manmade and the natural.

FLAGS
The world is full of patterns – you just have to keep your eyes open and you'll find them

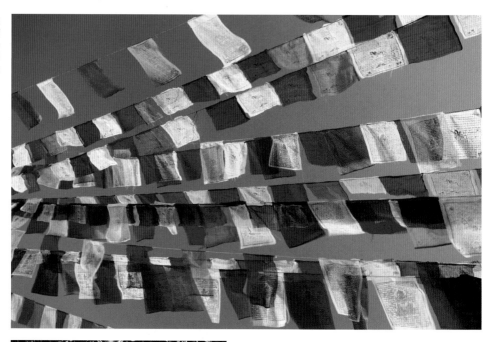

WATER DROPLETS
Spray water on glass and use props like card and lighting to create unusual and appealing results.

Is there a best lens for patterns?

Because patterns come in all shapes and sizes, there is no one particular lens of choice. However, a macro lens is a good option if you want to exploit the smaller patterns, such as a flower's petals. For more on close-up techniques, see Close-ups.

MANMADE PATTERNS

Symmetry dominates the manmade world. If you don't believe me, then just have a look down your street. Are the buildings all similar in size and shape? Does each one have a symmetrical set of windows and doors? Looking even closer; are all the bricks put together on a symmetrical basis? Of course they are. And it doesn't stop there. Go inside a building and you will see many patterns there too – the tiles on a floor, for example, the spiral of a staircase, or the arches of a cathedral roof.

Visit a market and you will see patterns in fruit and vegetables; take a close look at a bouquet of flowers and you'll see some more. View a town or a village from high on a hill, and you'll see that the streets conform to a pattern. Even the cars in a car park make a tidy arrangement. The manmade world is full of patterns; you just need to identify them.

SPIRAL STAIRCASE
Silhouettes of subjects like staircases can be used for interesting patterns.

RIPPLES IN THE SAND
The next time you are on the beach, look down at your feet and see if you're able to capture great images of patterns in the sand.

POLLEN
All flowers are the source of many natural patterns.

NATURAL PATTERNS

Nature follows symmetry too, so you won't be short of subjects to photograph in the natural world. Usually, you need to get in close to a specific subject before the patterns become apparent. Take a flower like a gerbera, for instance. Its petals form a uniform circle around its centre – there's one pattern for you to exploit. Pick up a leaf and examine it. Can you see the intricate series of veins that run through it? There, you have another pattern to photograph.

As for a wider view of the natural world – you won't go short of patterns there. Visit a sandy beach, and you will find ripples in the sand; visit a forest, and you have a pattern of trees to capture; a field full of poppies has its own colourful arrangement for you to enjoy, while every pond or lake offers collections of ripples.

One additional pattern to consider is that created by shadows. Whenever strong sidelighting is evident in a scene, watch for the shadows that appear, as these can be used to form another interesting composition.

We are truly spoilt for choice when it comes to patterns, so start looking for them and you can build up a portfolio of patterns to enjoy.

Create your own patterns

The next time it is raining outside or a blizzard has snowed you in, use the time on your hands to create your own pattern pictures. Slice up some fruit, for instance, and photograph the pieces on a lightbox, or look around the home for anything you have a collection of that could form a pattern, such as coloured pencils or matchsticks.

SUNSETS

The few minutes when day turns to night present photographers with an ideal opportunity to capture some of nature's most beautiful moments: sunsets.

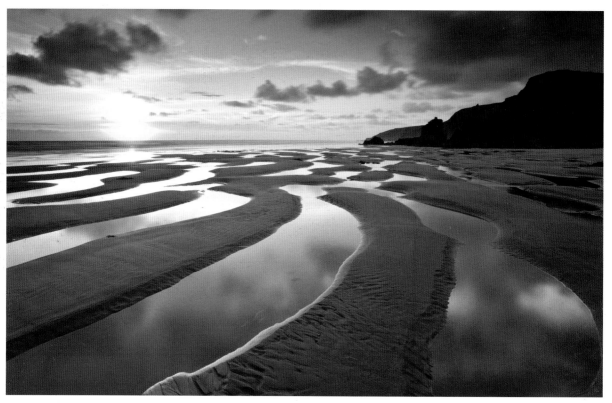

COASTAL SUNSET
When it comes to sunsets, you can't beat the coastline for locations that deliver brilliant results time and again.

SHOOTING SUNSETS

There is very little to match a glorious sunset for sheer colour impact. When nature gets it right, the splendour of a sky filled with golden hues is hard to equal.

The secret to taking great sunset images is to plan them well in advance and to be set up ready to go well before the sun starts its final descent in the sky. First, you should find the right location: coastlines or any areas with large expanses of water, such as lakes and rivers, are ideal as they allow an unobstructed view of the sky and horizon, and also provide the added bonus of reflections on the water's surface.

Good foreground interest is important. A frame-filling sunset is attractive, but will look even more spectacular if it forms the backdrop to fantastic scenery, such as a village or a coastline. You will often find that because you are exposing for the relatively bright backdrop, the foreground will tend to record dark, so it is important to choose subjects that have distinctive shapes that work well as silhouettes – boats, rocks and churches are good options. You can get around this by using a graduated filter (see Filter techniques).

Bear in mind that you will only see the sun sink below the horizon in flat areas or at the coastline. If you shoot inland, it is likely that the sun will disappear behind a hill long before it reaches the horizon.

Once you have decided on the location, you should find out at what time the sunset takes place. Most national and local newspapers will provide information on sunset times for your area.

EQUIPMENT

Any type of camera can be used to photograph sunsets. You are likely to want to include a fair amount of scenery in the frame, so you will need a wide-angle lens to capture foreground details as well as large expanses of sky. If you are using a DSLR or CSC, you will have the advantage of being able to fit filters to the lens, but this is not always essential.

Because the exposure will be quite slow, handholding the camera presents the risk of camera shake, so you should take along a tripod or other camera support.

You can boost sunset colours by adjusting the colour balance on your camera. There are two ways to do this. The first is to change the White Balance to give a warmer result; for example, from Daylight to Shade or Cloudy. The second is to increase Colour Saturation via the on-screen menu. Of course, you can adjust colours when post-processing too.

EXPOSURES

Sunsets can present problems for exposure systems, because of the wide range of contrast between the bright sky and dark foreground, but there are various ways to ensure that you have the correct exposure. Checking the image on the LCD monitor gives a good indication of the exposure, but this isn't completely foolproof, so try out the following methods.

The first technique is to shoot at the camera's recommended exposure and then bracket in 1EV-increments: +1 and +2 stops. If your camera has a partial or spot-meter facility, you can get an accurate exposure by taking a reading from a midtone in the scene.

Take your reading from an area of the sky that falls midway in brightness between the area closest to the sun and the darkest part. If you are still unsure, take an exposure reading of the brightest and darkest areas and shoot at the average of the two. You could also use a reading from the foreground. Use a graduate filter to prevent the sky from burning out in the frame.

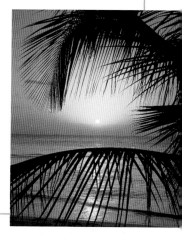

TOP TIP
Various websites and smartphone apps offer sunrise/sunset times for most areas around the world.

orange filter

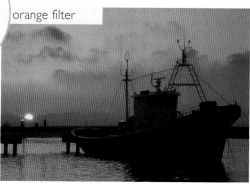

unfiltered

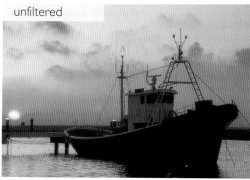

TRAWLER
These two pictures show the difference a filter makes. In the unfiltered image, while the sunset in the backdrop is pleasant, the colours are weak. Using a Cokin orange filter adds a boost to the scene to give it far more impact.

Filter choice

Two or three filters can be considered for photographing sunsets. A warm-up (81 series) or even an orange filter can be used when the colours in the sunset are weak. Some manufacturers produce an orange graduate sunset filter, as well as a range of colour graduates aimed at intensifying the colours in the sky. If the colours in the scene are naturally strong, a grey graduate can be used.

It is good practice to lock the meter reading from the foreground, otherwise the exposure will result in a pale or burned-out sky due to overexposure.

Finally, a diffuser can help to add a soft and romantic feel to sunsets. It can be used on its own or alongside another filter.

The weather conditions will dictate the intensity of the sunset and determine whether or not you should use a filter to enhance the colours. If the sky is naturally rich in golden hues, it is best not to overdo things by using a filter. If you decide to do so, always take an unfiltered shot, just in case.

TRAVEL

Visiting new locations offers an exciting potential for capturing new images, so make sure you are ready to take advantage of what is probably a once-in-a-lifetime opportunity.

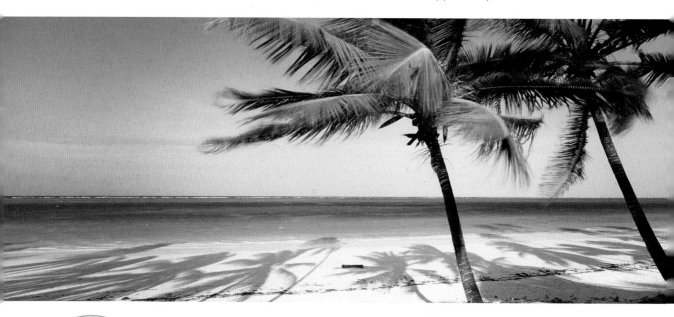

PARADISE
We all love the thought of visiting exotic locations, which is why images that capture the atmosphere of faraway places are so appealing.

TOP TIP
A card case allows you to store several memory cards together and keep them stored safely in your pocket or bag.

RESEARCH

Good travel photographers plan much of what they will photograph well in advance of the trip. This can involve guide books, such as the *Lonely Planet*, *Rough Guide* or *Blue Guide* series, which are excellent for discovering the locations that offer the best opportunities. The internet, with its huge resources of information, is another port of call for gathering knowledge on places that you plan to visit.

In addition to researching locations, check to see whether any special events are taking place when you travel. Festivals and fairs offer enormous potential for photography, so don't miss out on these colourful and lively occasions.

TRAVEL GEAR

Be very disciplined on what photographic kit you take abroad with you. It is pointless packing your entire outfit when you are only going to use 20 per cent of it on your trip.

Camera: An obvious inclusion, but before you travel, make sure it is working properly and you have packed spare batteries.

Memory cards: Have you packed enough for your trip? You might be able to buy more supplies abroad, but is it worth the risk when they take up only a small space in your luggage?

Filters: Another accessory that takes up hardly any room and weighs next to nothing. The minimum should be a polarizer and an ND graduate filter.

Tripod and remote release: It is worth packing a very lightweight or tabletop tripod and a remote for shooting night scenes.

Photo backpack: Invest in a small backpack, which provides protection for your gear and holds items like maps and snacks. Lowepro and Tamrac both offer excellent choices.

Lenses: Zooms are best. Packing an ultra-wide-angle and a telezoom covers most focal lengths. A macro lens is also useful.

Back-up device: Regularly back up images to a laptop or portable storage device in case a memory card corrupts or is lost.

Clear plastic bags: Pack your gear in these to prevent condensation forming on equipment.

CAPTURE THE CULTURE

The best travel pictures are those that reveal the culture of the areas that you visit. The three key subjects you should try to capture on camera are landscapes, architecture and people.

Landscapes offer the best potential when you visit a climate unlike what you are used to at home. It is unlikely that you have large expanses of desert or a Caribbean beach with overhanging palms around the corner, so ensure you make an effort to capture the landscape of the country you visit.

Architecture can reveal much about the history of the location. Churches and other places of worship are excellent sites to practise your architectural skills. After shooting the exterior, head inside – but make sure you gain permission first, and leave a donation as a gesture of thanks. Famous landmarks are obvious subjects to photograph. Take a look at postcards to find the best angles to shoot from, then try to be different and look for unusual ways of capturing a familiar scene. Break off from the beaten track and take long walks through the quieter streets – here you will find the real character of local architecture.

As well as using a wide-angle lens to include the whole building in a scene, use a telephoto to pick out details, such as intricate statuettes outside a temple, or use perspective compression to make buildings appear stacked against each other.

Nothing exudes the culture of a race more than its people. Look to capture people in traditional garments – some are happy to pose if you ask them; others request money, which seems a fair trade if you get a decent picture. Visiting local markets provides enormous potential for colourful compositions, candids and environmental portraits, as do ports and harbours, where you can look for fishermen emptying nets and traders bartering.

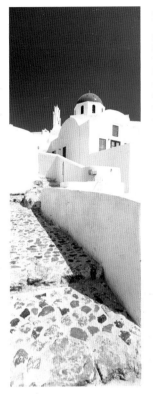

ARCHITECTURE
The best travel photographers are adept at capturing the culture of locations – great images of local architecture is one of the best ways of doing this.

X-ray machines

X-ray machines were once a major concern due to the risk of film being fogged. However, digital users need not worry as there is minimal risk of X-rays affecting images on storage cards.

USE YOUR TIME WISELY

Planning what to shoot during each day ensures that you make full use of every available hour. Mornings and late afternoons usually have the best light, so take the opportunity to shoot landscapes or wander round and capture architecture.

During the middle of the day, when the light is at its least attractive, look to capture details in the landscape or photograph the locals. While you are out, look around for ideal locations to shoot sunsets. Areas with large bodies of water, such as coastlines, are ideal.

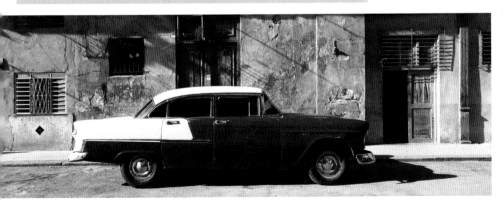

CLASSIC CAR
Placing the red car centrally in this panoramic works to contrast the shiny bodywork with the tatty street behind.

PAINTING WITH LIGHT

Techniques don't come much more surreal than painting with light, a method of using a long exposure with an artificial light source to create amazing results.

The theory behind painting with light is very simple: you take pictures in near or total darkness, set a very long exposure (we're talking times of 30 seconds to several minutes) and move an artificial light source (such as a torch or flashgun) around to illuminate a scene. The result is an image that has a surreal feel to it, caused by the uneven illumination of the artificial light source, often combined with any ambient light.

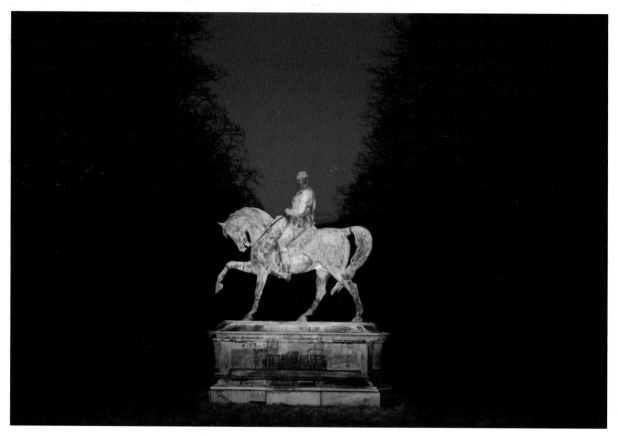

STATUE
Lighting up the statue and placing it centrally against the blue strip of night sky results in an unusual and effective nighttime composition.

HOW TO PAINT WITH LIGHT

As bizarre as the technique sounds, the results are well worth the effort, as the images shown here clearly illustrate. The good news is that painting with light isn't difficult to attempt; it is simply a case of trial and error. Fortunately, digital cameras allow you to check each exposure in turn, so that you can see what you are doing right and where you are going wrong.

The way you shoot varies slightly depending on whether you are taking pictures of small objects with a torch or large subjects with a flashgun; however, some factors remain the same. You need to set the camera to a long exposure. Start with a shutter speed of 30 seconds, then one minute, then two minutes. Alternatively, set the camera to its Bulb facility and use this instead.

Mount the camera on a sturdy tripod, set a mid-aperture such as f/8 or f/11, and focus manually to ensure sharp results.

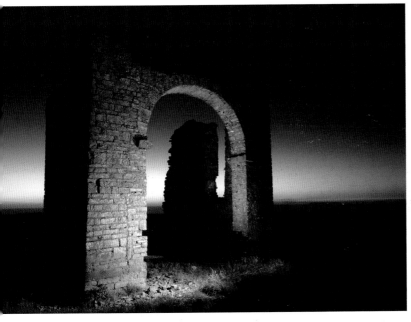

RUINS
Ruins captured at sunset using several bursts of flash produces a moody and haunting night landscape.

GUITAR
Using a torch to outline the recognizable shape of a guitar is a simple technique that can be applied to all sorts of everyday objects.

If you are using a torch to paint small subjects, practise the routine in daylight or with the room lights on so that when you work in darkness you have a better idea of how to paint your entire subject. Remember that you want to illuminate the whole scene and give particular emphasis to certain areas by painting them more than once. Use a slow, smooth movement to ensure the subjects are well illuminated. If shooting subjects like fruit, circle the outlines to emphasize their form. Note that LED torches give a clean, white light whereas traditional torches are warmer.

If you are working with flashguns outdoors, you will need to fire the flash far more times than you think necessary to get a decent exposure. Make sure you give emphasis to certain areas by giving them multiple flashes. Keep moving, or you risk recording yourself if you stand still. If you have a lot of ground to cover, ask some friends to help out.

The whole process behind painting with light is a hit-and-miss affair. Practising the technique will teach you what exposures work best and how you should light the scene. You will never get the same result twice, so it is a great technique to return to.

Advanced techniques
As you become more proficient in this technique, try advanced techniques, such as mixing light sources or using filters. For instance, with still life subjects, you could give a low-power burst of flash at the start of the exposure and use the torch for the remaining time to create different effects. With filters, by firing a flash through a colour filter, you can add an extra dimension to how your subject is illuminated. Remember, there are no hard-and-fast rules; experimentation will reveal its own rewards.

LIGHT PAINTING TIPS
- Keep a notebook handy and record all your exposure details, so when you return to shoot similar scenes, you have a far better understanding of where to begin.
- When photographing close-ups, bear in mind that the nearer the light source is to the subject, or the longer you illuminate it, the brighter it will appear on the final exposure.
- If using a torch, fit a snoot made from white card around the head of the torch to give a more direct direction to the beam; this will give more defined light trails on the exposure.
- When shooting large subjects, such as buildings, have more than one flashgun handy so that there is no delay while you wait for each one to recharge.

AFTER THE PHOTO
PHOTO CLINIC

Have you looked through your pictures and spotted something that shouldn't be there?

◄ VIGNETTING

Very dark or black edges signify something encroaching on the periphery of the lens. This problem predominantly occurs with wide-angle lenses, especially when set to the widest or smallest apertures.

Solution: Make sure you use the recommended lens hood. Avoid using a wide or small aperture – sticking to f/8 or f/11 usually avoids the problem. Stop using a combination of filters at the same time.

FLARE ►

Bright streaks or spots in the image.
Solution: The result of light bouncing around in the lens. Best avoided by using a lens hood or shielding the lens with your hand, to help keep the light source out of the frame.

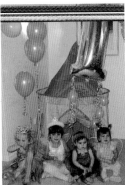

◄ CORRUPTED DIGITAL IMAGES

Part or all of the image appears as a messy pattern of noise.
Solution: Reshoot the scene.

IMAGE ARTEFACTS ►

Zooming into an image reveals a mosaic of unusual artefacts that degrade overall image quality.
Solution: Problem caused by JPEG compression. In future save images at maximum quality (minimum compression).

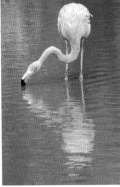

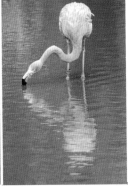

▼OVEREXPOSURE

The image appears too light.
Solution: Reduce the exposure compensation, or take a selective reading from a midtone.

UNDEREXPOSURE ►

The image appears too dark.
Solution: Add exposure compensation or take a selective reading from a midtone.

▼ COLOUR CAST

The scene suffers from a colour cast, most likely due to artificial lighting.
Solution: Use the appropriate White Balance setting or shoot in Raw and adjust White Balance when converting the image on your computer.

Camera clinic: looking after your camera gear

- If you are not planning to use your gear for a while, remove batteries and store cameras, lenses and flashguns in see-through polythene bags to protect them from moisture – this is also useful when travelling.
 ...ly with a suitable lens cloth.
 ...nd or water on the camera. If sea spray ...amera, wipe it with a slightly dampened ...absorb any salt.
 ...in a well-padded bag, and avoid bumps
 ...cs protected by fitting a cap over ...s.

▼ POOR FOCUS

The subject appears unsharp.
Solution: Make sure the autofocus is engaged and working properly. Use manual focus if AF falters.

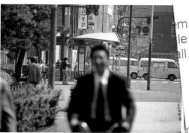

...AKE ▶

...lurred, ...e has ...osure. ...aster ...rest ...on a ...e, or ...ash.

...ct/ ...result ...from ...he ...ly ...ode.

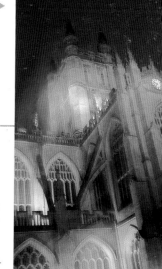

...RTION

...ide-angle lens, the ...distorted, with straight ...aring to be curved. ...Move away from the subject, ...p using a wide-angle and ...ocal length of 50mm or more.

▲ BLEACHED FLASH EXPOSURE

Flash exposures make the subject appear bleached white.
Solution: This is usually the result of the subject being too close to the flash, so increase the subject-to-flash distance.

◀ BLURRED SUBJECT

Moving subjects appeared blurred.
Solution: Use a faster shutter speed to freeze subject movement.

STORING AND DISPLAYING PICTURES

After spending time, money and effort on taking decent pictures, it seems a shame to leave them on your hard disk, never to see the light of day again. There are now many wonderful ways in which to show off your work.

PHOTO LAB SERVICES

The two most popular traditional photo services are reprints and enlargements. Most high-street and mail-order labs have offered these services for decades. Many now offer a service that accepts damaged or faded prints, and uses digital manipulation to correct colour casts, tears, scratches and stains.

The picture CD service has become increasingly popular. Along with a set of prints, the pictures from the film are scanned and stored on a CD. There are usually at least two folders featuring the images at different resolutions – low resolution for sending with emails, high resolution for future reprints.

PERSONALIZED ART

The advent of digital photography has brought with it many creative options on how pictures can be exhibited. In particular, there is now a vast number of personalized art services that allow you to turn an image into something far more spectacular than a photo in a frame. Home furnishings have seen an increasing number of photo-related products; from throws to blankets to cushions, there is an endless choice of products on which to print your images. Bags remains a very popular choice for personalized art, varying from small handbags to large holdalls. It's also possible to have images printed on purses, wallets and make-up bags.

WEBSITE OPTIONS

Having your own website is a great way of showing your images to the world. It also offers the possibility of selling your images to a world market. There are various companies available that allow you to do this easily. All you have to do is upload the images, along with appropriate details. One of the very best companies that provide this service is www.clikpic.com. Clikpic is a very inexpensive service that allows you to choose from a number of attractive templates. The choice is extensive and you can add custom functions to the website to suit your needs. Clikpic offers a free trial period and is highly recommended.

Personalized products

Most labs offering processing services often have various personalized products. These range from having your pictures placed on T-shirts, mouse mats, greetings cards and jigsaws. In the UK, you can also have Smilers stamps issued, which feature a picture of your choice.

PICTURE STORAGE AND ARCHIVING

Photographs should be stored in particular conditions to maximize their lifespan. The two biggest dangers to prints are light and moisture, which can cause irreparable damage. A very simple procedure to minimize harm is to store prints in a cool, dark and damp-free environment. A drawer or cabinet is ideal. Direct sunlight will fade colours in prints, so if you have exhibited in frames, bear this in mind when working out where to place them. When placing pictures in albums or slides in sleeves, look for products with a corrosion-free label. Some plastics, such as PVC, contain acids that can damage the emulsion over a number of years.

You should always store duplicates of your digital files onto at least two hard disks and keep one off-site in case of fire or theft. Work from one and keep the other as a master. Copying onto a DVD is also recommended although tests have shown these have a finite life and can become unreliable after a number of years, with cheaper makes proving most susceptible to failure. Therefore, try to use well-known and reliable brands. You should also consider backing files to a 'cloud' site like Apple's MobileMe service.

CANVAS BLOCKS

Canvas art blocks have been very popular in the last few years and now photo canvas blocks are available. These are canvas prints that are stretched over a wooden frame so that they are ready to hang. Canvas blocks are one of the most popular type of personalized art form, available in a range of sizes and shapes. Most places that handle canvas blocks can also print them onto wood blocks.

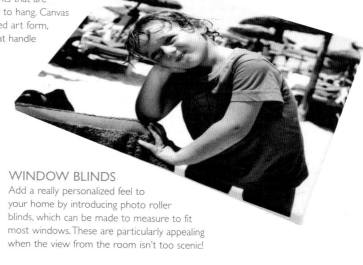

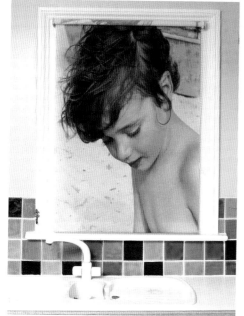

WINDOW BLINDS

Add a really personalized feel to your home by introducing photo roller blinds, which can be made to measure to fit most windows. These are particularly appealing when the view from the room isn't too scenic!

PHOTO BOOKS

Various companies now allow you to self-publish your own photo books, with various templates available to suit your liking. You upload images, arrange them and type in accompanying text, then once finished, upload the files, pay and within a few days you'll receive your own high-quality photo book.

ENGRAVED GLASS

Having images etched onto glass is another innovation in personalized art. The image is created by a laser, which makes thousands of tiny, but visible, fracture points in the glass. Engraved glass products include plaques, keyrings, tumblers and jewellery.

MAKING MONEY FROM YOUR PICTURES

A dream for many amateur photographers is to make money from their hobby. If your photographs are produced to a high enough standard, then there is a wealth of opportunities to make some spare cash, or even to earn a living, from your photography.

COMMERCIAL STRATEGY

There are many photographers already making a good living from their craft, so breaking into the market is not going to be easy. On their side is an established reputation for delivering the goods, so whatever direction you take, making a name for yourself and building up a reputation is vital.

Your best bet is to begin small – in other words, test your market in your local area; then if you are relatively successful and your sales grow, you can consider trying to break into a nationwide (and eventually even an international) market.

Becoming established is a very difficult task to achieve, as is becoming well known for your photographic skills. The various options that are outlined here are just some to consider on how to make money from your pictures.

WHAT TO CHARGE?

Determining how much to charge for an image or a service depends on your location, experience and competition. There is no set rate, but there are a few guidelines to consider. Charge too much and you will frighten away potential customers; charge too little and you will never make a profit. The best option is to look at the competition and find out their rates. Slightly undercut them to begin with, then charge more as demand increases.

Photography as a profession

There is no easy route to becoming a full-time photographer. Speak to the pros and you discover that some studied first; others worked as a photographer's assistant for a time; and some became a pro after years when photography was just a hobby. The biggest asset you can have, apart from natural talent, is a determination to succeed. With a few lucky breaks along the way, you might be able to make a living from photography.

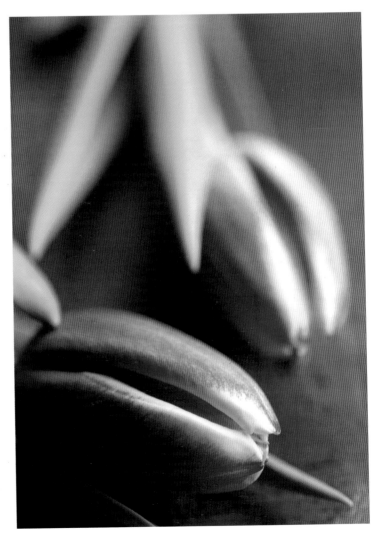

TULIPS
Artistic images of subjects such as flowers have the potential to make money as greetings cards.

MAGAZINE SUBMISSIONS

Photography magazines thrive on pictures, and most of them are open to submissions from their readers. If you have a good selection of images, it is worth sending them to magazines for consideration. If they are used, you will generally receive a fee. It will probably not be very much money, but enough to give you some encouragement.

PHOTOGRAPHY COMPETITIONS

Whatever the time of year, there are always one or two photography competitions worth entering. Photography magazines are usually a good bet, as well as national newspapers and general-interest magazines. In addition to the potential to win big prizes, entering competitions can be used as a discipline to help you take more care of your pictures. If unsuccessful, study the winning images and try to adopt some of the techniques that the winning photographers have used.

WEBSITES

Setting up your own website, or having someone do it for you, is a relatively simple way of allowing an audience of millions around the world to view your work. Of course, the real struggle is getting people to view your website – using keywords like 'photography' in the web address can help, but the website will receive more visits as your reputation grows. You can also display images on social network sites like Flikr and Facebook or photo websites such as ePHOTOzine as a means of directing people to your own website.

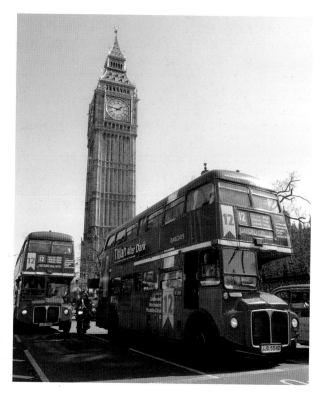

BIG BEN AND DOUBLE DECKERS
Pictures with famous landmarks and sights are potentially big sellers for postcards and calendars.

PUBLIC EXHIBITIONS

An exhibition is a good way to have your images seen by the general public. Your local hall or arts centre may not sound like a particularly exciting place to kick off your career, but it will allow potential clients to view the standard of your work.

And don't discount your local market. Find out if there's a stall selling art prints or paintings, and if so, are they willing to display and sell your work for a commission? This is a good way of gauging the popularity of your images.

STOCK PICTURES

Many photographers have their pictures with stock libraries such as www.istockphoto.com. The advantage is that the library can offer the pictures out to a far wider market than an individual could. The disadvantage is that the library takes a large chunk of the commission – usually around 50 per cent. You won't be able to submit individual images: libraries look to hold hundreds, if not thousands, of images from the same photographer, and expect regular supplies of new stock.

HISTORIC MOMENTS IN PHOTOGRAPHY

What are the most important events in photography since its birth in the early 19th century? The following does not aim to cover every significant moment, but instead provides an easy reference guide to the people, products and images that influenced photography.

1500s The camera obscura, used to aid drawing, dates back to the early 16th century.

1839 Daguerre creates photographic plates (silver-coated copper) that require exposures of only 30 minutes and have the image permanently fixed using salts. This type of image is called the Daguerreotype.

1839 Fox Talbot invents the paper-based Calotype, which, unlike the Daguerreotype, allows duplicates of the image to be created.

1839 Sir John Herschel is considered the first to use the term 'photography'.

1816 The Frenchman Nicéphore Niépce experiments with creating images on light-sensitive material.

1851 Frederick Scott Archer invents the Collodion wet-plate process, which is much faster (exposures of 2sec) and far cheaper than other processes. Archer later develops a positive image, known as the Ambrotype.

1871 Dr Richard Maddox develops a method to use gelatin as a base for the photographic material, rather than glass, which leads to the dry-plate process.

1904 The Lumière brothers reveal Autochrome plates for colour images.

1913 Oskar Barnack produces the Ur-Leitz prototype, which provides the basis of future 35mm cameras.

1900

1921 Man Ray creates Rayographs.

1924 Leica 35mm cameras are introduced.

1925 The first Leica camera, based on the body developed by Oskar Barnack and lenses by Max Berek, is introduced. It is called the Leica I. 'Leica' is derived from 'Leitz Camera'.

1925 The flash bulb is developed.

1928 The Eastman Kodak Company releases colour film for 16mm movie cameras.

1928 The Rolleiflex is introduced.

1800

1829 Nicéphore Niépce enters partnership with Louis Daguerre, who carries on the work after Niépce dies in 1833.

1848 Abel Niépce de Saint-Victor, a cousin of Nicéphore Niépce, is the first to coat glass with a photo-sensitive substance. Derived from the white of eggs, the albumen process offers better quality than Talbot's Calotype, but is much less sensitive, therefore requiring long exposures.

1887 Eastman markets the first Kodak box camera.

1827 Nicéphore Niépce creates the first fixed image – the exposure takes several hours.

1844 Fox Talbot releases the first photographically illustrated book, *The Pencil of Nature*.

1883 George Eastman introduces celluloid-based flexible film.

1932 The photoelectric cell light meter is introduced.

1932 The f64 group is founded by some of the most influential photographers of the time – Ansel Adams, Imogen Cunningham, Willard Van Dyke, Edward Weston, Sonya Noskowiak and John Paul Edwards. The aim is to promote 'straight' or 'pure' photography. The term 'f64' referred to the smallest aperture on many large-format camera lenses.

1934 Canon, or Kwanon as it is then known, introduces its first prototype camera, a 35mm rangefinder.

1936 Kodachrome film, in 35mm and 120 roll-film formats, is introduced a year after the emulsion is available for film cameras.

1936 Canon's first production camera, the Hansa Canon 35mm rangefinder, is based on the Kwanon prototype, and incorporates a Nikon lens.

1939 The stroboscopic flash head is announced.

1944 The Eastman Kodak Company introduces Kodacolor negative film.
1947 The Polaroid Land Camera, which produces a sepia print in 60sec, is marketed.
1947 The Magnum agency is formed.
1948 Hasselblad introduces its first 6x6cm-format SLR, the 1600F.
1948 Nikon introduces its first 35mm camera, the Nikon I rangefinder.
1948 Ansel Adams publishes his Zone System.
1944 The Eastman Kodak Company introduces Tri-X black-and-white negative film, still available today.

1981 Pentax introduces the ME-F SLR, the forerunner to modern autofocus SLRs. Nikon follows in 1983 with its F3 AF, while Canon markets the T80 in 1985.
1982 Sony introduces the electronic digital stills camera.
1985 The Minolta 7000 is the world's first autofocus 35mm SLR.
1987 The Canon EOS 650 is the first 35mm autofocus SLR in what is now the world's bestselling AF SLR range.

2008 Canon launches 'affordable' EOS 5D MkII boasting 21-megapixel full-frame sensor and HD video.
2008 The end of the year sees the release of the 24.5-megapixel full-frame Nikon D3X.
2008 Panasonic announces the Lumix DMC-G1, its first mirrorless Compact System Camera.
2009 Kodak discontinues Kodachrome slide film.
2009 Olympus introduces the PEN E-P1, its first Compact System Camera.

2003 Canon introduces the EOS 300D, the first 6-megapixel AF SLR to become available within the price range of the consumer.

1964 Introduction of the Cibachrome process, for making prints from slides.
1964 The Pentax Spotmatic is the first SLR to feature a through the lens (TTL) meter.

2005 Canon's 16.7-megapixel EOS-1DS MkII sets a new standard for digital SLRs.
2006 Konica Minolta sells its photo division to Sony.
2006 Digital SLRs and compacts with 10-megapixel resolutions become commonplace.
2007 Canon celebrates 20 years of its EOS range of AF SLRs.

2000

1952 Pentax markets the Asahiflex I, Japan's first 35mm SLR.
1957 The Asahi Pentax is the first SLR using a pentaprism. 'Pentax' is a derivative of 'PENTAprism refleX'.
1959 Nikon introduces its first 35mm SLR, the Nikon F.
1959 Canon markets its first 35mm SLR, the Canon Flex.

1991 Kodak introduces digital version of Nikon F3 camera, with a 1.3-megapixel sensor.
1995 The Nikon F5 is the first SLR to incorporate a metering sensor that uses colour to work out the exposure.
1996 The Advanced Photo System (APS) is introduced.
1999 Nikon announces the D1 digital SLR aimed at professionals. It sports a 2.74-megapixel sensor.

1971 The Pentax ES offers the world's first TTL automatic exposure system, with aperture priority AE as well as manual.
1972 Olympus introduces its M-1 (later renamed the OM-1) 35mm SLR, which becomes an instant classic.
1972 Developed for the 1972 Munich Olympics, the Canon F1 boasts a static pellicle mirror and motordrive, giving a top speed of nine frames per second.
1975 Mamiya introduces the world's first 6x4.5cm SLR, the Mamiya 645.

2010 Sony announces its first Compact System Cameras, the NEX-3 and NEX-5.
2010 Sony later announces the Alpha 33 and 55, its first DSLRs with 'Translucent' mirrors.
2010 Olympus introduces its flagship E-5 and reveals it will be its last DSLR.
2011 Canon reveals details of its latest flagship, the 18-megapixel full-frame EOS-1D X.
2011 The Nikon 1 series is announced, with the J1 and V1 being Nikon's first CSCs.
2011 Canon announces the Cinema EOS System – a range of EOS cameras designed for professional movie-making.

GLOSSARY

A

ABERRATION
Term used to describe an optical defect in a lens.

AE-L
Autoexposure lock. Facility to lock the exposure independently of the autofocus.

APERTURE
The opening in a lens, which determines how much light passes through the lens.

APS
Advanced Photo System. The most recent film format, launched in 1996, which failed to gain widespread success.

ARCHIVE
Process by which images are treated or stored for long-term life expectancy.

ARTEFACT
Unwanted information in a digital image – usually evident in images showing high compression, such as JPEGs.

AUTO EXPOSURE
This is the system where the exposure is calculated automatically by the camera.

AUTOFOCUS
The system whereby the lens focus is controlled by the camera so that the subject is automatically brought into focus.

B

BACK-UP
Security measure where a copy of an image, document or entire hard disk is made in case the original is damaged or lost.

BIT
The basic unit of a digital image or file, made up of a 0 or a 1.

BRACKET
A sequence of identical shots taken at slightly different exposures.

BRUSH
A tool used in image-manipulation packages to apply effects such as blurring or dodging.

BULB
Exposure mode that allows the user to set very long exposure times.

BURNING
A technique originally developed in the darkroom and now used digitally to increase exposure in specific areas of an image.

BYTE
A standard unit in computing terms, a byte is made up of eight bits.

C

CCD
Charge-coupled device. Was one of the most common types of image sensor used in digital cameras.

CLONING
A technique in image-manipulation software where a Clone Tool is used to replace certain areas with a clone from another area.

CMOS
Complementary metal oxide semiconductor. The most popular type of image sensor in digital cameras today.

COLOUR CAST
Using an incorrect White Balance preset to suit a particular lighting condition, can result in the whole image exhibiting an unwanted colour cast.

COLOUR TEMPERATURE
The measurement of the colour of light, usually expressed in degrees Kelvin (K).

COMPACTFLASH (CF)
One of the two main types of memory card, these robust but relatively large cards are mainly used in DSLRs aimed at enthusiasts or professionals.

COMPRESSION
Digital process where an image is reduced in size when stored. Depending on the process, this may or may not result in a loss of image quality.

CONTRAST
Describes the difference in brightness from the darkest to the lightest points in an image.

CSC
Compact System Camera – a mirrorless camera with interchangeable lenses. Its advantages are smaller cameras and lenses compared to DSLRs.

CMYK
Cyan, Magenta, Yellow, Black. The four inks used in colour printing.

CROP
The removal of unwanted areas of a frame.

CROSS-PROCESSING
The development of a film in an alternate chemistry for creative purposes, for instance, C-41 negative film in E-6 chemistry or E-6 slide film in C-41 chemistry. A similar effect is achievable in Adobe Photoshop.

D

DEPTH OF FIELD
The amount of a scene (from the nearest point to the furthest) that appears sharply focused. This varies according to several factors, including focal length, focusing distance and aperture.

DEPTH OF FOCUS
Distance in front of and behind the film plane that will retain sharp focus in the image.

DODGING
Digital technique used to reduce the amount of exposure in particular areas of an image.

DPI
Dots per inch. Measurement for printer and scanner resolution.

DSLR
Digital single-lens reflex. Camera that provides a through-the-lens view in the finder for accurate composition when taking pictures.

DX-CODING
System that uses a black-and-silver grid on a 35mm film canister to inform a camera of the film speed and type.

DYE SUBLIMATION
Printer that produces very high-quality colour prints.

E

EXPOSURE COMPENSATION
System used to override the camera's indicated exposure and add or subtract a preset value.

F

F/NUMBER
Common term used to describe aperture setting, such as f/4 or f/8.

FILE FORMAT
Term used to describe how a digital file is stored. Common examples include JPEG, GIF and TIFF.

FILTER
Optical glass/resin used with lens to provide creative options. Also used to describe digital effects with some image-manipulation software.

FIREWIRE
Common type of computer connection. Also known as IEEE1394.

FIXED FOCUS
A lens where the focus is fixed at a particular distance and image sharpness is determined by depth of field.

FIXED LENS
A lens that does not change focal length, such as a 28mm wide-angle or 400mm telephoto.

FLARE
Non-image-forming light that passes through the lens. Usually the result of a bright light source in or just outside the frame.

FLASH
Artificial light source that provides a strong, brief burst of light to aid exposure.

G

GIF
Graphic Interchange Format. A digital file format commonly used on the internet.

GPS MODULE
Many cameras can be used with a dedicated GPS module to record the location of captured images. A growing number of cameras now have a GPS function built-in.

GUIDE NUMBER (GN)
Used to determine a flashgun's power. GN = subject distance × aperture.

H

HISTOGRAM
Graphical representation of aspects of an image such as contrast and tonal range.

HYPERFOCAL FOCUSING

Technique used to determine the hyperfocal distance and consequently maximize depth of field.

I

IMAGE STABILIZATION

Many cameras and lenses have built-in shake reduction systems that help reduce the risk of camera shake. Most work by using a series of gyroscopes to alter the position of a floating element (in lenses) or the image sensor housing. The majority provide a benefit of 2–3 stops compared to not using any form of stabilization.

INFINITY LOCK

Feature on many digital and film compacts for fixing the focus of the lens to infinity when shooting through glass.

INKJET PRINTER

Most common type of home printer, which works by spraying tiny dots of ink onto the paper.

INTERPOLATION

Artificial method for increasing image size/resolution by adding pixels.

ISO

International Standards Organization. Rating originally used to determine film speed and now used to signify sensor sensitivity.

J

JPEG

Joint Photographic Expert Group. Popular file format as it reduces file size, albeit with a loss in image quality.

L

LAYER

Important feature on some image-manipulation programs, allowing sophisticated adjustments to be made to the image.

LCD

Liquid Crystal Display. Found on most cameras and flashguns, and used to provide important functional information.

LCD MONITOR

Screen on the back of digital cameras that allows images to be composed or reviewed.

LED

Light-Emitting Diode. Coloured lamp used to provide warning or confirmation.

LOSSLESS COMPRESSION

Image file compressed without loss of information.

LOSSY COMPRESSION

Image file compressed with loss of information, resulting in the image quality being degraded.

M

MEGAPIXEL

A shortened term for 1,000,000 (one million) pixels.

MEMORY CARD

Removable and reusable card for storing digital images and files. Various types are available in different capacities.

MEMORYSTICK (MS)

Sony's memory card format, used in many Sony DSLRs and CSCs.

METERING PATTERN

The system used by the camera to calculate the exposure. Patterns can range from the relatively basic centre-weighted average to sophisticated multizone patterns.

MONOCHROME

Image made up of grey tones from pure black to pure white.

N

NOISE

The pixels of a sensor transmit an electrical signal, which if strong enough, can result in digital 'noise' being evident in images as coloured or black dots. There are two main forms of noise, Luminance noise (dark grey/black noise present in all images to some degree) and Chrominance noise (coloured speckles usually seen in darker areas of the image). Noise increases the higher the ISO rating and also becomes more apparent when shooting long exposures.

NOISE REDUCTION

Most cameras offer one or two noise reduction modes. High ISO Noise Reduction targets Chrominance noise but should be used with care as it can affect image quality. Long Exposure Noise Reduction is used to minimize noise in exposures lasting several seconds or minutes. There are also several software packages available aimed at reducing noise levels.

P

PARALLAX ERROR

The difference between the viewfinder image and that recorded by the lens.

PIXEL

Short for picture element. The smallest unit in the formation of an image.

R

RAW

A Raw file is a 'pure' digital image file that has not been subjected to any processing by the camera.

RED-EYE

Direct flash photography often results in blood vessels in the retina being recorded on the image, providing subjects with red pupils.

RESOLUTION

The level of quality and detail recorded in an image. The higher the resolution, the finer the detail.

S

SATURATION

Refers to the intensity of colours in an image.

SCANNER

Device used to convert physical images (film and print) and documents into a digital file.

SECURE DIGITAL (SD)

The other of the two main types of memory card, these are far smaller than CF cards and are used in most compacts, CSCs and amateur-level DSLRs.

SECOND-CURTAIN SYNC

Standard flash exposures fire the flash at the start of the exposure. In second-curtain (also known as rear-curtain) sync, the flash fires at the end of the exposure.

SELF-TIMER

System that provides a delay before the shutter is triggered and the exposure is taken.

SHUTTER SPEED

This determines the duration of an exposure.

SLOW-SYNC FLASH

A flash mode that uses a long exposure with flash to record ambient light in the scene.

T

TELEPHOTO

A lens that offers a shorter field of view and increased magnification than that of the human eye.

TIFF

Tagged Image File Format. Image format offering very high quality at the expense of a relatively large file size.

U

UNSHARP MASK

Effective sharpening tool in many image-manipulation packages.

USB

Universal Serial Bus. Standard connection found on cameras, peripherals and computers.

V

VIEWFINDER

Window through which the image is composed on DSLRs and some digital compacts and CSCs.

VIGNETTING

Darkening of the corners of the frame, due to an obstruction – usually a lens hood or filter.

Z

ZOOM

Lens that allows the focal length to be changed, such as a 28–70mm.

INDEX

A DAVID & CHARLES BOOK
© F&W Media International, Ltd 2004, 2007, 2012

David & Charles is an imprint of F&W Media International, Ltd
Brunel House, Forde Close, Newton Abbot, TQ12 4PU, UK

F&W Media International, Ltd is a subsidiary of F+W Media, Inc
10151 Carver Road, Suite #200, Blue Ash, OH 45242, USA

First published in the UK in 2004
Reprinted 2004, 2005, 2006
Revised and updated for this new edition published in 2012

ISBN-13: 978-1-4463-0217-0 paperback
ISBN-10: 1-4463-0217-2 paperback

Printed in China by RR Donnelley for:
F&W Media International, Ltd
Brunel House, Forde Close, Newton Abbot, TQ12 4PU, UK

10 9 8 7 6 5 4 3 2 1

Commissioning Editor: Neil Baber
Assistant Editor: Hannah Kelly
Project Editor: Ame Verso
Design Manager: Sarah Clark
Production Manager: Bev Richardson

F+W Media publishes high quality books on a wide range of subjects.
For more great book ideas visit: www.rucraft.co.uk